ELLEN STEWART PRESENTS

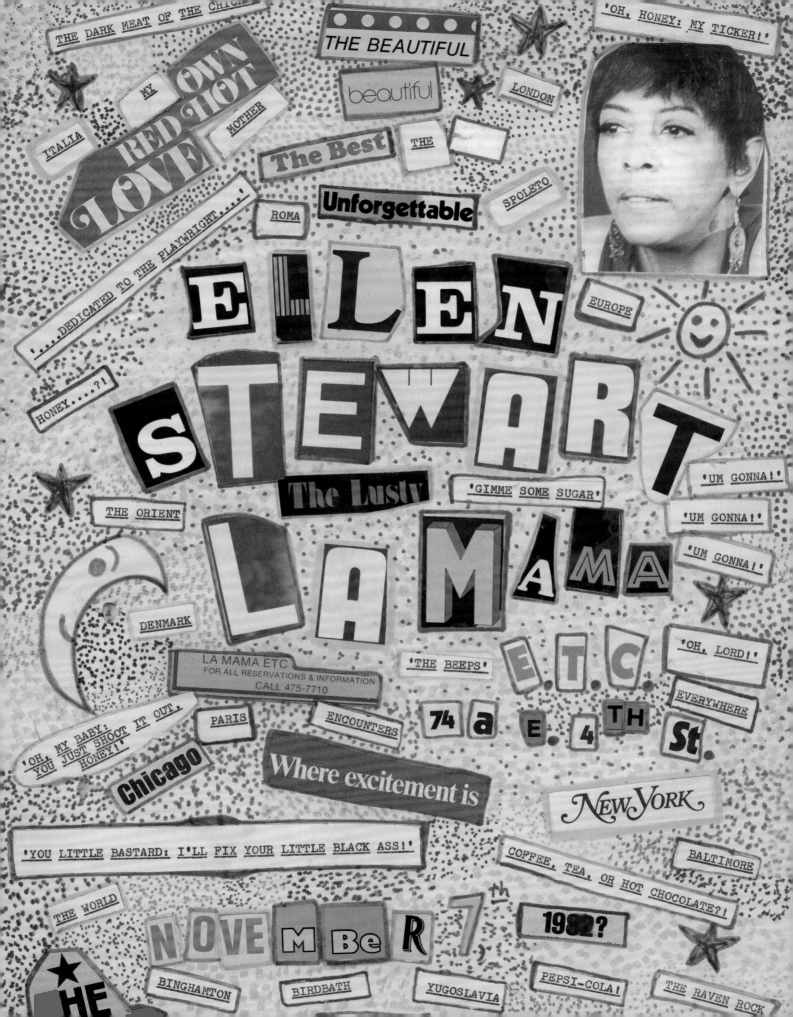

ELLEN STEWART PRESENTS

Fifty Years of La MaMa Experimental Theatre

CINDY ROSENTHAL

ART HISTORY CONSULTANT | CONTRIBUTOR | Elise LaPaix

POSTER PHOTOGRAPHY | Carol Rosegg

POST PRODUCTION | Amy Klein

UNIVERSITY OF MICHIGAN PRESS | ANN ARBOR

Copyright © by the University of Michigan 2017

Published in the United States of America by the University of Michigan Press

Manufactured in China

Printed on acid-free paper
2020 2019 2018 2017 4 3 2 1

A CIP catalog record for this book is available from the British Library.

Library of Congress Cataloging-in-Publication data has been applied for.
ISBN 978–0-472–11742–0 (hardcover : alk. paper)

If no photographer is named, the works in this volume were photographed by Carol Rosegg with postproduction by Amy Klein. All names listed in quotation marks refer to the signature found on the poster. Poster dimensions are in inches, height before width.

Frontispiece: Original artwork by Leonard Melfi, presented as a birthday gift to Ellen Stewart in 1972. Collage, stencil, type, Magic Marker, photography. Courtesy of La MaMa Archive.

Generous support for this publication was provided by Furthermore: a program of the J. M. Kaplan Fund.

Furthermore:
a program of the J. M. Kaplan Fund

In celebration and memory of Ellen Stewart,
because "good things always happen."

ACKNOWLEDGMENTS

Ellen Stewart is impossible to capture in a few words — but I'll try. She was strikingly beautiful, startlingly intuitive, wildly creative, and a unique and powerful figure in the history of experimental and intercultural theater. I am very grateful that she invited me to participate fully and intimately with her and the Great Jones Company in rehearsals, at performances, in meetings, at her apartments in New York and Umbria and on the road from Butrini, Albania, to the Venice Biennale. "I'm glad you're witnessing this," she told me many times. "It takes patience, little one, you can see that." Richard Schechner introduced me to Stewart in 2002 when he asked me to write a cover story on Stewart and La MaMa for *TDR: The Drama Review*. Working first on the article for the journal and afterward on this book had a profound impact on me, personally and professionally. The close relationship I had with Ellen is a precious gift in my life.

I am immensely grateful to Richard Schechner and Mariellen Sandford, who edited the *TDR* article and supported the first iteration of this project wholeheartedly. My exemplary editor and dear friend LeAnn Fields at University of Michigan Press has been a true champion of *Ellen Stewart Presents* through the years. I value her wisdom and her belief in this project more than I can say.

One of our important conversations concerned how to print "La MaMa" in the book. In the long life of La MaMa Experimental Theatre, "La MaMa" has been written and typeset many different ways. Following the preference of La MaMa's leadership and the most common spelling at the time of publication, I have opted for consistency's sake to use "La MaMa" throughout this volume. However, without a doubt, in the 1960s and 1970s this was less frequently used than "La Mama."

There are dozens of La MaMa family members, friends, and affiliate artists that I owe thanks to, for their patience and their inspiration throughout the decade-long research and writing process that has culminated in this book. Mia Yoo, La MaMa's artistic director following Ellen, has my deepest gratitude for her kindness and support.

Ellen Stewart Presents could not have been written without Ozzie Rodriguez, the director of the La MaMa Archive. There is no individual who knows

the details of the history of La MaMa as Rodriguez does. Ozzie opened doors and filing cabinets, moved boxes, tables, and mountains of materials in order to excavate a name, a date, a spelling — the accuracy and clarity of the stories of Ellen Stewart and La MaMa are a top priority for him. I owe Ozzie a huge debt of gratitude for his investment of countless hours and for pouring his big heart, sharp intellect, and sensitive soul into every page of this book. Shigeko Suga, the assistant to the Archive director, was also extremely generous with her time; she was a thoughtful, supportive comrade in arms throughout this project.

Two generous friends who are experts in their fields were creative partners on this project. Theater photographer Carol Rosegg came on board at the beginning of the book process and put her extensive professional background and talent to the task of photographing every poster and object in the book. Her sense of calm and humor and her supreme efficiency were essential to the project, as were the skills of Carol's assistant, Amy Klein, who made important contributions in the postproduction process. Art historian and curator Elise LaPaix was a dedicated and much-valued collaborator on this project as well. Elise was my researcher-consultant on theater posters and graphic art history and provided substantial organizational and technical support with regard to the selection, categorization, and analysis of the poster art in the book. I am tremendously grateful to Carol and Elise for the time and talent they shared with me.

There are many friends who supported this book project over the years in many ways, including James Harding, Dorothy Chansky, Lisa Merrill, Isobel and Michael Armstrong, Stephen Berenson, Brian McEleney, Jonathan Fried, Alan MacVey, Roberta Tepper, Sara Blair, Norman Frisch, and Cynthia Sophiea.

I am grateful to my parents, Lola and Murray Rosenthal (Murray and Ellen Stewart shared a birth year, 1919, and both passed away before I finished the book), who instilled in me a love of the arts and fostered my passion for theater and writing particularly. I owe thanks to my brother Jim Rosenthal and to my sister-in-law Diane Weiner, who shared and supported my dependence on coffee and chocolate in getting through late nights of writing. Diane died suddenly in 2013; I wish I could have celebrated the completion of this project with her.

Finally, I am indebted to my husband, Emanuel Levy, and to my daughters, Anya and Adin — who were generous and curious and thoughtful throughout this long process. It was especially gratifying when my family jumped on the roller-coaster ride with me, experiencing the wide-world adventures, witnessing the breathtaking spectacle that is Ellen Stewart's La MaMa. I am in awe of how my daughters have grown into young women during this decade of La MaMa performance research, travel, and writing. Their wit, beauty, and integrity always lift my spirit.

CONTENTS

1 Introduction

CHAPTER ONE

23 THE 1960s | *Ellen's Babies, a Basement, and a Bed*

CHAPTER TWO

55 THE 1970s | *A Defining Decade*

CHAPTER THREE

97 THE 1980s | *"Ellen Belongs to Everywhere"*

CHAPTER FOUR

127 THE 1990s | *La MaMa Turns Thirty*

CHAPTER FIVE

147 THE 2000s | *The Ellen Stewart Theatre / The Ellen Stewart Way*

173 Bibliography

181 Illustration Credits

187 Index

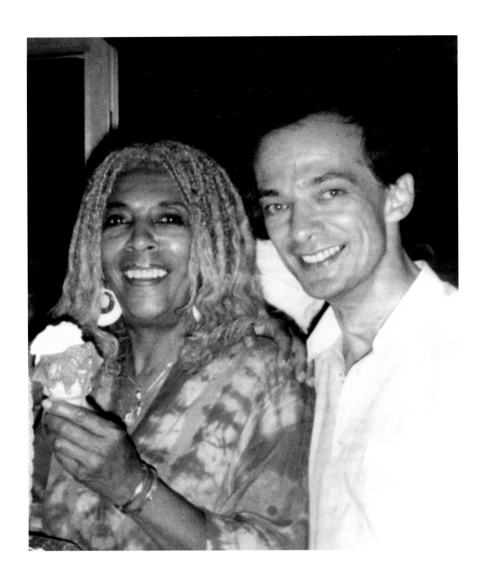

FIG. 1: Ellen Stewart and La MaMa
Archive director Ozzie Rodriguez,
1985. Photo by George Ferencz,
courtesy of La MaMa Archive.

INTRODUCTION

Ellen Stewart was a wonderful storyteller. I was fortunate to be a frequent guest in her apartment/lair four flights above the complex of theaters and La MaMa's offices on East Fourth Street, one of several buildings Stewart / La MaMa acquired in the 1960s and has operated since. On one of the occasions Stewart and I sat together among the big pillows and the photographs and the objets d'art in her museum/living space, she regaled me with a legendary Ellen Stewart origin story.

Stewart had come to New York City from Chicago in 1950 to launch a career as a clothing designer. Soon after she arrived, she paid a visit to St. Patrick's Cathedral to pray that she would find such a job in the city. After leaving the church, she walked across the street to Saks Fifth Avenue and was immediately hired at the department store, albeit as a porter. Porters at Saks, most of them African American, were required to wear a blue smock over their clothing. As Stewart related the story, her talent for fashion was soon discovered, Cinderella-like, when she removed the protective smock later that day to reveal her attractive, self-designed clothes. As a result, Stewart was rewarded with a designer position at Saks and a workroom of her own. After several successful years in fashion design (two of the dresses she designed were worn at Queen Elizabeth's coronation in 1953, she explained), Stewart found her true calling in the theater. Like a latter-day Mother Courage, Stewart believed that her mission was to provide a "pushcart" for "her children," the talented theater artists whose work she decided she would support.

Stewart's support for young artists began in a basement she rented on East Ninth Street, originally acquired as a space to sell the clothing she designed. Instead, she transformed the basement into a venue that produced the work of undiscovered playwrights. There is more to come on Stewart's real-estate savvy and the sequence of moves that finally situated La MaMa in its East Fourth Street theater complex. Many theater luminaries, both alternative and mainstream, cut their teeth at La MaMa. The long list includes Philip Glass, Bette Midler, Billy Crystal, Andre de Shields, Harold Pinter, Harvey Keitel,

F. Murray Abraham, Olympia Dukakis, Sam Shepard, Robert DeNiro, and Wallace Shawn.

This book documents and celebrates the first fifty years of La MaMa Experimental Theatre, and is, rather remarkably, the first book ever on Ellen Stewart's accomplishments and the long life of her theaters. While she could be a great storyteller in person, Stewart tightly controlled what was written about her. Stewart insisted loudly and definitively that she did not want a book on her life or her theaters. I had come to know Stewart and many of the artists who collaborated with her or created work under her roofs over a period of five years when I was commissioned by *TDR: The Drama Review* to write a substantive critical and historical essay on La MaMa, published in 2006. The article in *TDR* pleased her, and when eventually Stewart asked me to do "the book," I did not hesitate; I knew this was something multitudes of La MaMa spectators, artists, and performance scholars in the United States and abroad had been waiting for.

The book Stewart envisioned, the first authorized retrospective of her life in the theater, would have an innovative approach, tracing the history of La MaMa through the posters that announced key productions. Additionally, the book would feature the voices of and the stories from La MaMa artists from the first fifty years. La MaMa's new artistic director, Mia Yoo, whom Stewart appointed not long before Stewart's death, wholeheartedly supported the project. Because Stewart opened doors for me and made countless introductions in her downtown home and on the road, this book contains an assemblage of perspectives and imagery from the New York and international avant-garde scene since the 1960s that is not available elsewhere.

Stewart died in January 2011, just months before the launch of La MaMa's fiftieth-anniversary season, but her legacy continues. As of this writing, La MaMa in New York consists of a four-theater complex with offices on East Fourth Street, and five floors of rehearsal space and an art gallery on Great Jones Street. East Fourth Street also holds the La MaMa Archive, a vast spectrum of materials that include splendid and wild production ephemera and deep file cabinets filled with documentation of the work of the international directors, playwrights, performers, choreographers, troupes, and designers who collaborated at La MaMa's East Village campus and at La MaMa Umbria, a cultural center and artists' enclave Stewart established near Spoleto, Italy. La MaMa Umbria hosts the International Symposium for Directors, Playwrights and Actors every summer in a charming hilltop sanctuary. Under Stewart's auspices and with her support, La MaMa has produced over five decades of groundbreaking intercultural and avant-garde theater in New York and globally.

Of New York's four main Off-Off-Broadway theaters in the 1960s and 1970s (Caffe Cino, Theatre Genesis, and the Judson Poets Theatre were the others), only La MaMa survives. Extraordinarily forward-thinking, Stewart was virtually unique in New York experimental theater in the 1960s and 1970s in prioritizing the preservation of materials that documented the work of Off-Off-Broadway artists, collecting posters, programs, play lists, photographs, scripts, and often props, puppets, set pieces, and costumes as well. The first La MaMa Archive directors were Doris Pettijohn and Paul Corrigan, who began organizing the theater's vast holdings in the late 1960s and early 1970s. Corrigan left in 1974, Pettijohn in 2000. Ozzie Rodriguez, a longtime La MaMa performer, director, playwright, and production coordinator, reorganized the archive in 1987 and continues to direct the facility. Rodriguez is also involved in updating La MaMa's online archive at http://lamama.org/programs/archives/.

Stewart, ever the designer, thrived on powerful visual materials. A visitor stepping into the crush of colors and textures in Stewart's attic/apartment would be instantly aware of this, as would a theater spectator encountering Stewart's highly physical and vibrantly directed and designed productions in La MaMa's large Annex space (since 2009, The Ellen Stewart Theatre). Stewart also paid close attention to the visual representations of La MaMa and its theater artists and how they were depicted and publicized in the media and on the street. She kept a savvy and astute eye on her audiences and cared deeply about expanding her audience base and about making critics aware of La MaMa artists' work. But, following La MaMa's mission, style, and practice, Stewart granted artists freedom in making aesthetic/artistic choices, freedom that extended to the graphic design of the posters that represented and publicized their work.

As a performer, director, teacher, and scholar living in New York City, I've seen hundreds of performances at La MaMa over the past three decades. In the over ten years I worked first on the journal article and then on this book, Stewart invited me to become an insider — essentially, a member of the La MaMa "family," within which I was privileged to experience Stewart's vivid first-person narratives and those of the artists working at her theaters. *Ellen Stewart Presents*, informed by dozens of interviews I've conducted over the years and illustrated by more than one hundred previously unpublished play posters from La MaMa's archive, is part memoir, part oral theater history, and a catalog of the diversity and power of La MaMa's poster art, spanning the poster "heyday" of the 1960s through the beginning of the digital art explosion in the first decade of the twenty-first century.

There has been a resurgence of interest in the U.S. experimental arts scene of the late twentieth century, and especially in the movers and shakers in

downtown New York City in the 1960s and 1970s. Successful books by or about figures like Patti Smith and Joseph Papp speak to this interest. (These two very different individuals, in fact, spent creative time and energy at La MaMa.) Numerous revivals of plays of the 1960s and early 1970s, including La MaMa director Tom O'Horgan's production of *Hair* (1968), which was revived on Broadway in 2009 and again in the summer of 2011 (directed by Diane Paulus), and his *Jesus Christ Superstar*, which opened on Broadway in 1971 and was revived on Broadway in 2000 and again in 2012 (directed by Gale Edwards and by Des McAnuff respectively) are further evidence.

There has at the same time been an increase in the popular appreciation of and attention to poster art as a mirror of contemporary culture, politics, and aesthetics. The 1960s launched what has been identified as a "poster craze," which art critic Hilton Kramer dubbed "Postermania" in a 1968 commentary in the *New York Times*. *Ellen Stewart Presents* offers readers a wide selection of exciting high points in poster art from the past fifty years.

How is poster art a mirror of the time? Of a place? As the book celebrates the woman who is La Mama and the theater that bears her name, it traces an important era in the contemporary avant-garde. The book also depicts and describes the exciting encounters between La MaMa's downtown artists and the many international artists Stewart brought to New York and introduced to her audiences, from Europe, Asia, Africa, the Americas, and the Middle East: Romanian director Andrei Serban, British director Peter Brook, Polish director Tadeuz Kantor, and Japanese butoh artist Kazuo Ohno are only a few of the acclaimed international artists whose work Stewart premiered and supported at her New York theaters. Finally, and equally significantly, this book sheds new light on the history and evolution of a fascinating and diverse New York City neighborhood — the East Village — throughout a tumultuous half century.

WHO WAS ELLEN STEWART?

Ellen Stewart is La Mama and by now, anyone who knows anything at all about the contemporary American theatre is well aware of who and what La Mama is. She has unselfishly committed herself to bringing to life the plays of the new American playwrights. She wants nothing in return but to see us go forward, to be sure that our stomachs are full, to make certain that we are always encouraged . . . and that we continue to write our plays. Sometimes she designs dresses — beautiful, chic, and very feminine dresses — for seven days a week in order to be able to afford the pressing weekly expenses of running Café La MaMa; all we have to do is write our plays.
—Leonard Melfi, preface to *Encounters*

Stewart was born on November 7, 1919, in Chicago, Illinois. The focus of her interest, energies, creativity, and chutzpah over the years — and the content of our interview sessions — was the work done at her theaters and the artists who worked there. Stewart was not at all interested in talking about herself, her family, her background, or her private life. Nonetheless, from time to time Stewart would drop into our conversations an anecdote or a snippet about family members who were in show business. That is how I learned that prior to Stewart's arrival in New York City with the goal of being a fashion designer, she had spent her youth in Detroit and Chicago, where her mother, who raised her, designed and built costumes for vaudeville and variety shows. One of her mother's specialties, Stewart told me, was designing undergarments for cross-dressed chorus boys.

The impetus for establishing her first theater downtown was to assist two young men — two playwrights — in "giv[ing] them their dreams," Stewart told me. Paul Foster and Fred Lights needed a place to produce their plays — and Stewart decided that her job was to make that happen. Fred Lights was Stewart's foster brother; although not a blood relation, Stewart considered him family because her mother had helped raise him in Chicago. Although there is no documentation of Lights's plays being produced at the theater, Stewart asserted that her connection to Lights was fundamental to her idea of supporting playwrights. She wasn't actually interested in plays; she didn't read them. She was interested in people. With this initial quasi-familial connection as a springboard, Stewart began her lifelong familial relationship with La MaMa artists. Stewart opened her first theater in a tiny basement space on East Ninth Street in the East Village on October 18, 1961. Her plan was simple — she would use her basement space during the day as a boutique, selling the clothing she designed. At night she would see to it that the playwrights got to present their work. Although Stewart's boutique never materialized, Stewart housed young playwrights (and the young director Tom O'Horgan), cooked for them, and paid her playwrights and directors whatever she could out of her own pocket, using the money she made working freelance in the fashion industry (Stewart continued to work for women's casual wear and children's clothing manufacturers until the early 1970s). Stewart and Paul Foster remembered that one of her friends, Robert Paulson, came up with "La MaMa" as a name for the theater, instead of just "Mama," which was what Stewart's friends called her. From the beginning her legendary warmth and generosity of spirit and her selfless work and contributions on behalf of her artists were deeply rooted in what has been described by many as a "mother bond."

Stewart was a producing pioneer and a gutsy real-estate maven who moved her theaters up and down in a six-block and three-avenue radius in the East

Village of Manhattan in the 1960s and 1970s (see map with the locations of Caffe Cino, Theatre Genesis, the Judson Poets Theatre and of her theaters). She and her affiliated artists were forced to move when landlords or fire, housing, and licensing authorities reported her or filed claims against her. At 82 Second Avenue, Stewart's second space, she established "private" club status for her theater — including membership cards for spectators — in an effort to avoid closure because of zoning ordinances against cafes with entertainment. Finally, with the help of a Ford Foundation Grant in 1967 for $25,000, under the auspices of W. McNeil Lowry, and a Rockefeller Foundation grant of $65,000 with additional funds from the Doris Duke Foundation, Stewart transformed an abandoned sausage factory (originally a German singing club) at 74A East Fourth Street into her first multitheater building. A few years later, in 1974, with the help of another Ford and a Mellon Foundation grant, Stewart renovated a large former television studio two doors down (originally a German cultural center and gymnasium) and added the large "Annex" to her theater complex. This multitheater, office, and archive complex on East Fourth is still the heart of La MaMa's operations today. Stewart's performance spaces grew in flexibility and size in order to accommodate the evolving and expanding visions of the radical and experimental playwrights, directors, composers, choreographers, and designers that were part of Stewart's artistic "family."

But Stewart's impact and her real-estate holdings extend far beyond the borders of the East Village. She was one of the first to recognize the importance of international cultural exchange. So, while she created theaters that supported American artists in downtown New York City, she also extended her network to include artists from abroad, making it possible for performers, directors, musicians, choreographers, and playwrights from across the globe to present their work at her NYC theaters. At the same time, Stewart began to establish connections for her American artists, helping to get their work presented at La MaMa "satellites." The first of these kicked off in 1964, when La MaMa Bogotá opened with Paul Foster's *Hurrah for the Bridge*. Israeli playwright-director Mark Sadan worked at La MaMa in 1964; in 1970 Stewart helped found La MaMa Tel Aviv. La MaMa Melbourne is another outpost that continues to produce. La MaMa troupes have performed in Venezuela, Lebanon, Iran, Austria, Denmark, France, Italy, Spain, Croatia, Korea, Turkey, Greece, Ukraine, Macedonia, Cameroon, Zaire, Senegal, Brazil, Haiti, and Bulgaria — and this is only a partial list.

Stewart's first directorial credit is listed as *The Cotton Club Gala* in 1975. Tom O'Horgan, as the head of the La MaMa Troupe (1965–69) served as La MaMa's first artistic director. He was followed by Wilford Leach, who

MAP OF EARLY OFF-OFF-BROADWAY THEATER SPACES
MANHATTAN, NYC

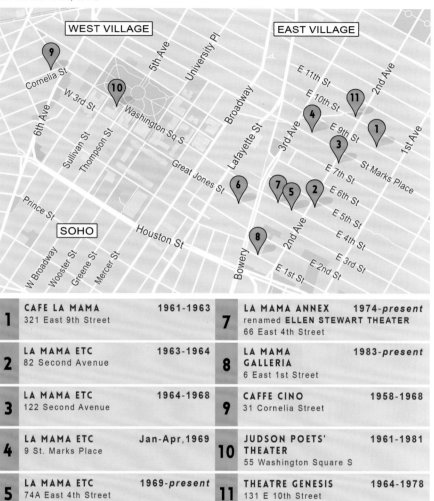

FIG. 2: Map of early Off-Off-Broadway theater spaces. Map design by Theo Cote and Ozzie Rodriguez.

1	**CAFE LA MAMA** 321 East 9th Street	1961–1963	**7**	**LA MAMA ANNEX** 1974-*present* renamed **ELLEN STEWART THEATER** 66 East 4th Street	
2	**LA MAMA ETC** 82 Second Avenue	1963–1964	**8**	**LA MAMA** **GALLERIA** 1983-*present* 6 East 1st Street	
3	**LA MAMA ETC** 122 Second Avenue	1964–1968	**9**	**CAFFE CINO** 31 Cornelia Street	1958–1968
4	**LA MAMA ETC** 9 St. Marks Place	Jan-Apr,1969	**10**	**JUDSON POETS'** **THEATER** 55 Washington Square S	1961–1981
5	**LA MAMA ETC** 74A East 4th Street	1969-*present*	**11**	**THEATRE GENESIS** 131 E 10th Street	1964–1978
6	**LA MAMA** **REHEARSAL SPACES** 47 Great Jones Street	1970-*present*			

with John Braswell directed the La MaMa E.T.C. company, a separate group, beginning in January 1970 and continuing "until Joe Papp [then the artistic director of New York's Public Theater] stole him" in the mid-1970s (as Stewart put it). Another of La MaMa's "umbrella troupes," as Stewart called them, Joe Zwick's La MaMa Plexus, also produced actively at her theaters located at 74A East Fourth Street during this period (1971–75). Serban took on a leadership role at La MaMa in 1970, when he led the first European tour of the

La MaMa Repertory Company, yet another group, with his productions of *Ubu* and *Arden of Faversham*. The La MaMa Repertory Company was renamed the Great Jones Repertory Company by Serban in 1974. Stewart assumed the primary artistic directorial role of the company in 1985 with her production of *Mythos Oedipus*.

Stewart received significant honors and awards in her lifetime, including over thirty Obie Awards for achievements Off-Off Broadway, an induction into the Theater Hall of Fame (1993), a Tony Honor for Excellence in Theatre (2006), and two major artistic and humanitarian awards from Japan (the Order of the Sacred Treasure presented by the emperor of Japan in 1994 and the Praemium Imperiale award in 2007). But the honor and recognition that perhaps had the greatest impact on her life and work and that of the international La MaMa "family" was the MacArthur ("genius") Fellowship, which Stewart received in 1985. With $300,000 awarded over five years (recipients do not apply for this award and in many cases, as in Stewart's, the grant comes as a complete surprise — and is a tremendous boon to their work) Stewart purchased a former convent dating from the fourteenth century near Spoleto, Italy, and established a home base and center for artists. "La MaMa Umbria" continues to thrive and serve theater students, directors, performers, and playwrights in successful residencies and programs each summer.

During the last decade of her life Stewart conceived, adapted, and directed epic productions based on Greek myths — most remarkably in 2004 when, at the age of eighty-four, she produced and directed *SEVEN* — seven Greek productions in repertory. Four of these were works created by Stewart and the Great Jones Repertory Company, and three of these had been originally developed and directed by Andrei Serban in collaboration with composer-writer-director Elizabeth Swados and the company. Ozzie Rodriguez, who worked closely with Stewart on all of the productions, describes Stewart as "a gatherer": Stewart developed her plotlines and librettos for her *Antigone*, *Seven Against Thebes*, *Dionysus Filius Dei*, and *Mythos Oedipus* after referring to books, Internet sources, and artworks. "Why is Oedipus (or Antigone or Dionysus) important?" was the driving question in the creation of each of these productions.

Mindful, during her last decade, that "time is marching on," Stewart quietly but firmly chose Mia Yoo, a much-lauded performer and longtime company member, as her successor, as the one to follow in her footsteps and lead La MaMa in the decades to come. In 2009, two years prior to her death, Stewart officially named Yoo as La MaMa's new artistic director, with managing director Mary Fulham and producing director Beverly Petty supporting her.

POSTERS IN (LA MAMA'S) HISTORY

Posters reflect the past, sometimes distorting history,
but in the end, revealing meaning to us in a dramatic way.
— Max Gallo, *The Poster as History*

The purpose of a poster — composed of words, often typography, and frequently accompanied by images — is to advertise or "deliver a message." "A simple, practical medium requiring paper, ink, and an idea, the poster has remained essentially unchanged from the industrial revolution until today," declares graphic artist and art historian Alston W. Purvis. The poster, however large or small, succeeds to the extent that it convincingly communicates to people who see it that the production is an event they want to attend. The poster accomplishes its goal if it is sufficiently compelling to draw in the stranger — someone who has no connection to the individuals involved in the production. It is the intermediary in the creative and business transactions between producer and audience.

The over one hundred posters chosen for reproduction here suggest the wide range of genres, materials, and artists represented in the over twenty-four hundred posters stored and cataloged in the La MaMa Archive. In graphic design historian R. Roger Remington's words: "Posters, when displayed before us, create a provocative panorama of detailed history looking back at us. They help to bring history alive." Thus, the posters in this book can be seen as important markers in the history of Ellen Stewart's efforts to pave a successful path for her "babies." That being said, this book makes clear that she was never a poster designer herself, nor did she have input on the designs per se. Stewart's hands-off attitude toward the posters marks an important distinction between her and mainstream, commercial theater producers. Nonetheless, the spectacular diversity of style, media, and content of the posters in the La MaMa Archive, and those selected for this book, stand as testimony to and evidence of the extraordinary history of her theater organization. They also attest to the confidence she had in her playwrights, directors, and others with whom decisions about the posters' content and appearance resided. In line with this idea, the "Core Values" section on the theater's website (lamama .org) states: "La MaMa trusts artists and values artistic exploration. At La MaMa, artists are free to challenge themselves and create work in an uncensored environment."

When the doors of Café La MaMa opened for the first time on Friday, July 27, 1962, to admit spectators to see Andy Milligan's production of Tennessee Williams's *One Arm*, it was anyone's guess as to how many people

would fill the twenty-five seats squeezed into the cramped space. Advance ticket sales? There was no system or mechanism in place to carry that out. Advertising budget? Did not exist. How did people know there was a performance about to be presented? Three communication efforts were in operation: word of mouth among friends and associates of Stewart, Milligan, the actors, and the small, volunteer production crew; a two-line classified advertisement in the *Village Voice*, and a large billboard posted outside the entry door leading to the basement at 321 East Ninth Street.

The low-key announcement in the *Village Voice*, a weekly newspaper that hit newsstands every Thursday, read simply, "A new play every Fri. Sat. and Sun. nite at 9 & 11 P. M.," not even mentioning the play's title, *One Arm*. Presumably Stewart herself as producer had handled the placement of the classified ad, which was situated under the two-column banner heading "Cafes & coffee houses." This ad was in line with the "marketing strategies" of other downtown cafés where occasional performances were offered, but it stood in stark contrast to the history of theater advertising and marketing efforts by commercial producers. All one needs to do is consider what was happening a couple of miles uptown in Manhattan's Broadway theater district to understand that Ellen Stewart's La MaMa was on a wholly different marketing track from its inception.

In mainstream, commercial theater the producer would construct a marketing budget and a plan at the beginning of a production process. Out of this budget and marketing plan a designer would be hired to deliver a poster that fit the overall design concept for the production within a deadline set well in advance of opening night. Significant dollars would be spent to place large ads on a continuous basis in mainstream news publications such as the *New York Times*, all of which would lead to critical coverage of the production and, hopefully, full houses.

In the early days of La MaMa there were no funds designated for publicity, and no one was hired to design a poster or embark on a marketing campaign. Hence, the business of designing, printing, and circulating a poster was almost entirely an "inside job." And despite the poster's importance as the single vehicle through which knowledge of a production could be circulated, the poster was often forgotten until the curtain was about to rise.

None of the conventions established for producers in the commercial theater applied to Ellen Stewart's enterprise. It was entirely up to the maker to interpret and fabricate the look of the thing: what information was included in the text, what materials were used to produce the original poster, whether or not an illustration or photograph was included, and what dimensions the poster would have. Archive director Rodriguez and Denise Greber,

La MaMa's marketing manager, attest that La MaMa does not follow a "branding" approach in marketing and public relations strategies.

In short, there is little consistency and commonality in these posters that identifies them as being produced for a La MaMa production. In one sense, it is impossible to reconcile how it could be that Ellen Stewart — with her keen eye for apparel design — was content to let others take over this decisive aspect of the visual representation of the productions at La MaMa from the early 1960s through her tenure of nearly fifty years. This raises the question — was Stewart's willingness to yield decisions about the conception and execution of the posters another expression of her desire to put other people's work forward rather than her own? Stewart was not, after all, a graphic designer or a visual artist. Was this a conscious decision on her part to remain an invisible force supporting the action? Or was this simply a decision made out of expediency? Ultimately, the richness and multiplicity of the poster collection at La MaMa reflects the broad international scope and the variety of genres, styles, and agendas of the performances presented at Stewart's theaters.

Unfortunately, Stewart's commitment to preserve in La MaMa's archive the posters and other paper ephemera such as notices, tickets, broadsides, and programs was not consistently supported by the kind of meticulous notation that would offer clarity about who actually did what with respect to the posters. In many instances, the item reveals little evidence of its maker. If a signature exists on the page, it may apply only to the illustrator or photographer. In the case of the poster for *Shango* (1970), for example, the designer's name, Nancy Colin, was found among the production credits in the play's program rather than on the face of the poster. It was only through the tireless efforts of La MaMa Archive director Ozzie Rodriguez and his assistant Shigeko Suga that the information crediting many of these poster artists could be found.

U.S. THEATER POSTERS: A BRIEF HISTORICAL OVERVIEW

In the early eighteenth century, the practice of posting programs or handbills on theater entryways or doors became the norm. These one-sided sheets, used to announce public theatrical events as well as other cultural spectacles and civic events, were also referred to as "broadsides." They were considered printed ephemera, because they were intended for short-term use: to be posted, read, and discarded. Some of the programs, which provided information about the plays, were sold to ticket holders during a performance. These programs consisted of typeset graphics of various styles and sizes. Usually the name of the theater, the title of the play, performers' names, and days and

dates of performances were included. Eventually woodcut illustrations of a scene or character or a decorative design would be added to the programs.

Until the end of the 1950s, most display type was still being set by hand, letter by letter, as it was with the original letterpress printing invented by Johannes Gutenberg in the mid-fifteenth century. However, after the introduction of photo offset in 1960, metal type was relegated to use by independent letterpress printers. Photo offset significantly lowered the cost of printing and gave the graphic designer more control over typefaces and the overall look of the letters.

The Industrial Revolution had a major impact on the design and printing of theater posters. Lithography was invented in 1796 by German author and actor Alois Senefelder as a method of publishing theatrical works more cheaply than was possible through metal plate engraving. This method involves printing from a finely surfaced, homogeneous stone (lithographic limestone) that has been drawn on with a greasy crayon; the design image is then offset onto paper. Lithography can be used to print text or artworks onto paper or other suitable material. Although one drawback to the lithographic process is that the image must be drawn backward (and reversed in the final print), the directness of the process affords the possibility of reproducing the artist's exact intention.

By the 1870s, show business was becoming a booming enterprise in the United States, and the demand for posters led to the establishment of large, successful printing houses. With innovations in lithography equipment (soft zinc plates that could be rolled around a rotary press replaced slabs of limestone that had been used in earlier lithography), "The amount of time that it took to print 100 posters diminished from one hour to one minute," according to theater historian Mary Henderson. Offset printing continues to be a commonly used technique in which the inked image is transferred (or "offset") from a plate to a rubber blanket, and then to the printing surface.

As was the case in La MaMa's first decades, the nineteenth-century poster was not considered high art and was not made to survive the elements where it was usually placed — outdoors, on a wall or another free surface. Posters designed for traveling theater companies that performed the same play at every tour stop would be produced in mass quantity and stored. When a poster for a play was designed, a blank strip was left on the bottom of the poster, which would be filled in with information about each successive venue. These bits of information inserted at the bottom of the poster were called "slugs."

In 1907 commercial silk screening was patented and initially was used almost exclusively for display signs and posters. Silkscreen is a modern form of stencil printing that doesn't reverse the image (unlike other print processes referred to here). Silkscreens may be prepared by hand or photographically

at a commercial screen-printing shop. This method was popular with Works Progress Administration artists in the 1930s and put to famous use by Andy Warhol in his avant-garde paintings of Campbell's soup cans and celebrity images such as those of Marilyn Monroe in the 1960s.

With the growth of advertising agencies in the 1960s came the tendency of commercial theaters to depend on them for publicity campaigns. This kind of professional marketing and systematization was a world apart from La MaMa's publicity. Instead, La MaMa artists sought the cheapest, most expedient, at-hand solution for poster making. Magic Markers were a popular tool in creating La MaMa posters in the early and mid-1960s. The Magic Marker, invented by Sidney Rosenthal in 1952 for his company Speedry Chemical Products, was an inexpensive permanent marker that could be used to write on virtually any surface: paper, glass, wood, stone, and plastic. In 1964 a similar product with a slimmer point, the Sharpie Fine Point black marker, was introduced by Sanford Manufacturing Company. Although the colored dyes used in these writing instruments were usually not lightfast, they became extremely popular among artists and children and were touted at the time by television celebrities Jack Paar and Johnny Carson.

Instead of mass production of posters, frequently only one poster on a board was created to advertise a performance at La MaMa. When duplication was necessary, office duplication technology, that is, copiers or other types of printers accessible in neighborhood or downtown businesses, was the method of choice because of its low cost and convenience and the "alternative" look of the finished product. To some extent, the early La MaMa poster makers were deliberate in their intention to create posters that revealed the process, the artist's hand, and the materials used. Coincidentally with these aims, a number of technological innovations occurred during La MaMa's history that gave designers more choices for making and duplicating posters.

One option, which had existed since the late nineteenth century, was the mimeo machine (mimeograph), a low-cost printing press that worked by forcing ink through a stencil onto paper. Mimeos were a common technology for printing small quantities because they were easy to use and inexpensive. An added benefit was that these machines could, in some cases, be operated without an external power source. By the late 1960s this technique was replaced by photocopying and offset printing.

Photostats were another popular form of office duplication in the early days of La MaMa. Such machines employed film and photography technology to reproduce documents. Based on George Eastman's late nineteenth-century invention of photographic film, photostat machines consisted of a large camera that produced images directly onto long rolls of sensitized paper. The process involved photographing an original document to create an initial

negative image (such as a standard letter that would appear as white type on a black page), which would then be rephotographed to produce a positive image (a page resembling the original letter with black type on a white page). Multiple copies of an original could be created this way by repeatedly photographing the black print and developing the resulting photographs on the special paper. The expense, bulkiness, and slowness of photostats made them inconvenient. These drawbacks prompted another inventor, Chester Carlson, to study electrophotography and invent a new way to share information — xerography — which made it possible for artists to produce multiple copies more easily. This invention relied on the action of light on an electrically charged photoconductive insulating surface in which the latent image was developed with a resinous powder (as toner).

Although Xerox machines were introduced in the 1950s and contributed to the demise of photostat machines, some businesses held on to the older machines through the sixties. These were used by a number of La MaMa poster designers, such as Yayoi R. Tsuchitani, who designed a poster for Paul Foster's *The Recluse* in 1964. (See figure 8.) The Xerox process for copying graphic matter gradually replaced copies made by verifax, photostat, carbon paper, mimeograph, and other methods. Duplicating machines were the predecessors of modern document-reproduction technology. They have now been replaced by digital duplicators, scanners, photocopiers, and inkjet and laser printers, but for many years they were the primary means of reproducing documents for limited-run distribution.

POSTER ART EVOLVES FROM HAND-DRAWN TO DIGITAL

The scale of intimacy, the lack of funds — sometimes even the common experience of harassment by city authorities . . . made them see a community regained.
—Sally Banes, *Greenwich Village 1963*

In the world of Off-Off Broadway, especially in the 1960s and early 1970s, there were certain givens: too little money, very little time, and ongoing challenges or problems associated with the legality, safety, size, and resources connected with the performance spaces. Stewart was a unique mother-figure, and Joe Cino a unique father-figure who provided safe havens and spaces for creative freedom and collaboration for fledgling playwrights, actors, designers, choreographers, composers, and directors. (Caffe Cino opened in 1958 and closed in 1968, a year after Cino's suicide at age thirty-five.) A feeling of family solidarity and community cohesiveness was engrained in the day-to-day working environment and in the nonbureaucratic, largely democratic structure of the rehearsal and production processes Off-Off-Broadway. In

Cino's words: "The best things happen when the entire company works together with concern for the entire production . . . when the entire company is completely involved with the production, onstage and off." These artists were at the forefront of a new wave of experimental theater. Indeed, the raw energy and the challenge to the status quo expressed by productions at La MaMa and other Off-Off-Broadway theaters was also reflected in the work of the graphic artists who crafted the posters, flyers, programs, and broadsides for these productions.

Who were the poster artists? Understanding how the rehearsal and production process worked is the first step in spotlighting the diverse, multi-skilled, and multidisciplinary crew that was — and in some cases, still is — responsible for poster design at La MaMa. Untangling the creative process — how and when a production poster came to be — is key to understanding who did the work and what were the conditions under which a poster was created at La MaMa. As artists in each decade of the theater's history explain, the work sometimes happened by committee, and often the poster was an afterthought, slapped together by someone on the creative team who happened to be available at the last minute. In the 1960s and early 1970s, there were numerous and complicated factors at work: Stewart was committed to getting spectators into her theater to see the work of her playwrights, but there was little or no advertising budget. The poster had to do it all, but, on the other hand, it was useful to remain "under the radar" and maintain the theater's "private club" status. The essential thing was posting something outside the theater on performance nights; sometimes the same graphic design on the poster would be reproduced onto mimeographed flyers, which often also served as programs. La MaMa Archive director Ozzie Rodriguez reports,

> I was recently giving a tour of the archive to some Serbians and I was trying to explain that the Xerox was the most important machine in the 1960s. People like Robert Patrick [playwright, actor] would get all the actors together and he would get wallpaper paste and everyone would put flyers up everywhere. That was the underground communication we had — he was a master of that. Everyone started doing it because they figured out that was how you got an audience. You could hand them out on the street or put them up on the walls. You had one-color paper and one-color ink. (2012)

Playwright, director, and designer John Jesurun, working a decade and more later, in the 1980s and 1990s, had a similar experience producing posters for his productions:

> Everything was very hands-on at that point in time. We had Xeroxes then, and that was the wonder of the age. We would spend time in a Xerox shop,

just printing and reprinting. Blowing things up, cutting things up. There was a whole aesthetic that came into being at the Xerox shops. I remember the *Red House* poster used to hang in the lobby, very near to where the box office was. I do remember there were comments about it —"Huh? This is a poster?"— even though it was the perfect kind of poster for the East Village. We were, in a sense, in another world. It was the Peter Brook kind of people who took a look at it and said, "Oh my God. You have to aspire to something better than this." There was a deliberate effort on our parts then not to look professional. Also, it was an age that had a sense of urgency about it. (2013)

The urgency Jesurun refers to was brought on as a result of the AIDS epidemic, which decimated the downtown arts community (and many other communities) in the 1980s and 1990s. The deadly scourge that was first known as "the gay cancer" cut short the lives of countless young artists and others; this feeling of living on the edge of an abyss or a battleground was the context for much of the downtown art-making at the time.

A sense of urgency and lack of funds for posters translated, for the most part, into a rough-and-ready, low-brow style. Scraps of paper, photos, and type were sometimes clipped from magazines; Magic Markers, "sharpies," primitive stencils, and collages were combined, creating a unique one-off style for each poster. Sometimes content or imagery from the play would be a focal point, vividly illustrated on the poster; sometimes a theme or image would be suggested more obliquely or abstractly. Many of the original posters listed each individual associated with the production; Rodriguez (chapter 2) and Jesurun (chapter 3) state that this was an essential element in their poster designs. However, Jesurun also admitted that with an opening night looming, under pressure, names of artists were sometimes inadvertently omitted. Rodriguez and Jesurun recount stories of last-minute poster designs that magically worked as the perfect representations of performances. Jesurun told me,

There was always so much to do — and then suddenly someone would say, "What about the poster?" and I would say, "Oh, darn — I forgot about the poster!" So that's probably why some things didn't end up on it. So we would run it over to wherever we could get it printed and then try to figure out a way to pay for it. That's probably why we weren't thinking about these things — they cost money and we didn't have the money. (2013)

Coming from a different perspective and working process, sculptor and painter Mary Frank also designed posters for productions at La MaMa. Frank became a regular at LaMama during the 1960s and 1970s after being invited by her friend, the director and performer Joe Chaikin, to sit in on rehearsals

and performances during the Open Theatre's residency at La MaMa in the mid-1960s. Frank's studio is filled with notebooks of drawings she made watching rehearsals and performances at La MaMa over four decades. She vividly recalls the brutal, beautiful imagery in Serban and Swados's *Fragments of a Trilogy*, which she saw in its original production. Frank trained as a dancer with Martha Graham in her youth; her sculpture and paintings often express her connection to movement, memory, and myth. Frank's association with Chaikin at La MaMa extended through the era of the Winter Project in the 1980s and 1990s; she also collaborated on set, mask, and poster designs with actor-director Paul Zimet and composer-playwright Ellen Maddow of the Talking Band. In chapter 3, Frank shares her appreciation for (and even her envy of) the extremes in emotion and powerful physical actions that are daily practice in the rehearsal room and opined what visual artists can gain from artists in live theater and performance:

> I think all the work I did in the theater had a big effect on my work. I made sculptures that were based on things I saw in rehearsals or performances. When you draw the theater, you're not just drawing portraits. You're watching people kill each other. You see people in fits of jealousy and joy and doing very physical and emotional things that you don't get to see in real life. (2013)

Frank's posters for Chaikin's productions and the Talking Band's were concentrated, conscious efforts to glean from rehearsals and work with performers, playwrights, and directors a two-dimensional representation that would effectively communicate the embodied, moving, voiced work on the stage to prospective theatergoers. Meredith Monk, in chapter 2, describes the process of creating posters as an integral part of conceiving, developing, and building a performance: "I always feel that a poster is the first part of your piece. In other words, that's actually the prologue to what you're going to do. That's why I find the poster extremely important, and I do it carefully because I think that's the first message that your audience gets — the poster" (2013).

For the most part, posters in the first four chapters of the book served a local community and had a distinctive, "downtown" quality. There were exceptions, as Jesurun notes, when international companies with significant state or national funding (Peter Brook is an example) brought their work to La MaMa. Additionally, La MaMa artists whose work was produced at well-supported international festivals were also represented from the 1960s to the 1990s by posters with a more upscale, high-art look. *Road*, by Jim Cartwright, for instance, with a poster designed by James McMullan, was a joint production of La MaMa and the uptown Lincoln Center for the Performing Arts. The style of the *Road* poster would be more familiar to uptown,

mainstream audiences, as McMullan frequently designed posters for Lincoln Center productions.

The digital age has had an extraordinary impact on the look and feel of posters and what it takes to create them. Today posters are rarely viewed exclusively "on the street," as they once were. Visual images are blasted via the Internet through email, blogs, social media, news media online, and web pages. Because of the Internet, La MaMa posters now reach a global community, instantly. Paul Zimet and Ellen Maddow in chapter 5 and Jesurun and Theodora Skipitares (chapter 4) make the point that the quality of posters has changed because of digital technology, but the use and value of posters has changed as well. Jesurun describes how the process of making posters has transformed for him over the years — and expresses a kind of love-hate relationship with the new way of working:

> Now I do all my posters on the computer. It's very different. There's no letters and pieces of paper cut up all over the house. At that time it was all rulers and X-Acto knives — it's all gone now. Now it's all done on the computer, and then it gets printed out very fast. But aesthetically, I still think very much the same way I worked then. Every once in a while I will still go back and do something with my hands and then put it into the computer. I've enjoyed that, and it works very well. I think when you do the poster with your hands, that's when the thinking and the working comes together in a way that it won't come together on the computer. I've realized that it's not good to throw away the deftness that you might have, working with your hands. There's a physical something that comes together between your eye and your mind on a piece of paper. That's still much more enjoyable for me than working on the computer and producing this instantly wonderful thing. (2013)

What is evident in Jesurun's account of working with his hands, with the texture and the clutter of the stuff in his house, is the importance of an embodied practice in poster making, which he feels may be lost when posters are made on the computer. The discovery of something essential to the performance itself is part of the poster-making process, as Meredith Monk observes above. Her perspective parallels Jesurun's as she reflects on the value of handmade posters and on the downside for artists working in the digital age:

> I do use the computer to do some things, of course. I'm not a complete Luddite, but my impulse has been to work away from the digital. As that aspect has become more and more predominant in our culture, my impulse has been to go closer and closer to the body and the voice and the handmade. We are in a culture of distraction and diversion. So I think my

interest has been to go closer and closer to the bone and the body and the present. (2013)

Monk also articulated why a La MaMa poster book represents Stewart's spirit and vision best and why Stewart gave this kind of book her blessing:

> Why did Ellen want a poster book? Posters do it better than photographs. It's hard to show in one photo what a play is about because a photograph taken during the course of a performance is capturing a specific moment in time — it's not a distillation of the gestalt of the experience of a performance. But if a visual artist can distill one powerful image in a poster that can represent a production — that is why she wanted to tell the story that way. Performances were prefaced by flyers / press releases outside on the street. (2013)

In this book that follows a chronological scheme, there are relatively more posters in the chapters on the 1960s and 1970s. From the mid-1980s through the early 1990s, there was a dip in the number of performances presented at La MaMa; this period was a particularly difficult one for not-for-profit arts institutions because of funding cuts in private foundations and government agencies. Chapter 5, devoted to La MaMa's productions during the first decade of this century, also contains fewer posters and describes fewer productions. Although the number of plays on La MaMa's play lists per year during this period did not diminish, there was a shift in the style and diversity of production posters in the early 2000s. Skipitares told me: "The whole idea of posters and the need for posters has changed now. All you need is a bit of social media, social networking, and you can get many more people in one place" (2012). Thus, with the digital age and the impact of social media, artists and their presenters placed less importance and emphasis on the poster in marketing their work. There are fewer posters chosen from the 1990s and the 2000s, but artists and productions that best represent the work of these decades continue to be highlighted here.

THE FIRST FIFTY YEARS OF LA MAMA

Each chapter tells the story of ten years in the life of La MaMa, using posters from the significant productions at the theater as reference points, accompanied by the oral histories and chronicles of many of the artists who worked at La MaMa during the decade. Each chapter begins with a narrative that provides a brief overview of La MaMa's history during the decade and includes at least one photographic portrait of Stewart at the time.

Chapter 1 traces the beginnings of La MaMa in the 1960s, centering on the

works of the playwrights Stewart first produced at her theaters in the East Village or supported internationally on tour. During this time Stewart presented plays by Jean-Claude van Itallie, Paul Foster, Lanford Wilson, Megan Terry, Adrienne Kennedy, Sam Shepard, and Maria Irene Fornes — to name a few. This chapter also focuses on the work of Joe Chaikin and the Open Theatre.

Chapter 2 tells the story of the 1970s in two parts, the first devoted to the work of the powerful directors that Stewart supported and who shared with Stewart the artistic leadership of La MaMa during this groundbreaking decade. In 1974 Stewart added the large and flexible Annex space (now called the Ellen Stewart Theatre) to her venues on East Fourth Street, providing directors with a truly distinctive space for staging performances. Renowned directors who worked at La MaMa during this period include Andrei Serban, Elizabeth Swados, Tom O'Horgan, Joel Zwick, Wilford Leach, Meredith Monk, and the "company of directors" that established Mabou Mines. The second part of chapter 2 illuminates the productions of some of the important ensembles that worked at La MaMa in the 1970s — multicultural and intercultural groups such as the Native American Theatre Ensemble, the Jarboro Company, the Pan Asian Repertory, the Tokyo Kid Brothers, Tadeuz Kantor's Cricot 2, and John Vaccaro's Playhouse of the Ridiculous, whose work foregrounded racial/ethnic identities and playful, transgressive performances of gender and sexuality. Stewart provided a welcome haven for these companies at her theaters on East Fourth Street and, in some cases, supported these artists on tour when they played at American universities and at international festivals.

In the 1980s Stewart launched her career as a director with sold-out runs of her production of *The Cotton Club Gala*; it was also a decade marked by the presence of renowned avant-garde artists of the 1960s on La MaMa stages again: Peter Brook, Amiri Baraka, George Bartenieff, Paul Zimet, and Julian Beck were all working at La MaMa during this time. Chapter 3 also describes Ellen Stewart's first encounters with a next wave of avant-garde artists from the United States and abroad. Some in this group would become La MaMa stalwarts, including Ping Chong, John Jesurun, and Dario D'Ambrosi. The celebrated butoh dancer-choreographer Kazuo Ohno first performed in the United States at La MaMa in the 1980s.

Chapter 4 describes Stewart's efforts during the 1990s to expand La MaMa's programming by bringing new and original international performance artists to her New York theaters. This chapter also focuses on U.S. artists such as Richard Schechner, Theodora Skipitares, John Kelly, Peggy Shaw, and Lois Weaver, who were among the radical and experimental performers and directors who had established themselves elsewhere before finding a sense of community and support for their work at La MaMa in the 1990s.

Chapter 5 tells the story of Stewart's final decade — the years leading up to La MaMa's fiftieth-anniversary celebration and her death in January 2011. Remarkably, this octogenarian artistic director continued to move, mix, and match it up; ever a gatherer, she brought together a huge cast of international actors, combining La MaMa regulars with some of the children of members of her original Great Jones Repertory Company to create the epic achievement that was *SEVEN* — seven Greek works she produced in repertory, four of which she created out of whole cloth for this event. Chapter 5 also looks ahead to the next fifty years of La MaMa and re-views Stewart's legacy — the visionary producer and director who continues to be celebrated as the mother of Off-Off Broadway — "La Mama of Us All."

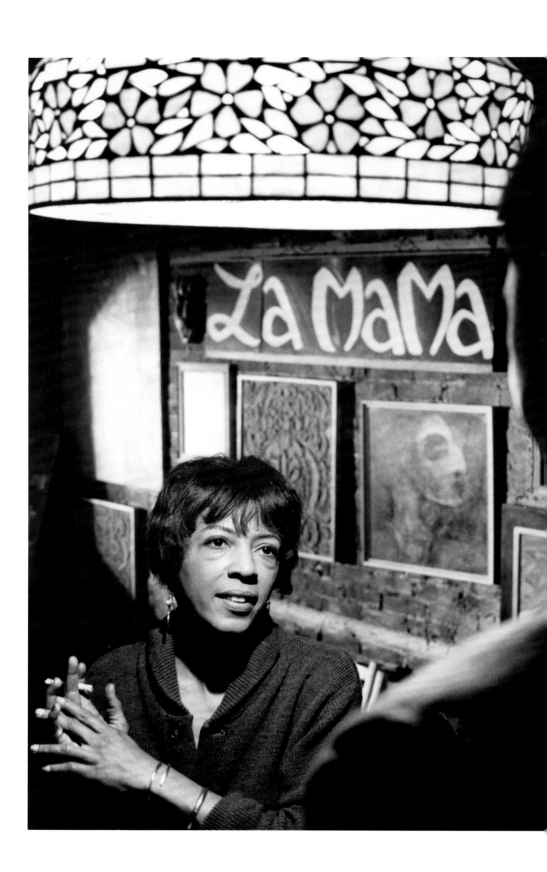

FIG. 3: Ellen Stewart at Café La MaMa, 82 Second Avenue, 1966. Photo by Dan McCoy.

THE 1960s

Ellen's Babies, a Basement, and a Bed

ELLEN STEWART (2004, 2005): In the beginning I wasn't interested in directing. I didn't call myself a producer either. I paid the rent. I took care of people, made the costumes, cleaned up the place. I never performed. I didn't even watch the plays.

I don't think of myself as a director. I think of myself as one who encourages people to explore their potential.

You let yourself become one of them and you use whatever skills you have to enhance what they have, what they do. This is my philosophy.

OCTOBER 18, 1961

Stewart opened the doors of her first theater in New York City's East Village. She began with a tiny basement space at 321 East Ninth Street where the rent was $55 a month and expenses were paid out of her earnings as a freelance designer of ladies' clothing, swimwear, and lingerie. Stewart's original idea for the space was to create a clothing boutique that would showcase her designs. But through her interactions with young playwrights Fred Lights and Paul Foster, who were looking for a place to present their work, the idea emerged to use the basement as a theater at night. Fred Lights was African American and Paul Foster white; Stewart referred to Lights as her brother (although he was not a blood relative) and to Foster as one of her "babies." Although there is no concrete evidence that Stewart ever produced any of Lights's plays at her theater, Stewart presented many of Foster's plays with great success — in New York's East Village, in Bogotá, Colombia, and on tour throughout Europe. Stewart felt what she described as a "click" or a "beep" while talking to Foster and Lights. "It's not voodoo. It's what I get from the person. . . . Playwrights know if I could do their work I would do it."

With each passing year, the artistic community of "Mama's babies" grew and diversified. Ellen Stewart's mission was to help her "babies"; she poured her money, energy, fearlessness, and ingenuity into moving her "family" forward. Stewart's goals evolved into the mission of the La MaMa Experimental Theatre Club — to actively support the work of theater artists in performance spaces Ellen Stewart called her own. Stewart sold coffee and cake and procured a café license in an effort to satisfy the NYC licensing bureau, because of restrictions placed on nontheater performance spaces at the time. In the early years of La MaMa, the one available set piece in the theater was a bed — really a cot. Hence, many of the first plays written for and produced in the theater were set in a bedroom, which frequently inspired critics' commentary and, occasionally, some controversy.

PAUL FOSTER (2003): In the beginning, Andy Milligan — a designer and a director — said, *Let there be light*, and there was. Ellen and I didn't know a damn thing about stage lighting. So Andy asked us if we had any lights, and we told him they hadn't come yet. Pause. And then he asked, "Do you have any gels [colored cellophane used to throw color onto the stage]?" Ellen looked in her pocketbook and said, "Maybe I've got some in here." We didn't have a clue what a gel was. So he used some old tin cans for lights and stole some gels from somebody who had a budget for gels.

Lanford Wilson, Sam Shepard, Jean-Claude van Itallie, Bob Patrick — this was our gang. It was very exciting. We didn't know how rare that time was. We would move back and forth between [Caffe] Cino's and Ellen's. And then there was St. Mark's Church in the Bowery on Tenth Street. It became a kind of a moving triangle. It was a tight little world. We all knew each other.

ELLEN STEWART (2003): Joe Cino was called the father of Off-Off Broadway. I was called the mother. He started working in 1958. I started in 1961. I started independently, although some people think he started me. There was a different atmosphere at his theater.

JULY 27, 1962

Tennessee Williams's *One Arm* is the first documented production in La MaMa's archive. The one-act play was based on a short story written by Williams in 1944 about a onetime boxing champ who loses an arm in an accident, becomes a street hustler, and kills a man. The story, which was later rewritten

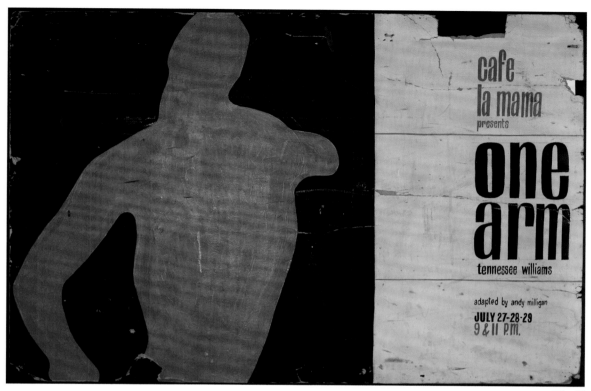

by Williams as a screenplay that was never produced, was adapted and directed by Milligan, who also presented the play at Caffe Cino. *One Arm* was not produced in New York City again until May 2011, when the New Group presented Moises Kaufman's adaptation Off-Broadway.

Stewart was the first in the United States to produce Harold Pinter's *The Room* during this early period of La MaMa's history (the play opened October 31, 1962) — but she had not paid royalties. Pinter made an impromptu visit to Stewart's Ninth Street basement theater, ostensibly to close the show down, but then decided to grant permission to Stewart to produce his play, purportedly because he was charmed by Stewart and irritated by the overreaching, pompous attitude of his agent, who had arrived with him.

APRIL 1963

The City of New York closed down Café La MaMa, citing a zoning problem (Stewart was told that cafés were prohibited in this area of the East Village, although this was later proven to be untrue). Ed Koch was the Democratic Party district leader in Greenwich Village from 1963 to 1965, and, according to Stewart, he had a "clean-up campaign going before the New

FIG. 4: *One Arm* by Tennessee Williams, adapted and directed by Andy Milligan, 1962, poster artist unattributed. Milligan worked as a performer, designer, and stage director and later went into underground film work. His productions at Caffe Cino were known for extremes in theatricality and risk-taking content. The *One Arm* poster for La MaMa features the dramatic, minimalist image of a hulking figure with one arm painted on a board. The information regarding the venue, La MaMa, is painted on the right side of the board. It is possible that the same board was used for the Caffe Cino production, where it had played two weeks earlier, with different information pasted or written on the right side of the board.

York World's Fair . . . and he wanted especially to clean *me* up." There had been rumors circulating among the tenants on Ninth Street about Stewart and her playwrights working in the basement.

STEWART: A bordello! [She shakes her head.] What was that colored woman doing with all those young white men in her basement?

Because of complaints lodged by some of her neighbors and Stewart's frequent conflicts with the licensing bureau and the fire department, Stewart decided to relocate the café.

JUNE 28, 1963

Stewart moved from the basement at 321 East Ninth Street to a loft at 82 Second Avenue. However, in March 1964, right after the run of Lawrence Ferlinghetti's *The Allegation Impromptu*, the theater was closed by the fire department and Stewart spent a night in jail. Stewart's legendary ritual of "ringing the bell" was created to introduce spectators to the performance that was about to begin at her theater. On opening night, Stewart took the prop bell from the cart on the set of Paul Foster's *Hurrah for the Bridge* and rang the bell to get the audience's attention.

ELLEN STEWART (ringing her bell): Good evening, Ladies and Gentlemen. Welcome to La MaMa — dedicated to the playwright and all aspects of the theater. Tonight we present . . .

MARCH 12, 1964

Ellen Stewart's café was officially named La MaMa Experimental Theatre Club (La MaMa E.T.C.). With its "club" status La MaMa E.T.C. could be considered a private rather than a public space; this distinction allowed club members to attend events that catered to a more "select" crowd — those who would be open to nudity in performance and to the more edgy, radical, and political work that Stewart regularly presented. Stewart wanted to make it clear to the authorities that La MaMa was a private club rather than a café. Nonetheless, the NYC fire department, health department, and licensing department closed down the second theater.

Balls, by Paul Foster, which opened November 3, 1964, is minimalist, imagistic, and cerebral, on a parallel track with the work of avant-garde playwrights Samuel Beckett, Edward Albee, and Harold Pinter. The scenic action in *Balls* consists of two brightly lit Ping-Pong balls rhythmically swinging back and forth across the stage. The text in Foster's play is spoken as a voice-over; his ghostly characters' stories play in counterpoint to the eerie simplicity of the small spheres' movements onstage.

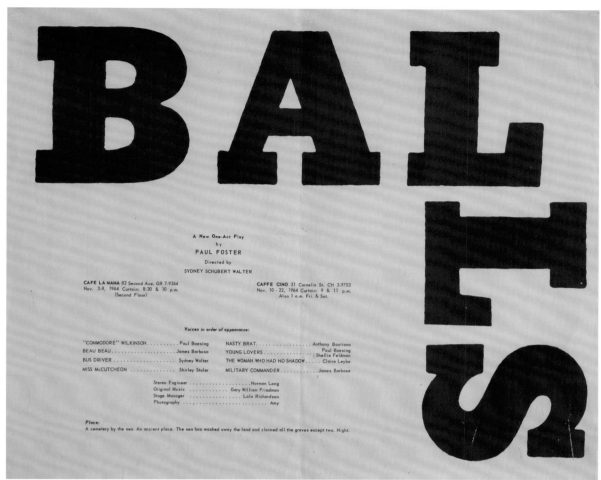

A New One-Act Play
by
PAUL FOSTER
Directed by
SYDNEY SCHUBERT WALTER

CAFE LA MAMA 82 Second Ave. GR 7-9364 CAFFE CINO 31 Cornelia St. CH 3-9753
Nov. 3-8, 1964 Curtain: 8:30 & 10 p.m. Nov. 10 - 22, 1964 Curtain: 9 & 11 p.m.
(Second Floor) Also 1 a.m. Fri. & Sat.

Voices in order of appearance:

"COMMODORE" WILKINSON Paul Boesing NASTY BRAT Anthony Bastiano
BEAU BEAU James Barbosa YOUNG LOVERS Paul Boesing
BUS DRIVER Sydney Walter Shellie Feldman
MISS McCUTCHEON Shirley Stoler THE WOMAN WHO HAD NO SHADOW Claire Leyba
 MILITARY COMMANDER James Barbosa

Stereo Engineer Norman Long
Original Music Gary William Friedman
Stage Manager Lola Richardson
Photography . Amy

Place:
A cemetery by the sea. An ancient place. The sea has washed away the land and claimed all the graves except two. Night.

14" × 17"

FIG. 5: *Balls*, by Paul Foster. Directed by Sidney Schubert Walter. This poster/flyer, unattributed, which displays both theaters' addresses prominently, confirms that *Balls* was produced collaboratively by La MaMa and Caffe Cino. Because of the aforementioned edginess of much of the work at these venues, posters and flyers in this time period usually did not list a phone number or the theater's address in order to maintain "under the radar" or "private club" status. The single design element of this poster is the choice to split the title into two parts.

NOVEMBER 11, 1964

Stewart opened her third theater. In November 1964, at the final performance of *Dear Friends*, written and directed by James Wigfall and Steve Gary, with music by Tom O'Horgan and Elmer Kline, Stewart urged her audience members to move their own chairs and the paintings on the walls of the theater to La MaMa's new space at 122 Second Avenue. This was another unconventional space, a loft space, where La MaMa remained until 1967.

ELLEN STEWART (2003): This procession is how we moved.

Although still a "private club"—advertisements for the plays in the *Village Voice* never listed the address of the theater or its phone number—La MaMa's membership grew through word of mouth to over three thousand members, who paid one dollar a week to belong. Membership at La MaMa and a

membership card were automatically granted with the purchase of a ticket; the card was required for entrance at the club from that point forward. The week's take, Stewart told me, was split among the actors. She also stated that the theater's rent and all operating expenses — everything from lightbulbs, coffee, and toilet paper to fabric for costumes — came out of her own pocket. Once the club had a membership policy, Stewart said, they no longer passed the hat. (Some accounts differ on this point, however, attesting that passing the hat continued to support actors' salaries.)

Balm in Gilead, Lanford Wilson's first full-length play, which had a cast of thirty-three, opened at La MaMa on January 20, 1965. With La MaMa E.T.C. at 122 Second Avenue, Stewart could offer playwrights and directors a larger stage than at any other Off-Off-Broadway theater at the time. Wilson and director Marshall Mason regarded La MaMa as the only suitable venue for this work. *Balm in Gilead* sold out during its La MaMa run. Wilson's play experiments with hyperrealism in its depiction of the street and café life of down-and-out East Villagers and breaks through "the fourth wall"— Wilson's characters directly address the audience at intervals throughout the play.

German-born playwright, poet, and novelist Ruth Landshoff Yorck was a passionate advocate for Off-Off Broadway's young artists and had strong ties with important figures in the European avant-garde (Bertolt Brecht, Jean Cocteau, and Thomas Mann, among others). She was actively involved with Stewart in her efforts to get recognition for U.S. playwrights through the publication and productions of their plays abroad. Celebrity artists as diverse as surrealist painter Salvador Dalí and Broadway, film, and television actress Lee Remick became fans of La MaMa when they came to the theater at the invitation of the highly esteemed Ruth Landshoff Yorck. She died of a heart attack in Ellen's arms when she and Stewart attended a matinee of Peter Brook's *Marat/Sade* at the Martin Beck Theatre in January 1966.

ELLEN STEWART (2004): We needed to go to Europe to get the critics' attention over there. That would get the New York critics' attention and then we could get the plays reviewed and published.

From the middle 1960s on Ellen Stewart was committed to international cultural exchange. Her mission expanded as she began to construct a global artistic network — La MaMa was multicultural and supported intercultural theater long before those terms became popular descriptors with academics, artists, and critics.

A Colombian friend of Paul Foster's, Edgar Negret, arranged for Foster's play *Hurrah for the Bridge* to be translated into Spanish (*Que Viva El Puente*). Negret produced the play successfully with students in Bogotá, Colombia in

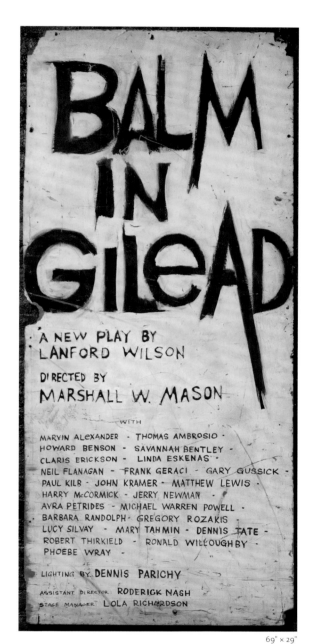

69" × 29"

FIG. 6: *Balm in Gilead*, by Lanford Wilson. Directed by Marshall Mason. 1965. Like the posters of many of the plays from the early 1960s, this large, hand-painted (possibly with house paint) billboard of Wilson's *Balm in Gilead* at Café La MaMa in 1965 captures the raw production values of the work as well as the spontaneity and the vitality of the community at La MaMa at the time—comprised largely of nonartists and artists-to-be. The Masonite billboard mentions the names of many of the individuals involved in the production, but no poster designer is credited.

1964 and again to acclaim with the same group in Erlangen, West Germany. Danish director Jens Okking saw the play in Germany and had it translated into Danish; he then staged it in Århus, Denmark. At the same time, in May 1964, two La MaMa actresses, Marie-Claire Charba and Jacques Lynn Colton, performed Tom Eyen's *The White Whore and the Bit Player* at Shakespeare and Company in Paris to very positive response. This gave Stewart the idea that a European tour might get the recognition and critical response her playwrights needed. Using her own money and donations from six actors'

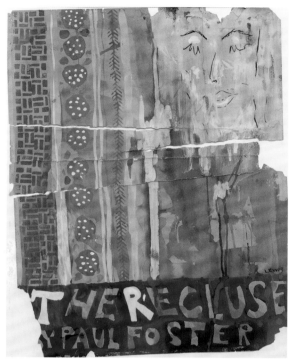

30" × 13.75"

FIGS. 7 and 8: *The Recluse*, by Paul Foster, opened February 24, 1965. Hand-painted poster by "Lewis." Black-and-white poster by Yayoi R. Tsuchitani. The differences between these two striking visual works, created to represent the same production, are in the materials employed, the methods of production, and mood. These posters are a testament to the widely divergent impulses and forms of visual, creative expression among those working at Café La MaMa in the mid-1960s. Both posters measure just under three feet in height. The monochromatic poster, dark and haunting, evokes the play, which was set in a cellar crammed with the refuse of a lifetime. This poster appears to be a "stat," or a photographic print produced by a photostat machine, which was in use prior to the introduction of Xerox technology in the 1950s. The colorful poster is a "one-off" that employs tempera paint on craft paper, very much like a child's early painting on an easel, created with broad paintbrushes. Some of the surface appears stamped like flocked wallpaper. There is an image of a female face in the upper-right corner.

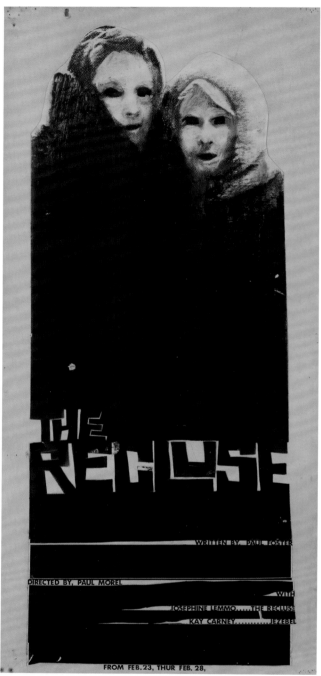

30" × 24"

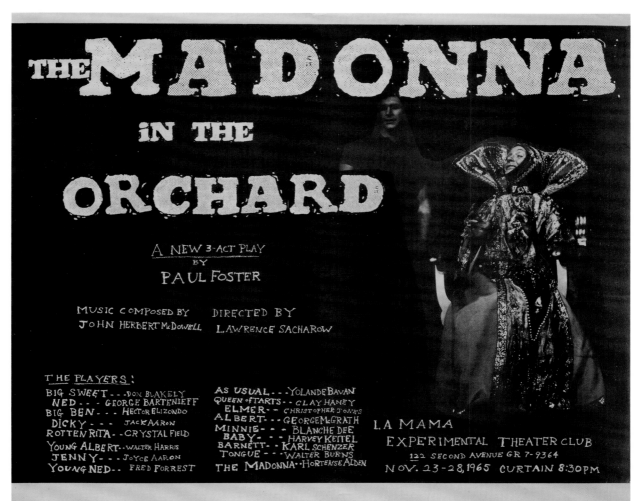

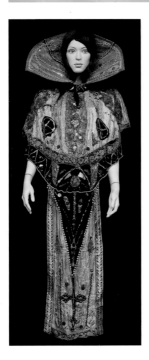

FIGS. 9 and 10: *Madonna in the Orchard*, by Paul Foster. Lawrence Sacharow directed *Madonna in the Orchard* and Harvey Keitel performed in this production, which opened November 23, 1965. The central image on the poster is a photograph by James Gossage of "the Madonna" wearing a costume Stewart designed. Gossage is an important photographer of this period who shot prominent theater people and productions Off- and Off-Off-Broadway. Stewart's costume, which she designed and built for Foster's play, is prominently displayed in the La MaMa Archive. The poster is printed as a "negative" with a black background and white typeface; numerous credits— including the seventeen actors' names—are crammed into the lower-left quadrant of the poster.

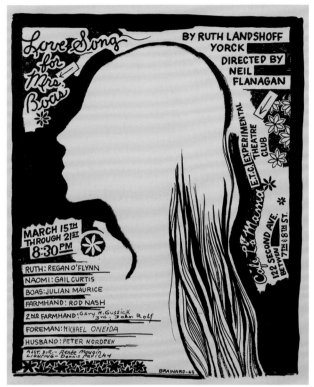

11.25" × 8.5"

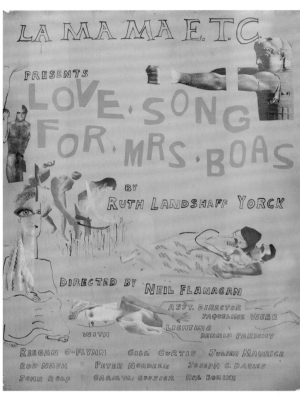

40" × 30"

FIGS. 11 and 12: Two posters for *Love Song for Mrs. Boas* by Ruth Landshoff Yorck, which opened March 15, 1965. Directed by Neil Flanagan. Black-and-white poster artist: "Brainard." Artist Joe Brainard used this flower motif frequently in his work from the 1960s. Flowers signified peace and love during this period, as in "flower power." Poster with collage and Magic Marker designed by Kenneth Burgess.

FIG. 13: *El Rey se Muere* (English translation, *Exit the King*), written by Ionesco, directed by Paco Barrero. A La MaMa Bogotá production. La MaMa Bogotá was established on May 5, 1968. Poster by Jon Oberlaender, lithography by Escama, 1968. In this poster the central figure in the play, the king, extends a gargantuan leg across the title on the poster. The design on the artwork resembles netting.

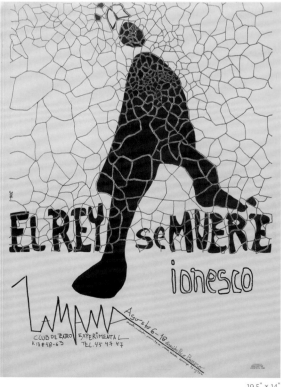

19.5" × 14"

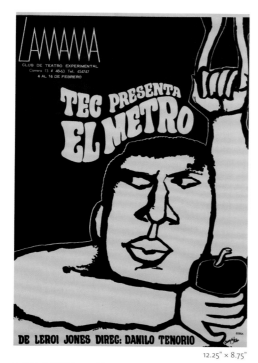

FIG. 14 (*left*): *Le Metro* (or *Dutchman*) by Le Roi Jones / Amiri Baraka, directed by Danilo Tenorio. A La MaMa Bogotá production. Poster signed by "Dugie '68," lithography by Escama. This highly charged one-act play takes place on a New York City subway, depicting an encounter between an African American male and a white female.

FIG. 15 (*below*): Poster for the first European tour at the American Center in Paris and the Aaso Skole Theater in Copenhagen, 1965, unattributed. The tour included 21 new American plays, which ran in repertory.

12.25" × 8.75"

LA MAMA

EXPERIMENTAL THEATER CLUB
122 Second Avenue, New York
(Tel. GR 7-9364)

PRESENTS: OFF-OFF-BROADWAY THEATER

AMERICAN CENTER
261 Blvd. Raspail
Paris 14eme
Tel. ODE 99.92 CURTAIN 21 hours

AASØ SKOLE THEATER
Glumsø, Copenhagen
Tel. 03645–317 CURTAIN 20 hours

Oct. 3-4	AMERICA HURRAH by Jean-Claude van Itallie / RAT'S MASS by Adrienne Kennedy / LITTLE MOTHER by Ross Alexander	Nov. 14-15	HURRAH FOR THE BRIDGE by Paul Foster / 4 H CLUB by Sam Shepard	Oct. 8-10	AMERICA HURRAH by Jean-Claude van Itallie / THE CIRCUS by Gerald Schoenwolf / HURRAH FOR THE BRIDGE by Paul Foster	Nov. 12-14	AFTER THE BALL by Ross Alexander / RAT'S MASS by Adrienne Kennedy / LITTLE MOTHER by Ross Alexander
Oct. 10-11	FRENCH WEEK	Nov. 21-22	FRENCH WEEK	Oct. 15-17	DANISH WEEK	Nov. 19-21	DANISH WEEK
Oct. 17-18	WHO PUT THE BLOOD ON MY LONG-STEMMED ROSE? by Mary Mitchell / WAITING BOY by Robert Sealy / SPIES by Harvey Perr	Nov. 28-29	MISS VICTORIA by William Hoffman / BIRD BATH by Leonard Melfi / WAR by Jean-Claude van Itallie	Oct. 22-24	MISS VICTORIA by William Hoffman / BIRD BATH by Leonard Melfi / WAR by Jean-Claude van Itallie	Nov. 26-28	LULLABYE FOR A DYING MAN by Ruth Yorck / WAITING BOY by Robert Sealy (A French Play to be announced)
Oct. 24-25	FRENCH WEEK	Dec. 5-6	FRENCH WEEK	Oct. 29-31	DANISH WEEK	Dec. 3-5	DANISH WEEK
Oct. 31–Nov. 1	LULLABYE FOR A DYING MAN by Ruth Yorck / HOME FREE! by Lanford Wilson	Dec. 12-13	THE MADNESS OF LADY BRIGHT by Lanford Wilson / WINDOW by Jean Reavey	Nov. 5-7	THE RECLUSE by Paul Foster / THE CIRCLE by Alex Civello / 4 H CLUB by Sam Shepard	Dec. 10-12	WHO PUT THE BLOOD ON MY LONG-STEMMED ROSE? by Mary Mitchell / SON OF FRICKA by Bruce Kessler / SPIES by Harvey Perr
Nov. 7-8	FRENCH WEEK	Dec. 19-20	FRUSTRATA by Tom Eyen / MY ORPHEUS by Harry Koutoukas			Dec. 17-19	DANISH WEEK

French Director: Jean-Loup Philippe
Danish Director: Jensen Okking
American Directors: Ross Alexander, Tom O'Horgan

French Playwrights: Robert Filiou, David Guerdon, Augy Hayter, Arlene Colombus Higuily, Daniel Maurac.
Production Staff: Dominique Serreau, Katherine Henry D'Epinoy, Robert Tomlinson, Alan Rosenkoetter

Danish Troupe: Jytte Abildstrøm, Henning Nielsen, Jørgen Sonne, Clifford Wright.
American Troupe: Seth Allen, Marie Claire Charba, Jacque Lynn Colton, Jerry De Luise, Marjorie LiPari, Victor LiPari, Kevin O'Connor, Michael Warren Powell, Shirley Stolyar, Stefan Sztybel.
Composers: Gary William Friedman, Jean Jacques Perrey.

14" × 17"

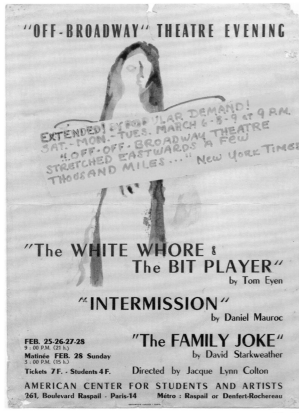

17" × 12"

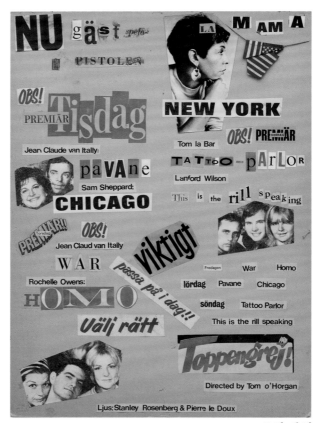

23.25" × 16.25"

FIG. 16 (*left*): Poster for the *White Whore and the Bit Player*, 1965.

FIG. 17 (*right*): This touring poster is a lyrical collage with bits of typography and photographs from newsprint and magazines. The prominent word in Danish on the poster, "viktigt," means "important." There is a photograph of Ellen Stewart in profile on the top-right corner, where she appears to be looking to her left at a folded American flag. "LA MA MA" is collaged across her head and the area of the flag. The names Stanley Rosenberg and Pierre le Doux printed along the bottom of the poster may refer to the poster makers. The names of playwrights Sam Shepard and Jean-Claude van Itallie are misspelled.

parents, Stewart purchased one-way tickets and sent two companies of eight actors each to Europe in September 1965. One group, led by director Tom O'Horgan, went to Denmark; the other, led by director Ross Alexander, went to Paris. The La MaMa Troupe, under O'Horgan's direction, toured Western and Eastern Europe a second time in October 1966 and a third time from June to November 1967.

JEAN-CLAUDE VAN ITALLIE (2003): When I went to La MaMa for the first time, it was to 122 Second Avenue. I had gone to see *The Madness of Lady Bright* [by Lanford Wilson] at Caffe Cino, and on the table there was a card that said, "Come to La MaMa" or something like, "If you like Cino you'll love La MaMa." So I made an appointment and went down to see Ellen. I went up two flights of stairs and through a big metal door into a space that was a New York loft with beautifully washed-down brick walls, wooden chairs and tables, a bar, and of course, the performance space. It

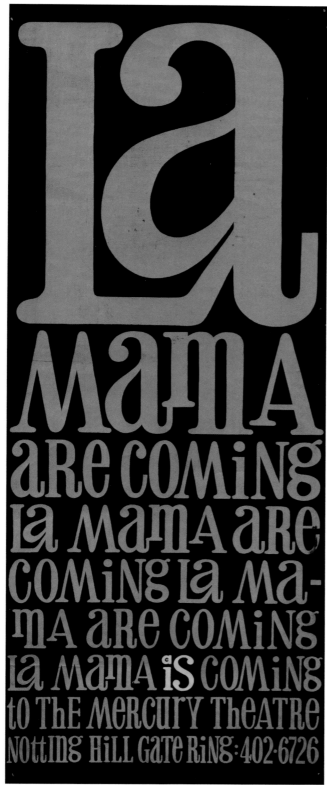

25" × 10"

FIG. 18: This narrow poster is all typography that begins very large at the top and gets progressively smaller. Using a lyrical font, the words establish a kind of chant enthusiastically trumpeting the imminent arrival of the La MaMa company. This visual style harks back to posters of the early nineteenth century that effectively used typeface without any illustrations.

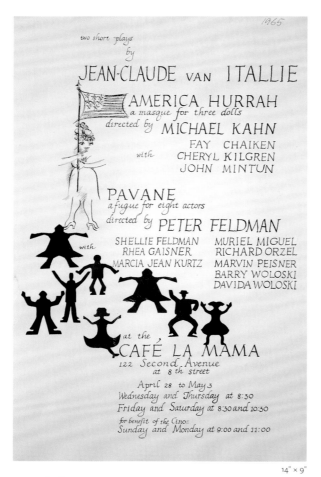

14" × 9"

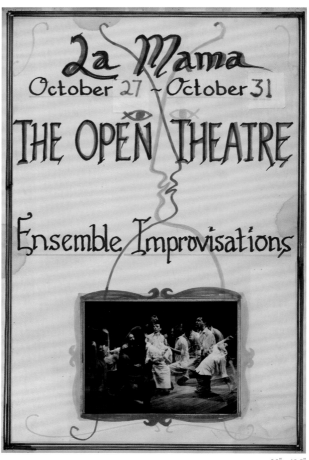

30" × 19.5"

FIG. 19 (*left*): *Pavane*, directed by Peter Feldman, and *America Hurrah*, directed by Michael Kahn, playwright Jean-Claude van Itallie, opened April 28, 1965. This poster is small, 14 by 9 inches. Poster calligraphy by Gwen Fabricant; artist of figural images unknown. The poster indicates that there will be performances on Sunday and Monday (twice each evening) to benefit Caffe Cino, which had been damaged by fire.

FIG. 20 (*right*): *The Open Theatre Ensemble Improvisations*, directed by Joseph Chaikin and Peter Feldman, opened October 27, 1965. Poster with photo by Phill Niblock, designed by Ken Burgess. This large fanciful poster (30 by 19.5 inches) is a one-off, using gray, black, red, and yellow Magic Marker. Two overlapping profiles with fish eyes become the easel to support the faux-framed photograph by Niblock. This poster is in poor condition and faded, an example of work that was not made to last very long.

was unexpectedly clean and spacious. She basically said to me, "Honey, you're home. This space is for you to put on plays." The combination of her kindness and her smile and the beauty of the space were overwhelming. At the time, the Open Theatre was a place to work, to create, to exercise, but it was not a place to perform. The Cino [laughs] was really too gay for me. La MaMa was perfect. Peter Feldman directed a play of mine there — it was the first production of my play *Interview* [original title: *Pavane*], which became part of *America Hurrah*. Ellen took my play to Europe on her first

tour there. It was directed by Tom O'Horgan. The large doll heads for the show were made by Robert Wilson. This was Rob's first commercial job in the theater.

Ellen broadcast to the world that we were doing something important. We were her baby playwrights, and she sat on us like eggs that would hatch. She told us what we were doing mattered, and we wouldn't get confirmation of that anywhere else. In a sense, what Ellen personified was the positive side. There's a reason she's called La Mama. Ellen was the heart of Off-Off Broadway.

JEAN-CLAUDE VAN ITALLIE: During intermissions at performances of *America Hurrah*, Ellen would go out and harangue the critics. She told Walter Kerr, "This is really important. Pay attention to this work." And actually it was that review of Walter Kerr's of *America Hurrah* that turned everything around. It put me on the map. *America Hurrah* flipped it. I was on the front page of the *New York Times*.

The *Times* review Van Itallie refers to here is Kerr's review of the Off-Broadway production at the Pocket Theatre, which opened in November 1966. This later, acclaimed production of *America Hurrah* was actually three one-acts, with different casts and directors from those advertised on the 1965 poster (figure 19). The version of *America Hurrah* at La MaMa in 1965 was a one-act, later retitled *Motel*. *Pavane*, also advertised on the 1965 poster, was later retitled *Interview*. The Pocket Theatre production of *America Hurrah* consisted of *Motel*, *Interview*, and a third one-act, *TV*.

NOVEMBER 3, 1965

Playwright Robert Patrick, with the assistance of Paul Foster, hastily produced an evening of twenty-six three-minute skits called *BbAaNnGg!*—a benefit organized to raise immediate cash for extensive repairs to La MaMa's electrical system, because the theater had once again received a summons from the fire department. According to Patrick, at his urging, Stewart reluctantly requested donations, passing around a large coffeepot at the performance. Stewart was genuinely surprised by the audience's positive response and generosity. Many playwrights from the corral of La MaMa and Caffe Cino participated, including Jean-Claude van Itallie, Sam Shepard, Lanford

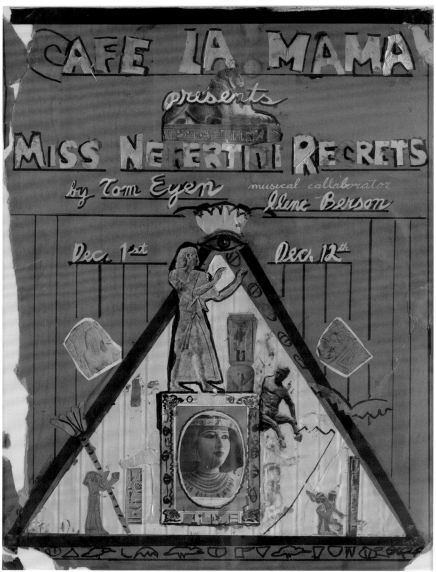

FIG. 21: *Miss Nefertiti Regrets* by
Tom Eyen opened December 1, 1965.
Poster artist: Ken Burgess.

40" × 30"

Wilson, Ruth Yorck, and H. M. Koutoukas. This special event accomplished
its essential purpose —"saving La MaMa!" According to Patrick, this evening
also made evident "the scope and scale of what we now realized was 'a real art
movement.'"

Tom Eyen was one of the most prolific playwrights presented at La MaMa
in the 1960s. Eyen established the "Theatre of the Eye" company at La MaMa
in 1967. Eyen's later accomplishments include writing the book and lyrics for
the Broadway musical *Dreamgirls*, directed by Michael Bennett, for which
Eyen won the Tony Award for Best Book in 1982. Many of Eyen's plays at

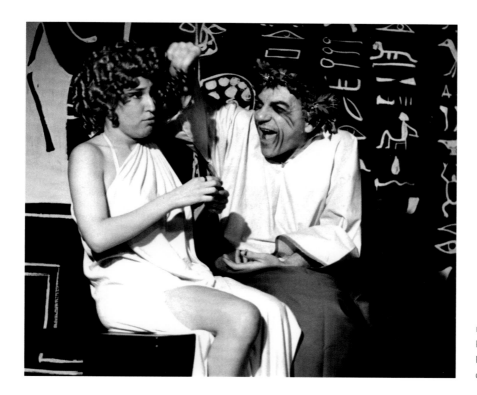

FIG. 22: Bette Midler and Martin Peisner in *Miss Nefertiti Regrets*. Photo by James Gossage, courtesy of the photographer.

La MaMa were in the style and spirit of musical revues, an outgrowth of his work as a comedy sketch writer and his interest in B movies and burlesque. *Miss Nefertiti Regrets*, a "trashy" musical send-up of the story of an Egyptian queen, is noteworthy primarily because a young Bette Midler was featured in the cast. The blockbuster, epic film *Cleopatra* starring Elizabeth Taylor and Richard Burton had opened two years earlier, and Eyen's show may have been spawned in the wake of the film's spectacular excess and notoriety.

Off-Off-Broadway stalwart Joseph Chaikin worked with the Living Theatre as an actor in the 1950s and the early 1960s before he helped found the Open Theatre in 1963. At the start of the 1965–66 season, Ellen Stewart invited the members of the Open Theatre to present work at her theater during a time when most of Stewart's regulars were touring in Europe. The decision to present their work at La MaMa created conflicts and tensions within the Open Theatre — some company members, like Chaikin, were more interested in keeping the work closed to spectators and continuing to develop their exercises and techniques in workshops. For Chaikin and others during this period of the Open Theatre's development, rehearsing for public performances inhibited the creative process and diminished the power of the ensemble. Other Open Theatre members, especially playwrights Van Itallie and Megan Terry and director Jacques Levy, had the opposite point of view; they were excited

FIG. 23 (*right*): *The Clown Play*, by Bertolt Brecht, directed by Joseph Chaikin, and *Comings and Goings*, by Megan Terry, supervised by Peter Feldman, opened April 27, 1966. Gerome Ragni, co-author of *Hair*, performed in both plays. This poster, done in graphite and watercolor, is significantly faded. Fixative was not applied to the surface (fixative was inexpensive and easily available at the time).

FIG. 24 (*below*): *Viet Rock*, written by Megan Terry, directed by Joseph Chaikin, Peter Feldman and Megan Terry, opened May 18, 1966. Dreamlike photographic imagery on the poster evokes war and crisis and melds icons of Western and non-Western cultures: a grenade, prayer beads, an upside-down Jesus Christ in fragments, a dream catcher. Background texture resembles a wall riddled with bullet holes. Title is stenciled and the same stencils, on a smaller scale, are used for information about dates and location at the bottom of the page. Along the right side of the poster, credits are hand-lettered in white ink.

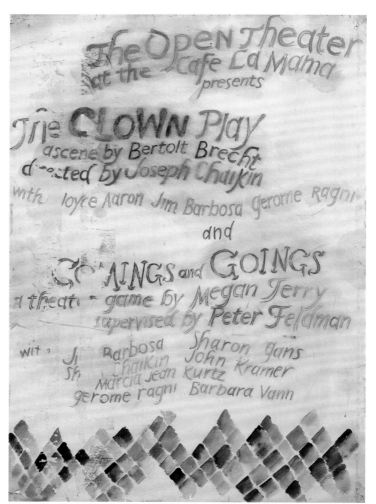

30" × 21"

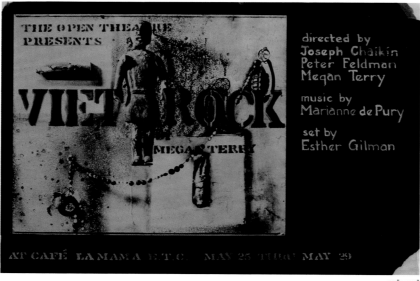

20" × 30"

by the performance opportunities for the company at La MaMa. Chaikin served as director of the Open Theatre until he disbanded the group in 1973. He worked again at La MaMa with Sam Shepard and with the Winter Project later in the 1970s and 1980s.

Viet Rock, by Megan Terry, was a groundbreaking critical and commercial success in its run at La MaMa in May 1966. A full-length play about U.S. involvement in the Vietnam War, *Viet Rock* was based on the Open Theatre's improvisational work, especially the "transformation" exercises that Terry helped develop with the company in her one-act plays such as *Comings and Goings* and *Calm Down Mother*. *Viet Rock* reopened Off-Broadway at the Martinique Theatre in the fall of 1966 at the same time that *America Hurrah* reopened Off-Broadway at the Pocket Theatre. *Viet Rock* closed after a six-week run and was not deemed a success Off-Broadway; *America Hurrah* ran Off-Broadway for a year and was a smash hit.

PAUL FOSTER (2003): Ellen was always the banker. We would sit around her kitchen table late at night. She had her apartment on East Fifth Street, and we would sift ideas as we ate dinner. Many of those original scripts had food on them. There was no formality to it. Tom O'Horgan moved in by this time; Jim Moore [known as "Mr. Jim," he was La MaMa's business manager for almost forty years until he retired in 1999] already lived there. She would give me two dollars for expenses a day. But I noticed she gave Tom three dollars a day. And I kept bugging her about that — why'd he get three dollars a day? And she told me, "Honey, he has a lot of laundry to do." For some reason I accepted that. But in those days, on the Lower East Side, you could still buy a hamburger for 55 cents. Don't ask me how we lived — but we all seemed to be pretty healthy and happy. It's a big argument for socialism.

TOM O'HORGAN (2003): Ellen could always pull things together: find people, insist on their doing things. People could not say no. Her genius was pulling people in and continuing to inspire them. Joe Cino was inventing it — inventing the Off-Off-Broadway form. Ellen came and supported it. Ellen is the only person I think of as my mentor.

East Bleeker was written by Jack Micheline, who made his mark first as a Beat poet. Gary William Friedman composed the music for this work and others

FIG. 25: Life-size photo "cut-out" of Ellen Stewart, Tom O'Horgan, and Sam Shepard, 1966. The National Center for Experiments in Television (NET) selected works of La MaMa's playwrights Shepard (*Fourteen Hundred Thousand*), Foster (*The Recluse*), and Van Itallie (*Pavane*, later renamed *Interview*) for broadcasting on public television, March 1, 1966. This life-size photograph of members of the viewing "audience" was made because director O'Horgan insisted it was needed as background in a shot for the broadcast. O'Horgan's first production at La MaMa in 1964 was Jean Genet's *The Maids*, for which he cast male actors as Solange and Claire. Actors in this production would later become members of the La MaMa Troupe. The La MaMa Troupe under O'Horgan was formally titled in 1966.

53" × 51"

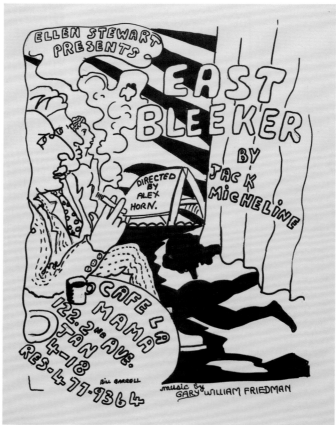

FIG. 26: *East Bleeker* by Jack Micheline, directed by Alex Horn, with music by Gary William Friedman, opened January 4, 1967. Poster design by Bill Barrell.

11.75" × 9.5"

at La MaMa; he went on to win an Obie Award (for achievements Off- and Off-Off-Broadway) and a Drama Desk Award (celebrating artistic excellence in New York theater) for his score for *The Me Nobody Knows* at the Orpheum Theater in 1970, which transferred to Broadway, earning five Tony nominations.

La MaMa's productions of *Futz* and *Tom Paine* in New York and in Europe catapulted playwrights Rochelle Owens and Paul Foster and director O'Horgan into the public eye. O'Horgan's collaborations with the La MaMa Troupe — playful, physical, erotic, musical, and wildly imaginative — set the stage for successful experimental theater to come. O'Horgan built on the ensemble techniques and exercises he developed at La MaMa in directing the Broadway production of *Hair* two years later. *Futz*, Owens's controversial play, which opened on March 2, 1967, became a cult classic and was the first

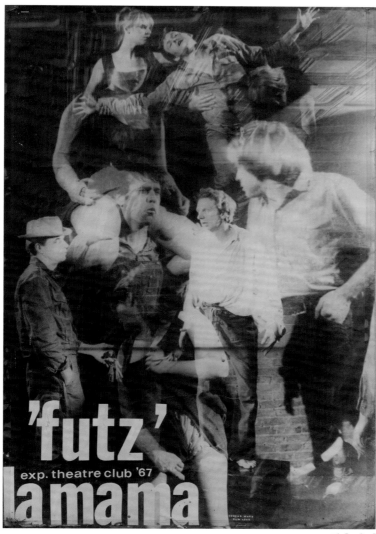

26.5" × 18.25"

FIG. 27: *Futz*, 1967. Photographs on poster by Conrad Ward.

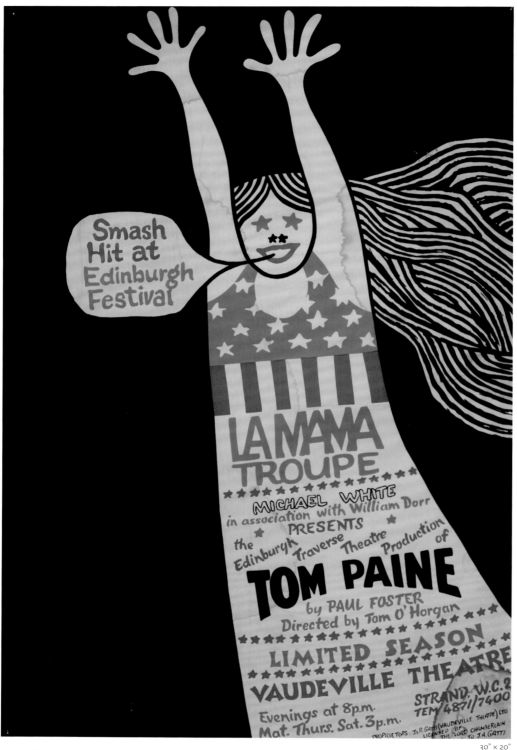

30" × 20"

FIG. 28: *Tom Paine*, 1967. Poster for the 1971 touring production. Unattributed. *Futz* (Rochelle Owens) and *Tom Paine* (Paul Foster), directed by Tom O'Horgan. Both productions premiered at La MaMa in 1967, and ran successfully Off-Broadway in 1968. The powerful photo collage by Conrad Ward on the *Futz* poster for La MaMa is printed with numerous layers of "ghost" images. *Tom Paine* poster from the 1971 touring production, unattributed.

28" × 22"

FIG. 29 (*left*): *Spring Play*, by William Hoffman, directed by Lee Hickman, featuring actor Harvey Keitel, opened March 16, 1967. Poster design by Kent. This one-off poster is created with Magic Marker. The blurred ghostlike image of a face and hands reaching out of the poster plane seem to be presenting the information about the play's credits to the viewer.

FIG. 30 (*below*): *Experimenta 2* (Frankfurt am Main, Germany) poster. Advertising productions from La MaMa's third European tour, June 1967: Paul Foster's *The Hessian Corporal*, Leonard Melfi's *Times Square*, and Rochelle Owens's *Futz*. Black-and-white surreal assembly of seemingly unrelated photographic images. Designer unknown.

23" × 32"

La MaMa work to earn an Obie Award (for playwriting) and the first to be made into a film, which the La MaMa Troupe completed in 1969. A fantasy about a man's passionate love for his pig, *Futz* predated Edward Albee's Broadway hit about a man's lust for his goat, Sylvia (*The Goat or Who is Sylvia?* 2002) by nearly forty years. *Tom Paine*, which opened April 26, 1967, crossed over more smoothly into the mainstream and was a greater critical success than *Futz*. A highly physical ensemble piece based on a historical figure, *Tom Paine* frequently broke through the "fourth wall," drawing attention to the theater event *as* a theater event and emphasizing the work's relevance to contemporary revolutionary politics.

From the beginning, Stewart was a strong supporter of the work of women playwrights and directors. In the 1960s Megan Terry, Rochelle Owens, and later Adrienne Kennedy and Irene Fornes were presented at La MaMa. Performer, producer, director, and playwright Julie Bovasso also deserves recognition for her many and varied achievements in the realm of Off and Off-Off Broadway. Her history includes many "firsts." From 1955–58 Bovasso ran the Tempo Theatre, which was the first theater in the United States to produce works by Theater of the Absurd playwrights Jean Genet and Eugene Ionesco. She won one of the first Obie Awards for acting in her production of Genet's *The Maids* (1956). Bovasso's large-scale revue *The Moon Dreamers* premiered at La MaMa and transferred to an Off-Broadway run in 1969. The same year Bovasso wrote, directed, and co-starred in *Gloria and Esperanza* at La MaMa (with another La MaMa regular, Jeff Weiss, in a "Candide-like" role). For this time-traveling musical epic Bovasso won three Obie Awards for writing, directing, and acting. *Gloria and Esperanza* was selected for a limited Broadway run at the ANTA Theater in 1970, which was sponsored by the American National Theatre and Academy as part of a series of new plays and new playwrights. Jerry Tallmer described *Gloria and Esperanza* as "a miracle," which, at "four hours long . . . was at least one full hour too many." He called Bovasso "a ferociously talented artist . . . the American Duse from Brooklyn." In 1977 she played John Travolta's mother in *Saturday Night Fever*, a film about growing up in Brooklyn. In 1987 Bovasso was featured in another film about Brooklyn, *Moonstruck*, in which she played Cher's aunt; Nicholas Cage and Olympia Dukakis also starred.

DAVID BYRD (2013): *The Moon Dreamers* was the goddamnedest extravaganza. It was a nutso fabulous show. I had no idea what it was about. I was just out of art school. I went to rehearsals, including the dress rehearsal. I knew Julie Bovasso, Hervé Villechaize, Randy Barcelo, and Lamar Alford

FIG. 31: *The Moon Dreamers*, Julie Bovasso. Premiered at La MaMa, February 1, 1968. Poster from the 1969 Off-Broadway production. Billed as "the largest show ever presented off-Broadway." David Byrd poster design. Done contemporaneously with his poster for Jimi Hendrix Experience concert (1968). Byrd is the designer of numerous Broadway show posters, including the iconic graphic images for *Follies* and *Godspell*.

22" × 14"

[all La MaMa artists]. Ellen Stewart was like a vortex. She got so much done. The smoochers on the poster were inspired by Charles Dana Gibson's drawings; the soldier in the gas mask is vintage World War I; the snake woman is the Whore of Babylon. These were images of demonic America. For the poster, I delivered to my friend Peter Moreau [one of the show's Off-Broadway producers] a pair of color separations, one red, one blue. It was camera-ready artwork, ready for offset printing. John Guare, Tom Ford Noonan, and Sam Shepard also always needed artwork at the last minute. Money was the big difference between Off-Off- and Off-Broadway.

APRIL 2, 1969

Tom Eyen's *Caution: A Love Story* opened, and was the first play produced, in what is known today as La MaMa's First Floor Theatre, one of the two theaters at La MaMa's new and permanent location at 74A East Fourth Street. Originally built in the late 1800s as a German singing club, Die Aschenbrodedel-Verein (Cinderella Club), the building was later used as the Hygrade Hot Dog Factory, according to Stewart. By the time Stewart acquired the building, it had been abandoned and left in ruin for a number of years. Hence, it required extensive renovations. With the support and efforts of W. McNeil Lowry at the Ford Foundation and additional grants from the Rockefeller Foundation and the Doris Duke Foundation, Stewart purchased and transformed the building into the multitheater complex that is the center of La MaMa operations today. Bovasso's *Gloria and Esperanza* opened in the second-floor theater, later known as The Club, on April 3, 1969. After his first visit to La MaMa's new building, Clive Barnes wrote in the *New York Times*: "At the moment the building is unfinished, apart from the two auditoriums. The place has a rather curious air, as if it were continuing business as usual after an

FIG. 32: Ellen Stewart at 74A East Fourth Street, in front of the *Balm in Gilead* poster, 1969. Photographer unknown, courtesy of La MaMa Archive.

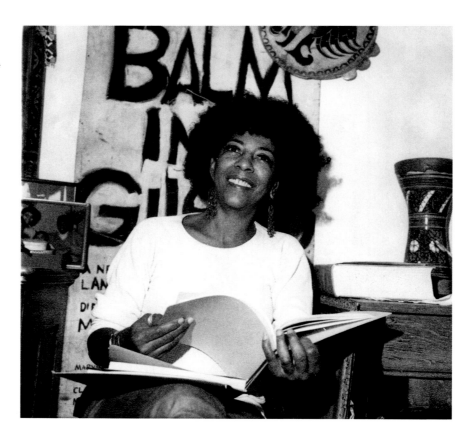

air raid. There is a kind of gallantry in its bare cement and naked passageways that imperceptibly adds to the excitement of the place."

In 1969 La MaMa was home to three other Obie Award–winning playwrights — Sam Shepard, Adrienne Kennedy, and Maria Irene Fornes. Three decades later the Signature Theatre Off-Broadway would honor each of these playwrights by dedicating an entire season to their work.

Cuban-born Maria Irene Fornes has been compared with playwrights Gertrude Stein, Eugene Ionesco, and Samuel Beckett. Her minimalist, poetic, and sometimes gritty work drew the attention of feminist artists and critics. Women and women's experience are often at the center of her plays. *A Vietnamese Wedding* was originally created as part of an "Angry Artists Against Vietnam" event. Much like a Happening, the play takes the form of a ritual enactment of a Vietnamese wedding ceremony that involves audience participation. The simplicity of the work underscores its political message: there are greater similarities between Eastern and Western cultures than there are differences between them. *The Red Burning Light*, in high contrast, is a string of musical and often raunchy burlesque bits laced with irony, which condemns U.S. imperialism and the military. These two works opened together at La MaMa on April 12, 1969. *The Successful Life of 3* was presented as part of La MaMa's second European tour. Fornes also collaborated with the Open Theatre and was produced by the Judson Poets Theatre in 1965.

Adrienne Kennedy's *Funnyhouse of a Negro* was a critical if not a popular success when it was produced at the East End Theater in New York City in 1964; Edward Albee was an early and enthusiastic supporter of Kennedy's work.

Written in 1963 and first presented in Rome in 1966, Adrienne Kennedy's *A Rat's Mass* opened at La MaMa on September 17, 1969, directed by Seth Allen, with music by Lamar Alford. In an interview in 1990 with Paul Bryant-Jackson and Lois Overbeck, Kennedy remembers this production "as a very big success." Clive Barnes in the *New York Times* noted that "when acted, [Kennedy's] phrases float accusingly in the air" (November 1, 1969, 39). Mary Alice (who later won a Tony Award for her performance in *The Delaney Sisters* on Broadway) and Gilbert Price played Sister and Brother Rat, and Marilyn Roberts played Rosemary, the "first girl [they] ever fell in love with." Rosemary, a white girl in communion dress, reads to Brother and Sister Rat from her catechism book and persuades the two African American children to engage in sexual play. In response, they create a child's "rats' Mass" in an attempt to purify and sanctify themselves. Rosemary ultimately betrays the children and Brother and Sister Rat are destroyed. At Stewart's suggestion and urging, in 1976 Cecil Taylor directed *A Rat's Mass* at La MaMa in an experimental, musical version.

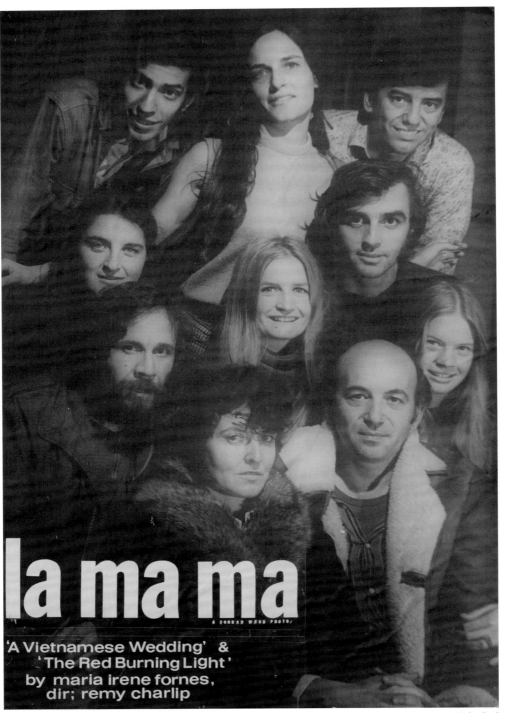

la ma ma

A CONRAD WARD PHOTO,

'A Vietnamese Wedding' &
' The Red Burning Light '
by maria irene fornes,
dir; remy charlip

26.5" × 18.25"

FIG. 33: *Vietnamese Wedding* and *The Red Burning Light*, 1969.
Photograph on poster by Conrad Ward.

A RAT'S MASS
LA MAMA E.T.C.
74A EAST 4TH ST.

OCTOBER 22-25 10PM
OCT. 26 · MIDNIGHT

16" × 20"

A Rat's Mass

by ADRIENNE KENNEDY

with
Lamar Alford
Mary Alice*............Sister Rat
Gilbert Price*.........Brother Rat
Marilyn Roberts*.......Rosemary
Robert Stocking

directed by..............Seth Allen
music composed and
directed by..............Lamar Alford
set....................Theodore S. Tie

lights..................Johnny Dodd
lighting asst..........Steve Whitson
costumes.............Ann-Marie Allen
stage manager..........June Perz
asst. stage manager....Steve Askinazy

(*)Actors appearing through the courtesy of Actors Equity Association.)

Special thanks to Joe Chaiken, Rodney and Kiki Kundry.

Rosemary was the first girl we ever fell in love with. She lived next door behind a grape arbor her father had built. She often told us stories of Italy and read to us from her Holy Catechism Book. She was the prettiest girl in our school.

FIG. 34: Adrienne Kennedy's *A Rat's Mass*, 1969. This collage including photo and program from the La MaMa production was created by Ozzie Rodriguez, La MaMa Archive director, for an event celebrating the opening of the New Lafayette Theatre in 1987. Photo of actress Mary Alice by Amnon Ben Nomis.

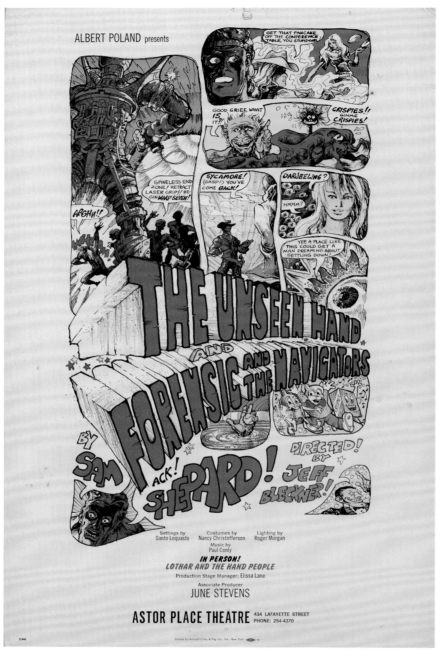

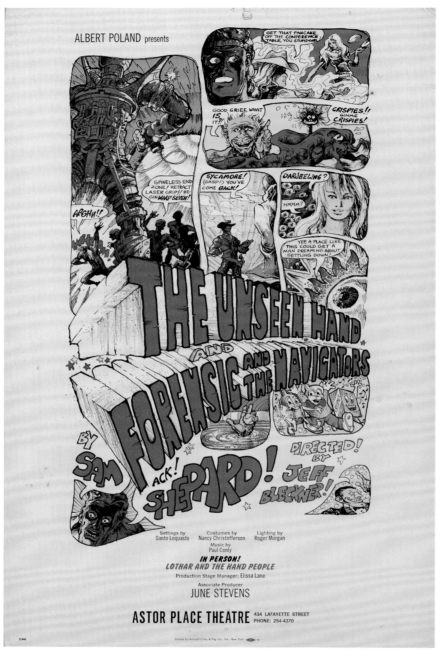

22" × 14"

FIG. 35: *Unseen Hand* by Sam Shepard; La MaMa opening, December 26, 1969. Poster for the Off-Broadway production: 1970, Astor Place, *Unseen Hand* and *Forensic and the Navigators*, Jeff Bleckner, director. Poster design by Robert U. Taylor, an acclaimed scenic and production designer. The poster, using primary colors, is similar to pop art created in the early 1960s by artist Roy Lichtenstein; comics were the inspiration for this poster. Here it appears as if an entire page was lifted from an action hero comic book. Nearly every frame is punctuated with multiple exclamation points or question marks. The title appears to be carved out of thick stone.

Shepard was first produced at La MaMa in 1965 (beginning with his short plays *Dog* and *Rocking Chair*). He had worked as a waiter at the Village Gate with Ralph Cook, the director of Theatre Genesis, who first produced Shepard's plays in 1964. While waiting tables at La MaMa's 122 Second Avenue theater, Shepard's plays were being directed by Tom O'Horgan on tour with the La MaMa Troupe. Shepard's one-acts from the 1960s are darkly playful and shot through with shock value; they capture the nihilism of the "sixties generation" even as they pulse with energy, reflecting a mythic America and his beginnings as a rock-and-roll drummer. His interest in jazz and his collaborations with composer-director O'Horgan also informed and expanded his early works. Shepard won the Pulitzer Prize in Drama for *Buried Child* in 1979; the play had two Broadway productions, in 1996 and 2000. Shepard was nominated for an Academy Award for his performance in the film *The Right Stuff* in 1983.

SAM SHEPARD (2006): When I first came to La MaMa I had two plays, *Dog* and *Rocking Chair*. I said to Ellen, "Maybe you'd want to read them." She told me, "Honey, we don't have to read them. We're just going to do them." Now that's a producer! She was the best producer in the whole world. She was always the most generous, and she still is.

FIG. 36: Stewart at the La MaMa
opening of *Golden Bat*, 1970. Photo
by Tokyo Kid Brothers, courtesy of
La MaMa Archive.

CHAPTER TWO

THE 1970s

A Defining Decade

A GROWING ROSTER OF DYNAMIC DIRECTORS

ELLEN STEWART (2002): I've never worked at any other theater in New York City. Words are a part of what I do, but they are not the primary piece. The musical, the visual, these are more important.

If, as Stewart declared, La MaMa was born in the 1960s as a home for playwrights, in the 1970s La MaMa's focus shifted to directors — and La MaMa became a versatile and flexible nest where Stewart nurtured the director's art. Stewart's support for and relationship with Tom O'Horgan in the 1960s had inspired this impulse to foster the work of visionary directors; O'Horgan and others in this chapter of La MaMa's history were artists who created work that was extremely powerful visually or musically or both.

On a visit to see O'Horgan and the La MaMa Troupe perform at an International Festival in Zagreb in 1966 (part of La MaMa's second European tour), Stewart "discovered" the Romanian director Andrei Serban. Stewart first produced Serban's *Arden of Faversham* and *Ubu* in La MaMa's First Floor Theatre in February 1970. These productions toured Europe. Following the tour, Stewart, Serban, and composer Elizabeth Swados created the Great Jones Repertory Company, which was the newest addition to the roster of La MaMa resident companies. Serban, Swados, and the company began work on *Medea*, which premiered in the basement of La MaMa in 1972, where a cave-like environment was created to reflect the ritual nature of the work. A limited number of spectators (thirty) could be accommodated per performance. The company followed the success of the *Medea* tour in Europe with the creation of *Electra* in Saint Chapelle Church in Paris. Stewart's experiences touring the international theater festivals of Europe with her companies

FIG. 37: Stewart and Andrei Serban, *Medea* rehearsal, 1987. Photograph by Jerry Vezzuso, courtesy of La MaMa Archive.

led to her realization that these wide-ranging and emerging theatrical forms required the creation of a new performance space at La MaMa in New York. With support from the Ford and the Mellon foundations she renovated a former television soundstage on East Fourth Street a few doors down from her existing theater and office complex and transformed it into a uniquely large and versatile indoor performance space. The dimensions of the Annex (forty-eight by one hundred feet with thirty-foot-high ceilings) contributed to the monumental impact of Serban's New York City premiere of *Fragments of a Trilogy* (1974), with music by Swados. Celebrated by mainstream and downtown reviewers alike, this landmark production, which included adaptations of *Medea*, *Electra*, and *The Trojan Women*, marked the beginning of a new phase for Ellen Stewart and La MaMa. Now, large-scale, highly physical works that had previously been presented only in environmental or amphitheater settings at international festivals could premier and be produced at La MaMa in the East Village. The Annex (renamed the Ellen Stewart Theatre in 2010) has been and continues to be a fertile petri dish for directors and theater companies.

ANDREI SERBAN, from an interview in 2003 and another after Stewart's death, in 2011: As a young Romanian student in the late sixties, Ellen "discovered" me in Zagreb, Croatia, at an international festival. While waiting in line to have lunch, she said a current of energy circulated between us, and she knew right away we belonged to the same artistic family. This accidental shoulder touching was essential to the way Ellen operated, and changed my life. I left Romania to work at La MaMa when nobody knew who I was — but Ellen knew.

It wasn't easy, though. Ellen had to come to Bucharest and go to the Romanian Ministry of Culture to plead my case, because the Communist Party would not issue a passport to me. She said that "the voices from above descended," and she suddenly started speaking Romanian to the minister of culture. As she commented, smiling on her way out: "I sounded pretty convincing, baby. You shall see!" I will never know if she spontaneously spoke Romanian and charmed the stiff cultural Communist censors, but one thing is certain: Ellen obtained a passport for me. And that's how I got to America, with a generous Ford Foundation grant arranged by Ellen with the help of W. McNeil Lowry. I toured the American regional theaters, and then I came back to La MaMa and did a first show, based on an old Elizabethan domestic tragedy — *Arden of Faversham*. Because of the

26.75" × 19"

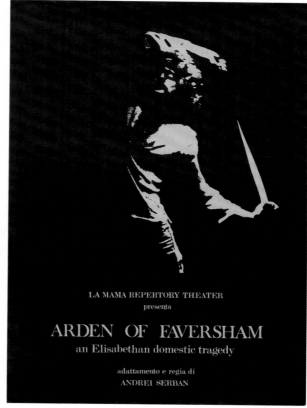

LA MAMA REPERTORY THEATER

presenta

ARDEN OF FAVERSHAM

an Elisabethan domestic tragedy

adattamento e regia di
ANDREI SERBAN

16.75" × 12"

FIG. 38 (*left*): *IFSK* poster, unattributed, is from the International Festival in Zagreb where Stewart met Serban, September 1966.

FIG. 39 (*right*): *Arden of Faversham*, a revenge tragedy by an anonymous Renaissance playwright, played in repertory with *Ubu*, which was based on *Ubu Roi* by Alfred Jarry with music by Lamar Alford; both were directed by Andrei Serban in his U.S. debut; the works premiered at La MaMa on February 6, 1970. Eighteen-year-old actor Billy Crystal performed in both New York City premieres. Poster for the Italian tour (including the Spoleto Festival, July 1970) features a high-contrast photograph of the actor playing Arden, Lou Zeldis, by renowned Dutch photographer Maria Austria.

rave review in the *New York Times* and at Ellen's invitation, Peter Brook saw the play. Immediately after the show he invited me to work with him in Paris for one year and become a member of his international research group. So the possibility of working with Brook, the mentor that opened so many doors in my future understanding of life and theater, I owe to Ellen.

ANDREI SERBAN: After the year with Brook I returned to La MaMa and I asked Ellen if I could do an experiment in voice and sound with Greek

tragedy, using dead languages, which is what Peter Brook did with *Orghast*, when I had been his assistant director. Ellen said: "Go ahead, baby, but, of course, you know we have no money like Peter Brook. You can only have seven actors and nothing else." A recent graduate of Bennington College, Liz Swados, met me in the lobby of the theater and said that she would like to compose music. She heard that I was searching for a new approach to sound and she was ready to embark on this impossible journey to find life in dead languages. And who would have imagined that would be the start of a long collaboration between us, together with Priscilla Smith and other dedicated actors. So we did *Medea* in the basement of La MaMa with nothing but seven actors! Diane Lane was six years old when her father brought her to audition for the child role in *Medea*; she got the part and later joined us on endless tours all over Europe. Ellen was the leader of the tribe, and she made us land in the most unusual places to perform what in time became a trilogy [*Medea, Elektra, The Trojan Women*]. Very soon, due to its original form and radical relation to space and audience, the trilogy became a favorite of the international festivals. Looking for unusual locations to perform, I told Ellen: "I need either an ancient temple or a ruin, or some grotto, an old factory, an ocean beach, a dilapidated slaughterhouse, a museum hall, a forest, or why not, a mountain cliff." "No problem, I'll get them for you, baby!" was her reply. And, miraculously, she got them. We played in all these places. These were the best years of our youth, traveling like nomads to the most wonderful and unusual places, some dangerous, like the temple of Baalbeck in Lebanon [when Lebanon became the target of early terrorism] or in Persepolis, where we were generously invited by Queen Farah, just as the situation got very tense politically, not long before the shah had to relinquish power in Iran.

Once I started working outside of La MaMa, I soon came to a crossroad. I was presented with many opportunities to expand the scope of my work with much, much larger budgets. I asked Ellen if she could allocate a more significant share of La MaMa's financial means to my group — by then called the Great Jones Repertory Company — so I could develop new projects with longer rehearsal periods and adequate pay for the actors. Although I was intent on this idea, she was not. Her answer was: "Baby, all my children need me equally." In other words, no special treatment. It has to be said of Ellen that she held steadfast to that dictum from the very beginning and, to my knowledge, always. Her mission is to nurture young artists from every culture and corner of the world and spread La MaMa's name and spirit. The multicultural mix of energies is what makes her happy. She did not waver from that. Therefore, I felt I had little choice, so I began working in many different arenas both in the United States and abroad.

I always kept a strong connection with Ellen. Why? Because Ellen is unique. She has a very special perception of people. I felt like I am really seen by her. Months could go by without getting in touch with one another, but the second she sees me, she can read my mind at once, seeing exactly what is happening inside me, even before I know it myself. She can tell like a clairvoyant what is the desire of my heart, and this came each time as a revelation. She was the one who gave me the courage at my beginnings to follow my own intuition, to develop and nourish in myself the best intelligence an artist should have, the intelligence of the heart. She is a good example to follow in this respect. Some think that Ellen is a shaman, a voodoo goddess, but for me she is a very practical and down-to-earth woman, filled with common sense, intelligence, sensitivity, and courage to undertake impossible risks and inspire many young artists in need of finding a home. I was one of them and I owe her my gratitude for that.

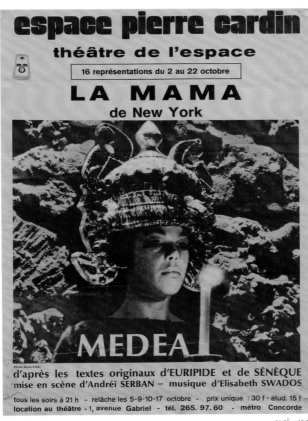

21.5" × 15.5"

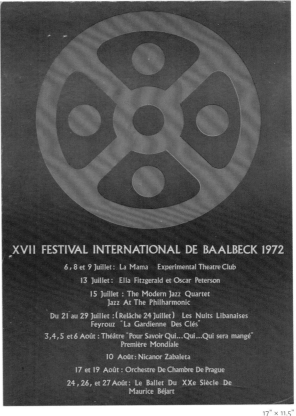

17" × 11.5"

FIG. 40 (*left*): Serban and Swados's collaborations included this early Great Jones Repertory Company's production of *Medea* in Paris, October 1972. Priscilla Smith as Medea in an elaborate headdress, with a lit candle in her hand and a stone wall as a backdrop. Photograph on poster by René Pari. The production premiered at La MaMa on January 21, 1972.

FIG. 41 (*right*): *XVII Festival International de Baalbeck*, 1972.

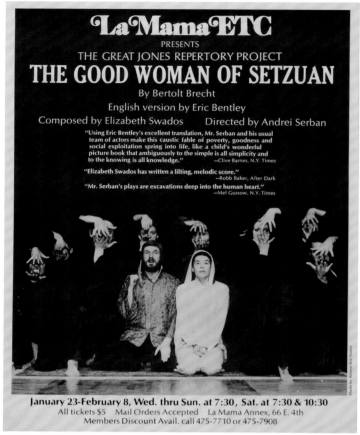

FIG. 42: Bertolt Brecht's *Good Woman of Setzuan*, in an English translation by Eric Bentley. Directed by Serban, composed by Swados. Photograph on poster features Jon de Vries, Priscilla Smith, and other members of the Great Jones Repertory Company. Amnon Ben Nomis, poster design. *Good Woman of Setzuan* premiered at La MaMa on January 23, 1976.

ELLEN STEWART (2003): 50 percent of the *Trilogy* was Serban's and 50 percent was Swados. For all of the Greek works, Elizabeth has composed the music. But that music is collaborative — my musicians also have created it. All of the Greek texts, Greek vocal work, Greek songs, that's Elizabeth Swados.

ELIZABETH SWADOS, from interviews in 2003 and 2005: I went to Bennington [College] . . . and then I came to La MaMa. Ellen kind of caught me. . . . Something was pulling me in the direction of international work. I wanted to be a folk singer. I wanted to be a political person. All of those disparate things came together at La MaMa. There were political groups coming in, absurdist groups coming in. Incredible music was being done.

Ellen took me to Tom O'Horgan's apartment. To a young composer — she opened the door for me — it was the beginning of my creative life. . . .

She introduced me to Andrei Serban. "Baby, you should work with him." . . . Ellen was behind Andrei. Behind the scenes, but she was there, whispering. And he listened. You don't not listen.

In 1972 we did *Medea* on the ruins of Baalbeck. And then at some point, the second night, Andrei and Ellen decided that there would be a *Medea II*. After the performance I was supposed to make up music and Andrei was going to lead the audience through more ruins and Andrei had a story about what the next part of *Medea* would be. . . .

When *The Trojan Women* opened at Sarah Lawrence [in 1974], she came up to Andrei and me and told us that this wasn't our work. You've lost it. And he and I went back to my apartment together and cried. But we fixed it. She said we needed more balls. More passion. To be more grounded. My response was that it needed more drums, it needed to be more rhythmic, louder.

. . . Being a La MaMa baby, you immediately have a kinship with a La MaMa baby from another country that you wouldn't have with another person. It's true that there are techniques and a frame of reference with people that have worked with her — the vocabulary comes very fast. Very physical, very rhythmic, eclectic, ethnic, free, highly dramatic, highly visual, big sets, and environmental, site-specific theater. . . .

She's like a shaman. Whatever it is, it works. I mean, she's traveled all over the world and you can find her mopping the floors in the theater's bathroom — or rather, she used to. I think if she still could, she would.

LA MAMA ARCHIVE DIRECTOR OZZIE RODRIGUEZ in 2012, on designing and creating the poster for the 1996 production of *The Trojan Women*: Ellen came down to the archive and said we need a poster for the La MaMa thirty-fifth-anniversary production of *The Trojan Women*. It would shortly thereafter go on tour — this was December of 1996. So I remembered Susan Haskins's poster for the twenty-fifth anniversary and I remembered she had used a black-and-white image of the mask. I had a costume designer friend, Rosa Lopez, who was also a stylist and a photographer. On a dime's notice I decided to incorporate that image and I asked her to come down to the archive. I got a piece of beautiful red velvet fabric, because I thought that represented La MaMa well, and I asked Ellen if I could have her bell, which provided a token representation of other La MaMa Greek tragedies that have been produced here, and I did a setup on one of

FIGS. 43 and 44: *The Trojan Women*, 1974. Poster for the 1996 production. Ozzie Rodriguez. Text layout by Mary Beth Ward, mask designed by Feu Follet, photograph on poster by Rosa Lopez. Mask from archive used in production of *Medea*, 1974. Mask designed by Feu Follet.

15" × 10"

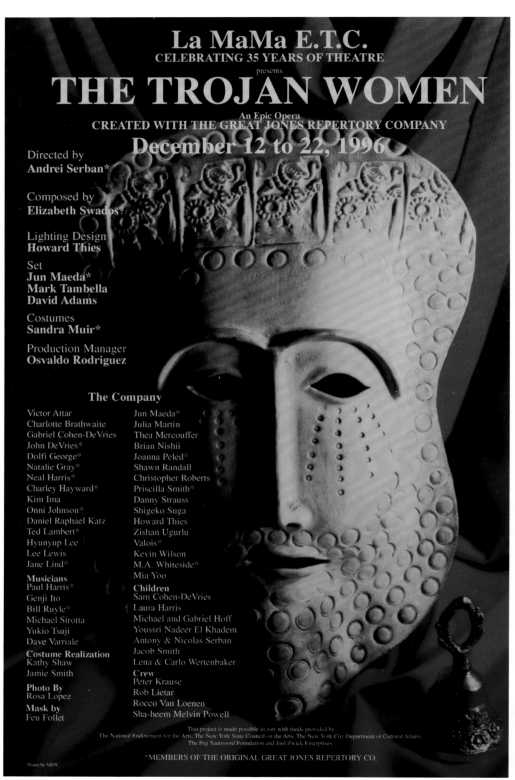

36" × 24"

the desks. I asked Rosa to take a photograph. We took photographs of the actual mask against this blood-red drapery with Ellen's bell prominently displayed. Ellen had no idea what I was doing, but I knew that all these things were important to her. More importantly, I thought it was dramatically viable and I thought it was attention-getting, which is required of a good poster. Mary Beth Ward was fascinated with laser printing, which was a new process at the time, and I asked her if she would supervise that aspect of producing the poster. So, using the photograph, I selected the typeface and also selected the order of names and elements on the poster as they should appear. Then we made sure we had everyone's names and all the correct information that was necessary. In a day and a half we had a poster we could use here and abroad when we traveled. It became a distinctive representation, not only of the *Trilogy* but of a La MaMa production.

The Mabou Mines Company, with founding artistic directors Lee Breuer, Ruth Maleczech, JoAnne Akalaitis, Philip Glass, and David Warrilow, was established in 1970 after the group spent a summer rehearsing near Mabou Mines, Nova Scotia. Later that year Mabou Mines became a resident company of La MaMa, and in November Stewart helped produce the company's experimental theater work *The Red Horse Animation*, with music by Philip Glass, at the Guggenheim Museum. *The Red Horse Animation* was later presented at La MaMa, premiering there on June 9, 1971. Working in art galleries and with visual artists, as Mabou Mines did in the early 1970s, was unique among theater collectives at the time. Teachers and directors Herbert Blau, R. G. Davis, and Jerzy Grotowski were powerful influences on the development of Mabou Mines' working processes.

The Plexus Group originated at La MaMa under the direction of Stanley Rosenberg in the 1960s. In the early 1970s the group became known as La MaMa Plexus under the artistic directorship of Joel Zwick. Focusing more on experimental workshops than on public performances, the Plexus Group developed physical exercises that drew from Jerzy Grotowski's techniques, yoga, capoeira, and the martial arts. Zwick later worked extensively on and off Broadway and as a television director (*Happy Days* and *Laverne and Shirley*) and film director. The Oscar-nominated *My Big Fat Greek Wedding* is one of Zwick's best-known films. He directed *Dance Wi' Me*, by playwright Greg Antonocci, which premiered at La MaMa on February 13, 1971, and later moved to Broadway.

One of the most important playwrights in the 1960s at La MaMa, Tom Eyen, was also a successful director whom Stewart championed in the 1970s.

17" × 11" 20" × 15.75"

FIG. 45 (*left*): Mabou Mines in conjunction with La MaMa produced *The Red Horse Animation* at the Guggenheim Museum in November 1970. Peter Moore, poster photographer, was London-born and renowned for documenting a variety of dance and theater performances, as well as Happenings and work that was associated with the Fluxus movement. His archive includes over half a million photos of performances, including those by Allan Kaprow, Nam June Paik, and Yvonne Rainer. He was a columnist and editor for *Modern Photography* from 1978 to 1989.

FIG. 46 (*right*): La MaMa Plexus: poster for *Dance Wi' Me*, director Joel Zwick, February, 1971. Photograph on poster: Zodiac Photographers, Joseph Abeles, and Sy Friedman. The photograph of the company is set up to look like a typical school class photo. There are no credits, dates, times, or addresses listed.

In 1973 Eyen directed a new production of his play *The White Whore and the Bit Player* (first presented at La MaMa in 1964), which was produced by the Duo Theater in a Spanish translation as well as an English version, which alternated in back-to-back performances. The central characters in Eyen's play are a fading Hollywood movie star (referencing Marilyn Monroe) and a fanatical and fatally jealous nun. Magaly Alabu and Candy Darling starred as the Marilyn Monroe character in the Spanish and English versions, respectively.

Described by critics as "fluffy" and a triple spoof ("soap opera, opera and 'adult western' horse opera all wrapped up into one"), the production sported a miniature train set and sawhorses in place of real ones. *Horse Opera* was a

LA ESTRELLA Y LA MONJA/
THE WHITE WHORE & THE BIT PLAYER

By Tom Eyen
The Bilingual Production of the Duo Theatre
A Resident Company at La MaMa

14" × 8.5"

FIG. 47: *The White Whore and the Bit Player*, written and directed by Tom Eyen. Poster from the Duo Theater production, which opened January 17, 1973. Poster design: Jose Erasto Ramirez. Images of women on the poster appear to be swiped from easily recognizable portraits of "pin-up" celebrities, including Mae West, Jean Harlow, Betty Grable, Marilyn Monroe (and Candy Darling). This poster was small, 14 by 8.5 inches, and may have been distributed for display in shop and café windows. The design consists of a highly detailed photo-collage and an intricate drawing with crosshatch shapes in the background. There is a close-up of Marilyn Monroe's famous gap between her upper front two teeth juxtaposed against a figure of a nun on the central cross design, which suggests the conflict between the play's two central characters.

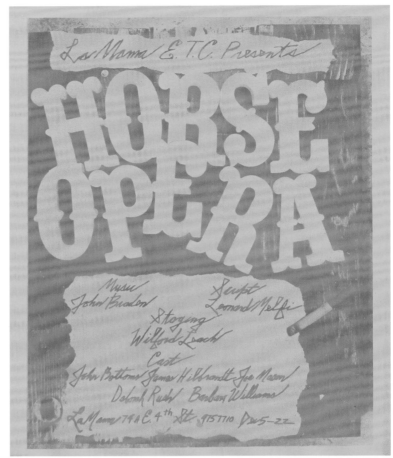

14.25" × 11.5"

FIGS. 48 and 49: Leonard Melfi's *Horse Opera*, director and set designer, Wilford Leach. Poster and photo of the train set used in the La MaMa production, which opened December 6, 1974. The font of this poster recalls typography typically found on circus, carnival, and Wild West posters. The poster image was printed in multiple color combinations. In this example a dark red ink was applied to the plate and printed on a deep yellow paper, creating orange.

unique collaboration between director Wilford Leach, playwright Leonard Melfi, and composer John Braden. Leach conceived the idea to transform Melfi's play into a raunchy satire that juxtaposed Wild West stereotypes with the lyricism of opera. Leach went on to direct on Broadway, where he broke ground with his version of the Gilbert and Sullivan light opera *The Pirates of Penzance*. He won the Tony Award for *The Mystery of Edwin Drood* (1986).

Multidisciplinary artist, composer, filmmaker, and choreographer Meredith Monk created the opera *Quarry* at La MaMa in 1976 and revived it in 1985. John Killacky calls the work "one of the masterpieces of the twentieth century." Monk describes La MaMa in the 1960s (remembering *Viet Rock* in particular), as well as Caffe Cino, Judson Poets Theatre, and The Gate as having a powerful influence on her work and inspiring her interest in "transformation."

MEREDITH MONK (2012): This room [referring to the La MaMa Annex] was so inspiring. The size of it — it could be intimate and epic. *Quarry* was a meditation on World War II. I was contemplating what it would be like to be taken away.

Monk performed the role of "the little girl who is sick" in this sound- and image-rich work; for Monk this central figure in the piece references her family's roots as Eastern European Jews. The second movement of the three-movement work is titled "March," for which Monk entirely filled the Annex with a moving, choral landscape of a world at war.

MEREDITH MONK: The audience itself became our set. We had forty-two people in the cast. The piece was about childhood fear and about how dark times recur in human history. We first performed *Quarry* at La MaMa in April 1976 and were supposed to perform it again in December. But La MaMa was hit with code violations and we weren't able to do the work later in the year. I remember sobbing with Ellen in this room. What producer would be sitting there, crying with you?

Distinguished theater artists Lee Nagrin and Ping Chong performed in the 1976 production. Chong, in his first appearance on a La MaMa stage, played the central dictator, part of the "little girl's" nightmare vision. La MaMa stalwart Nicky Paraiso played the role of the central dictator in 1985.

QUARRY

conceived and directed

by Meredith Monk

with The House

Lanny Harrison, Monica Moseley, Ping Chong, Gail Turner,

Coco Pekelis, Daniel Ira Sverdlik, Lee Nagrin,

Tone Blevins, Pablo Vela, Mary Schultz, Steve Clorfine, Steve Lockwood

Music: Meredith Monk

Lighting: Beverly Emmons. Costumes: Lanny Harrison. Sound: Tony Giovanetti.

Decor: Ping Chong and Jean-Claude Ribes.

La Mama Annex

66 East 4th Street

Previews: April 2, 3, and 4 at 7:30 p.m.

Opening night: April 6, 1976 at 7:30 p.m.

Performances continue April 7-11 and 13-18 at 7:30 p.m.

Tickets $5, student rush $3

Box office 74A East 4th Street, open 11-7

475-7710 or 475-7908

La Mama E.T.C. presents Meredith Monk/The House. Quarry is funded by NYSCA and NEA.

Photo: David Geary. Poster: Monica Moseley.

22" × 16.5"

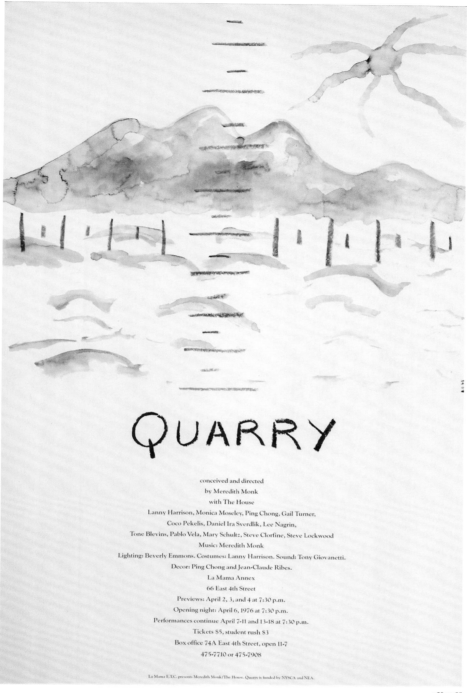

QUARRY

conceived and directed
by Meredith Monk
with The House

Lanny Harrison, Monica Moseley, Ping Chong, Gail Turner,

Coco Pekelis, Daniel Ira Sverdlik, Lee Nagrin,

Tone Blevins, Pablo Vela, Mary Schultz, Steve Clorfine, Steve Lockwood

Music: Meredith Monk

Lighting: Beverly Emmons. Costumes: Lanny Harrison. Sound: Tony Giovanetti.

Decor: Ping Chong and Jean-Claude Ribes.

La Mama Annex

66 East 4th Street

Previews: April 2, 3, and 4 at 7:30 p.m.

Opening night: April 6, 1976 at 7:30 p.m.

Performances continue April 7-11 and 13-18 at 7:30 p.m.

Tickets $5, student rush $3

Box office 74A East 4th Street, open 11-7

475-7710 or 475-7908

La Mama E.T.C. presents Meredith Monk/The House. Quarry is funded by NYSCA and NEA.

28" × 18"

FIGS. 50 and 51: Two posters of Meredith Monk's *Quarry*, which opened April 2, 1976. Poster photo of the quarry by David Geary; poster design, Meredith Monk and Monica Moseley. The marine blue drawing on the second poster occupies nearly two-thirds of the page. The image of a mountainous landscape is viewed through the crosshairs of a periscope. Drawing by Meredith Monk, typography design, Monica Moseley.

MEREDITH MONK (2013): The black-and-white poster from 1976 is from a film that I shot up in Vermont for *Quarry*. I decided to call the piece *Quarry* because I really wanted to work with the idea of digging and bringing up memories, histories — bringing them into the present. I started envisioning images of tiny figures with a gigantic rock quarry behind them. I was working with extremes of scale. I asked David [Geary] to shoot the film for me. I had already thought that there would be a triumvirate of characters — the little girl, the mother who was a radio singer — radio was a "messenger" of that time — like Mercury — in the 1930s and 1940s. And the third character was a kind of dictator. We explored many composites of dictator qualities. I have a European Jewish background, but my family had come to America by the turn of the twentieth century, so I didn't lose anyone in Europe during World War II. But in my imagination I was wondering what it would have been like to be in Europe at that time. A man in a World War II museum in Paris let me look at all their archival photographs and clippings, and the strange thing is that there were two photographs of Jews in a rock quarry being forced to carry rocks. The way it was shot looked exactly like my film. It was so shocking. The scale was the same. It was incredible. And I remember when I shot the film I thought this is going to be the dictator/propaganda film.

When it came time to do the poster, I was trying to figure out, was I going to do a drawing for it? Monica Moseley was a member of The House [the company Monk founded in 1968] — one of the earliest members in the late 1960s. She was an amazing person who was a lovely performer. She was also a wonderful calligrapher. We worked together often where she would do the typeface and I would do the visual artwork. And so with *Quarry* I decided to go with a still from the film that David shot. I think that was the first time I used a film still in a poster.

And I think that's why I also made a second poster because my style was really to use my handmade drawings. In a way, my drawing is quite primitive, but it went up against Monica's quite elegant print type.

I had made films from 1966 onwards. Some of my films had more of a circular time-sense or more the sense of time of an installation artist's work — not a linear structure. That was something that was important to me as an artist. Most of my work has been inspired by the visual arts and film.

I always painted and drew throughout my childhood. I did not have formal training. At Sarah Lawrence College they allowed me in my last year to do a combined performing arts program — I was in the voice, theater,

and dance departments. When I was graduating, I realized that I had never taken an art history course, so I went to the library, got stacks of books out, and taught myself art history. Then when I came to New York I was very active in the gallery scene, and I performed in some of the last Happenings.

I always drew as part of how I worked — I drew charts and maps. Sometimes when you haven't had formal training but you have the sensibility of an artist you can come up with something very fresh because you don't have the history or the limitations that are imposed on you by what you have learned.

I can't remember how it happened that Ellen asked me to do a new piece in the Annex. It was 1975. I walked into the space and thought, *This is the perfect space for me.* I know that I was extremely excited about it. We performed the piece in April 1976 and it won an Obie Award. Then we went to the Venice Biennale with my whole cast and crew — there were fifty people on the train. We were going to do it again at La MaMa and then Ellen got a violation notice for the Annex. We did it after that at BAM, produced by the Women's Interart Center. BAM was not as ideal a space as the Annex because of the proportions. I told Ellen we were doing it there and she said, "Go ahead, baby, it's your thing."

Ellen always came out and rang her bell before a show and said that this is a theater dedicated to playwrights, but I always had the feeling that I wanted people to walk into my reality, into the world of the piece. I would create a "preset" situation. The audience would walk in and something was already going on. There wasn't a beginning and an end. And so in *Quarry* the lights were on the four corners — illuminating the little rooms — and the radio was playing four songs I had composed for voice and piano. And so the whole atmosphere was already set up. Ellen was so gracious. I told her, "Ellen it won't really work to ring the bell." Well, every time I worked at La MaMa I had that "preset" idea and there was never a time that she ever said, "No, this is the way we do it here and you have to adapt to my way of doing things." That never happened. She always understood exactly what I was going for. That's the kind of person she was. She always had the big picture in mind. She was devoted to the metaphysical idea of what theater gives you, being on this planet. It was bigger than both of us.

She never had input on the posters — I think we talked it over with her to make sure it was okay, but we never heard any feedback. I think that's wonderful, because each artist is very different in what they want their poster to say. I have so much respect for Ellen because we all had so much freedom. Ellen was totally about love.

Achievements are interesting, of course, but it's really about the love you leave behind. I'll have been working fifty years in 2014 and there are places

in my mind over the years that are "yes" places and there are "no" places. The "no" places are when you come into a situation and you want to do something and it's "No, no, you can't do this, you can't do that." And then there are the yes places where anything is possible and you try everything that you can and you have that sense of freedom and support. And that's La MaMa.

Tom O'Horgan, like directors Wilford Leach and Joel Zwick, forged a vibrant, iconoclastic identity and developed a devoted following in the experimental theater community before he emerged as an exciting and unique force to be reckoned with in the mainstream. And O'Horgan proved (as did Leach and Zwick) that the gap between radical-experimental and mainstream-commercial was not, in fact, very wide — he quickly made the leap from Off-Off and Off Broadway into Broadway celebrity and film work. O'Horgan's production of *Hair* opened on Broadway in 1968, and perspectives on and expectations for commercial theater were utterly and forever transformed. O'Horgan commented with chagrin that there wasn't a new play that opened for months afterward that didn't contain rock and roll and nudity of some kind. In 1971 three of O'Horgan's directorial works played on Broadway at the same time: *Hair*, *Jesus Christ Superstar*, and *Lenny*. This would be an outstanding achievement for any director, but it was especially so for one associated primarily with noncommercial, experimental work. In addition to taking on film projects including his adaptation of Ionesco's *Rhinoceros* with Zero Mostel, O'Horgan expanded his repertoire to include opera. A multitalented musician, he composed music for many of the plays he directed. After a six-year hiatus from Off-Off Broadway, he returned to work at La MaMa in 1975. In 1976 he directed and composed instrumental music for *The Architect and the Emperor of Assyria*, a co-production with the Nelly Vivas Company, which premiered on May 27 and was acclaimed by mainstream critics, including Harold Clurman in the *Nation*, who described Arrabal's play as "a sado-masochistic farce," and "a send-up of modern civilization." The play depicts the master-slave relationship between the sole survivor of

FIG. 52 (*facing*): Poster for Tom O'Horgan's 1986 production of Fernando Arrabal's *The Architect and the Emperor of Assyria*. Poster artists M. Ilic and N. Lindeman. Mirko Ilic is a Bosnian-born designer and illustrator who has collaborated with the noted graphic designer Milton Glaser, among others. He has designed album covers and books and created titles for films. Bits of the detritus of popular culture are spewed from the mouths of two mirrored heads and form an ornate collage including a Madonna and child, a pack of Camel cigarettes, Ipana toothpaste (a popular brand in the 1950s), a handgun, a baby bottle, a "Holy Bible," and a wrist watch. On the poster's border there is an Assyrian sphinx stamp.

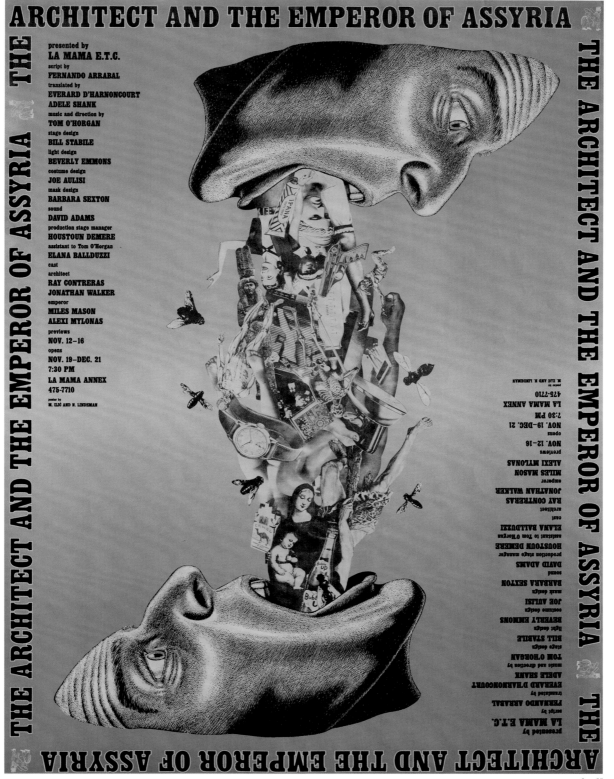

ARCHITECT AND THE EMPEROR OF ASSYRIA

presented by
LA MAMA E.T.C.
script by
FERNANDO ARRABAL
translated by
**EVERARD D'HARNONCOURT
ADELE SHANK**
music and direction by
TOM O'HORGAN
stage design
BILL STABILE
light design
BEVERLY EMMONS
costume design
JOE AULISI
mask design
BARBARA SEXTON
sound
DAVID ADAMS
production stage manager
HOUSTOUN DEMERE
assistant to Tom O'Horgan
ELANA BALLDUZZI
cast
architect
**RAY CONTRERAS
JONATHAN WALKER**
emperor
**MILES MASON
ALEXI MYLONAS**
previews
NOV. 12–16
opens
**NOV. 19–DEC. 21
7:30 PM
LA MAMA ANNEX
475-7710**
poster by
M. ILIC AND N. LINDEMAN

24" × 18"

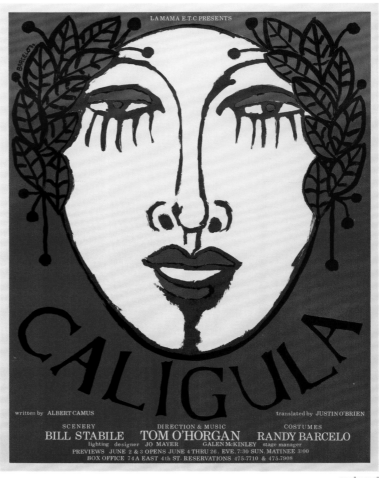

LA MAMA E.T.C PRESENTS

CALIGULA

written by ALBERT CAMUS translated by JUSTIN O'BRIEN

SCENERY DIRECTION & MUSIC COSTUMES
BILL STABILE TOM O'HORGAN RANDY BARCELO
 lighting designer JO MAYER GALEN McKINLEY stage manager
 PREVIEWS JUNE 2 & 3 OPENS JUNE 4 THRU 26. EVE. 7:30 SUN. MATINEE 3:00
 BOX OFFICE 74 A EAST 4th ST. RESERVATIONS 475-7710 & 475-7908

22.5" × 17.5"

FIG. 53: Poster for O'Horgan's production of Camus's *Caligula*. Randy Barcelo, poster and costume design, 1977.

a plane crash who designates himself as "Emperor" of an almost deserted island, where he encounters a native, whom he titles "Architect." In O'Horgan's production the Emperor made his first entrance through the ceiling of the La MaMa Annex theater. In the 1976 production, Ron Perlman played the Emperor and Lazaro Perez played the Architect. Clive Barnes raved about the "elegant inventiveness" of the production, describing the actors "as brilliant in an evening of dizzy revelation," and said that this was "the best thing" O'Horgan had done in years. O'Horgan's production of Camus's *Caligula*, which opened a year later, on June 4, 1977, featured a much-celebrated performance by Seth Allen in the title role. The production's poster and costumes were designed by Randy Barcelo, a Cuban American artist with whom O'Horgan frequently collaborated. Barcelo worked in opera and dance and on and off Broadway, earning a Tony nomination for the costumes for *Jesus Christ Superstar*.

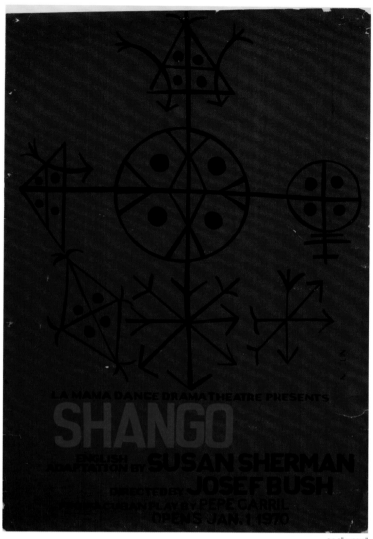

34.5" × 23.5"

FIG. 54: *Shango* poster, a silk-screen print on paper, designed by Nancy Colin, who also designed the mask used in the production, 1970.

HOW LA MAMA'S MULTICULTURAL FAMILY GREW

Shango de Ima, a "Yoruba Mystery Play," is the story of Shango, a god in the Yoruba religion. Stewart produced the premiere presentation of Susan Sherman's English translation and adaptation of this African-Cuban dance theater piece by Pepe Carril. At a time when the U.S. government had imposed severe restrictions on arts exchanges with most communist and socialist countries (Stewart's difficulties in acquiring a passport for Andrei Serban, the Romanian director, is just one example of the challenges she faced), Stewart enthusiastically supported Sherman and director Josef Bush in bringing an example of Afro-Cuban culture to La MaMa audiences — a culture that was

26" × 29"

FIG. 55: Poster designed by Akira Uno for *La Marie Vison*. U.S. premiere at La MaMa was on July 8, 1970. Aquirax Uno, also known as Akira Uno, was an important artist in the Japanese underground of the 1960s and 1970s. Poster style combines expressionism (evoking a kind of morbid realism) and a pop art / psychedelic sensibility, to create a decadent nightmare scene. The La MaMa Archive prominently displays the original tempera and ink drawing on paper mounted on board. All the main characters in the play are depicted in the poster. The upper-left corner of the poster features a "butterfly boy," and in the lower center, the title character, Marie Vison, wears a phallic headdress.

off-limits to most U.S. citizens after Castro came to power. On opening night, January 1, 1970, devotees of the Yoruba religion who were in the audience came dressed in white in observance of the reenactment of Yoruba legends and rituals; the production included sacred music as well.

La Marie Vison introduced U.S. theatergoers to the work of Japanese playwright-director/filmmaker-poet Shuji Terayama, who founded the experimental theater company Tenjo Sajiki ("Peanut Gallery") in 1967. The unusual poster by Akira Uno reflected the production design of *La Marie Vison*, which used surrealistic and expressionistic elements. Underground art in 1960s and 1970s Japan was called *angora*. Terayama was involved in Japan's Little Theater movement of the 1960s, which challenged theatrical norms for spectators and performers alike. Some of Terayama's work seemed inspired by the Happenings that took place in New York City in the 1960s. In this production, La MaMa's theater space was transformed into a three-room chicken-wire cage, in which Marie, a black transvestite, recounted the story of her life to her son, her "Butterfly-Boy." The play ends with the release of a thousand butterflies into the audience as phantasmagorical figures pose and dressed in haute couture laugh wildly while Wagner's "Ride of the Valkyries" blasts at full volume.

Yutaka Higashi, like many other young Japanese performers of the 1960s, had been influenced by Shuji Terayama and the work of the experimental company Tenjo Sajiki. He was a member of the Peanut Gallery but left the company to form the Tokyo Kid Brothers. Higashi wrote and directed the Tokyo Kid Brothers' 1970 production of *Golden Bat*, which was presented as a "Japanese Rock Celebration" with music by Itsuro Shimoda. The work was based on a Japanese comic strip character who symbolized "Matsuri," the hopes and dreams of Japan's younger generation. *Golden Bat* transferred from La MaMa to a successful run Off-Broadway. The motorcycle motif in the poster for *The City*, the Tokyo Kid Brothers' second production at La MaMa, similarly evokes American stereotypes and U.S. popular culture.

Beginning in the early 1970s Stewart produced the work of Ed Bullins, Leslie Lee, and Richard Westley at La MaMa and on tour in Europe. The GPA Nucleus (later renamed the Jarboro Company, after opera singer Katarina Jarboro), with Hugh Gittens as director, was the first resident African American theater ensemble at La MaMa. By Stewart's report some black activists and theater artists resented the fact that she was not exclusively concerned with black political theater. By her own admission, Stewart "did not want to be put in a black woman box," and her choice was to spread her resources among many groups and artists, not to focus on a single figure or issue. At a critical time in the civil rights movement, Stewart states, she was targeted by the

28.5" × 20.25"

11" × 8"

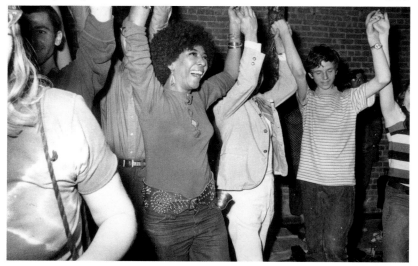

FIG. 56 (*top, left*): *Golden Bat:* This poster for the Japanese production was designed by Pater Sato to M. 1970. The impact of American pop culture on Japanese art and artists is evident in the poster design for the original Japanese production of *Golden Bat*, which references the album cover imagery of the Beatles' *Sgt. Pepper's Lonely Hearts Club Band*.

FIG. 57 (*top, right*): Flyer for *Golden Bat* for the New York La MaMa premiere, June 17, 1970, by Sato Kenkichi, who also performed in the production and designed the set. This is an example of a screen print or silkscreen, a printing technique popularized by visual artists Andy Warhol and Robert Rauschenberg, when pop artists took images of popular culture and transformed them into "high" art in the 1960s.

FIG. 58 (*right*): Stewart at *Golden Bat* opening, 1970. Photographer unknown, courtesy of La MaMa Archive.

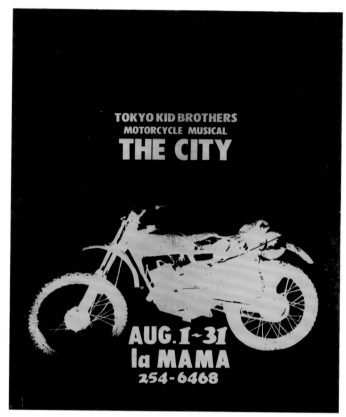

FIG. 59: Tokyo Kid Brothers (playwright/director Yutaka Higashi, composer Itsuro Shimoda) presented two U.S. premieres at La MaMa. Poster is a photostat for the La MaMa production of *The City*, which opened August 3, 1974. The design is effective, albeit minimalist, using a straightforward font with no serifs.

13.5" × 10.5"

Black Panthers when she toured internationally in the late 1960s. W. McNeil Lowry of the Ford Foundation sought protection for her during that time.

ELLEN STEWART (2005): I was the only one that took black theater to Europe. We were on a good start, but blacks wanted me to do black theater only. . . . You know my mama always told me never to forget I was many different kinds of people.

Playwright Ed Bullins, a "black radical" according to scholar Mike Sell, is a self-declared "literary gangster of the twentieth century." His work (at La MaMa, *Street Sounds*, *Short Bullins*, and *Clara's Old Man*) can be seen as a kind of "blues history of African America."

The buzz produced by Bullins's *Clara's Old Man* (premiered 1965, opened at La MaMa in New York on March 3, 1972, and toured Italy in October 1972) helped establish Bullins as a major voice in the Black Arts movement.

Playwright, director, and performer Charles Ludlam was a foundational artist in what has been called "queer theater." *Bluebeard*, which opened at La MaMa on March 25, 1970, was based on a dark and violent Grimm's fairy

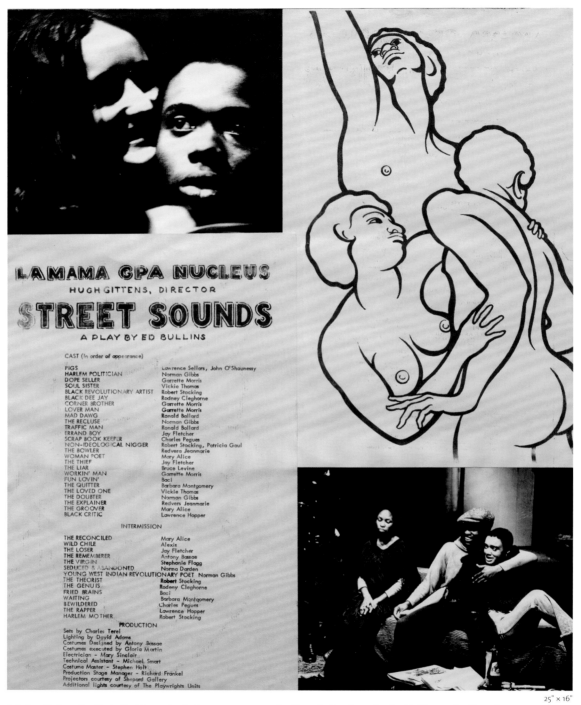

25" × 16"

FIG. 60: Collage by Ozzie Rodriguez including program, production photos from the La MaMa production of *Street Sounds*, playwright Ed Bullins, which premiered October 14, 1970. The drawing is signed by Bradley Phillips.

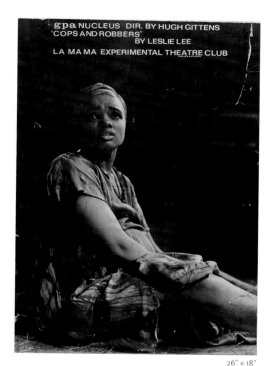

26" × 18"

FIG. 61 (*left*): *Cops and Robbers*, playwright Leslie Lee, which premiered at La MaMa January 29, 1971; the photograph on the poster is by Conrad Ward.

FIGS. 62 and 63 (*below*): Two posters from the 1972 touring production of Richard Westley's *Black Terror* and Ed Bullins's *Short Bullins* and *Clara's Old Man*.

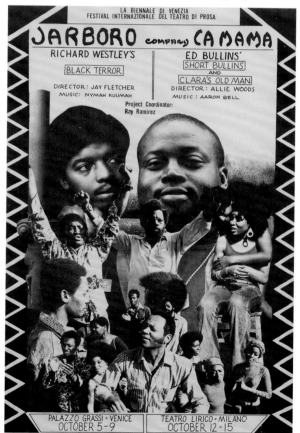

17" × 11"

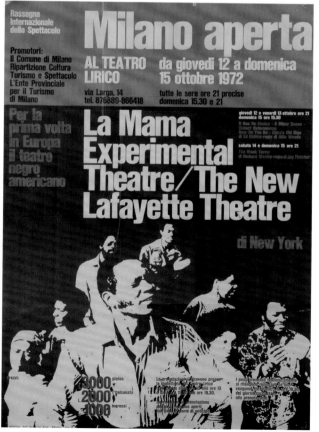

33" × 23"

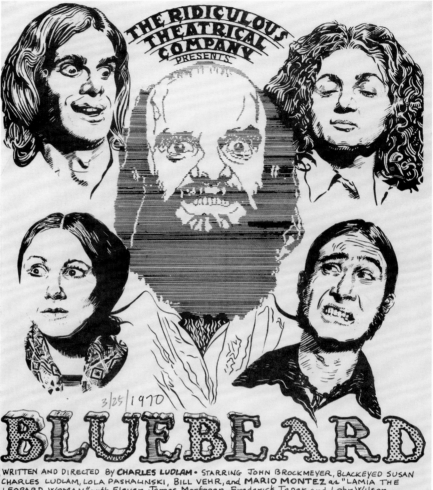

FIG. 64: *Bluebeard*, written and directed by Charles Ludlam. Ludlam performed the title role to acclaim in the Ridiculous Theater Company production at La MaMa and elsewhere. Black and white line drawings of heads on the poster based on photographs by Anita and Steve Shevett, 1970.

10.5" × 8.5"

tale, which Ludlam "re-vamped" as an edgy and hilarious cross-dressed romp. Ludlam founded the Ridiculous Theatre Company after parting ways with director John Vaccaro, who went on to form the Playhouse of the Ridiculous. Ludlam chose La MaMa as the launching pad for a new phase of his company's work, "more formal" in his view; in mainstream and fringe critics' eyes, *Bluebeard* was campy and successful gender- and genre-bending satire. "My plays let men and women step out of their traditional roles," stated Ludlam. "Theatre is a way of experimenting with life — a kind of research-and-development department for the culture at large."

Vaccaro, who recalls Caffe Cino as the original site of inspiration for much queer performance, directed many of his company's productions in the 1970s

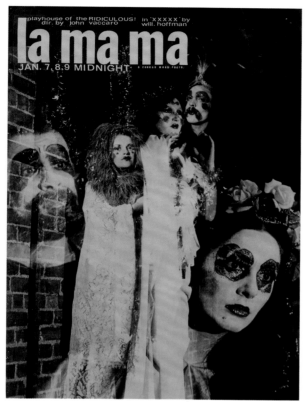

26.5" × 18"

FIG. 65 (*left*): *XXXXX*, performed by the Playhouse of the Ridiculous. Premiered at the Old Reliable Theatre Tavern in 1969 and at La MaMa on January 7, 1972. Written by William Hoffman, directed by John Vaccaro. Photo-collage photostat poster by Conrad Ward.

FIG. 66 (*below*): *The Sixty-Minute Queer Show*, performed by the Playhouse of the Ridiculous, 1977. Playwright: Kenneth Bernard, director: John Vaccaro, composer: John Braden, poster artist: M.R. (Mark Ravitz). Ravitz, also a set designer, uses the imagery of drips prominently in much of his work, both two- and three-dimensional. This poster features a drawn clock in the style of a pocket-watch, where four hands of the clock are red nail-polished fingers. Blood or red nail polish drips from the letters of the title and from the numbers of the clock. Is the poster signaling that time is running—or bleeding—out?

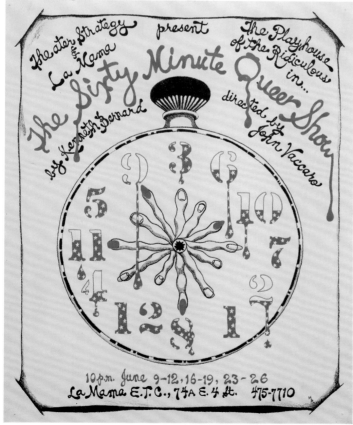

20" × 16"

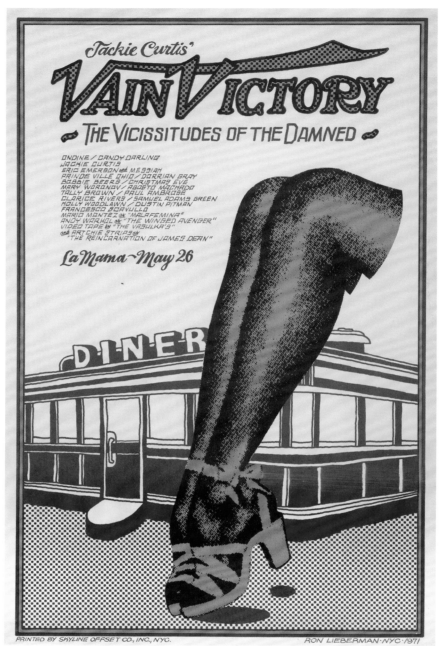

FIG. 67: *Vain Victory: The Vicissitudes of the Damned*. Playwright-director: Jackie Curtis. Poster artist: Ron Lieberman, 1971. The clouds on the set were painted by Larry Rivers; Warhol's cow-print wallpaper was lent to the production by the Leo Castelli Gallery. The title typography for *Vain Victory* is lifted from the style of *Variety* magazine's title and resembles a font popular in the 1930s and 1940s. This poster is another example of two-color separation offset lithography in red and blue—as in David Byrd's poster for *The Moon Dreamers*.

at La MaMa as well as the work of other companies. (The American Indian Theatre Ensemble's production of *Body Indian* is but one example.) *XXXXX* was directed by Vaccaro and written by William Hoffman. A seriocomic, avant-garde "nativity play," the five "X's" stand for the choreographic patterns performed by each of the play's five characters: God, Jesus, the Holy Ghost, Mary, and Joseph. Hoffman went on to write *As Is* (1985), which was one of the first plays to focus on the AIDS epidemic and was nominated for a Tony Award on Broadway. *The Sixty-Minute Queer Show*, which opened June 9, 1977, was written by one of Vaccaro's frequent collaborators, playwright Kenneth Bernard.

Many styles, forms, and levels of drag performance were developed and championed at La MaMa. Jackie Curtis, a member of Andy Warhol's entourage, stepped out of drag and performed "straight" in his "trashy" send-up of Hollywood musicals, *Vain Victory: The Vicissitudes of the Damned*. The play, which Curtis wrote and directed, premiered at La MaMa on May 26, 1971. It was set on a sinking ship and boasted a rotating cast of Warhol factory "superstars"—Andy Warhol, Candy Darling, Holly Woodlawn, Ondine, Francesco Scavullo, Agosto Machado, Mario Montez, and Larry Ree. Jackie Curtis held the curtain for an hour and a half on opening night for John Lennon and Yoko Ono, who attended that evening's performance accompanied by Warhol and filmmaker Paul Morrissey. Spectators were frequently cajoled into joining the cast for a night; on one occasion Curtis persuaded Peter Allen (a onetime "protégé" and the second husband of Liza Minnelli) to perform a song during a performance.

The all-male *Ekathrina Sobechanskaya Dances with her Original Trockadero Gloxina Ballet Company* parodies the traditions of classical ballet and the attitudes and allure of classical ballerinas. Larry Ree, the company's director and choreographer, is depicted as a "prima ballerina" on the poster below—Ekathrina Sobechanskaya is his playfully constructed stage name, which pokes fun at the names and the legendary over-the-top personalities of the great Russian ballet dancers.

Stewart advocated early on for the American Indian Theatre Ensemble, renamed the Native American Theatre Ensemble. An integral part of Stewart's vision for La MaMa was the creation of a community gathering place where diverse groups evolved into resident companies that presented theater of and for underrepresented ethnic and cultural minorities.

ELLEN STEWART (2005): Five young Indian men came here and wanted to talk with me. They had gotten a grant to set up a Native American theater from the Rockefeller and the Ford foundations. They wanted to do it here.

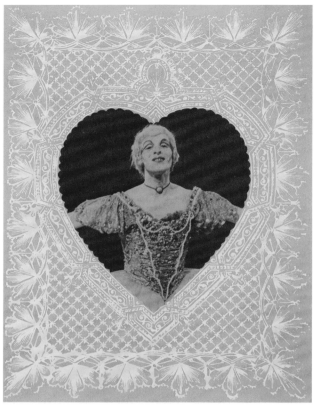 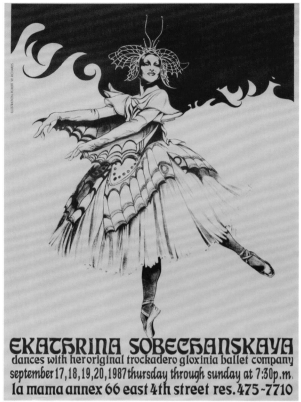

12.5" × 9.5" 20" × 14"

FIGS. 68 and 69: *Ekathrina Sobechanskaya Dances with her Original Trockadero Gloxinia Ballet Company.* Program for the 1974 produc-
tion, which premiered on Valentine's Day, and the poster for the September 1987 production. Program design by Mel Byars with a
photograph by Roy Blakey made to look like a farcical Valentine's Day card constructed of crocheted lace or a paper doily. Poster illus-
tration by Robert W. Richards. One-color line rendering based on a photo of director-choreographer and "prima ballerina" Larry Ree for
the poster by Roy Blakey. The typography and style of the poster mocks the traditional graphic art representations used for Russian
classical ballet.

In 1972 NATE premiered two works at La MaMa: *Body Indian*, directed
by John Vaccaro and written by playwright Hanay Geiogamah, a Kiowa-
Delaware native from Oklahoma, and *NA HAAZ ZAN*, written and di-
rected by Navajo playwright Robert Shorty. The works toured U.S. colleges
and Indian communities following their premieres at La MaMa. The first
published collection of Native American plays, *New Native American Drama*
(1980), is dedicated to Ellen Stewart. Geiogamah worked in Senator Edward
Kennedy's office on drafting a proposal to develop programs that would create
a new national Indian identity. With this mission in mind, Geiogamah was
the first to envision "an organic Indian theatre company." Robert Shorty was
encouraged and supported in his writing and direction of *NA HAAZ ZAN*
by Lee Breuer of Mabou Mines, who was a La MaMa resident director at this
time. His play is based on Navaho creation myths.

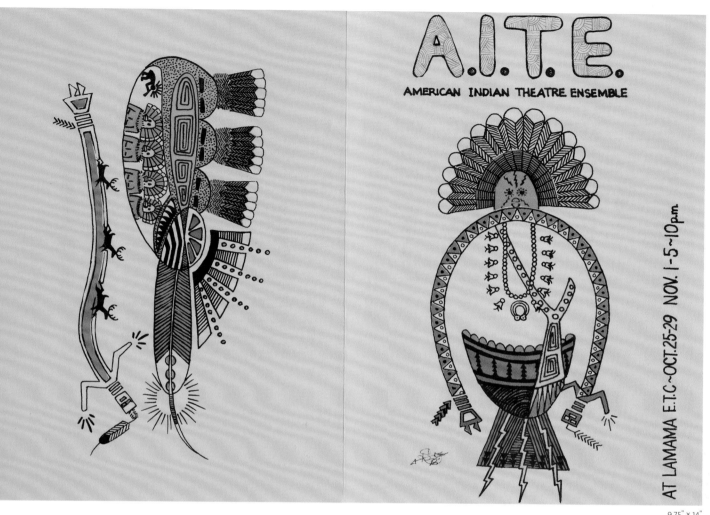

A.I.T.E.
AMERICAN INDIAN THEATRE ENSEMBLE

AT LAMAMA E.T.C.~OCT.25-29 NOV. 1-5~10pm

9.75" × 14"

Wu Jing-jyi and Ching Yeh from Taiwan served as directors of La MaMa Chinatown, a resident company of La MaMa that later evolved into the Pan Asian Repertory Theatre, directed by Tisa Chang. Numerous Asian American artists and theater companies were an outgrowth of La MaMa Chinatown, including H. T. Chen and Dancers, the National Asian American Theatre Company, and the Ma Yi Theatre Company.

The Dowager was a CETA production. CETA (Comprehensive Employment and Training Act) was a federal jobs program that subsidized unemployed artists and not-for-profit arts programs, with the goal of enriching cultural resources on the community level. These kinds of government subsidies for the arts had not been instituted in the United States since the WPA in the 1930s, a program upon which CETA was modeled.

FIG. 70: Program for American Indian Theatre Ensemble productions of *Body Indian* and *NA HAAZ ZAN*, which opened at La MaMa on October 25, 1972. Program illustrations by Robert Shorty, who wrote and directed *NA HAAZ ZAN*. The illustrations are finely drawn and full of rich detail, with colorful renditions of man and animals from the creation story told in *NA HAAZ ZAN*.

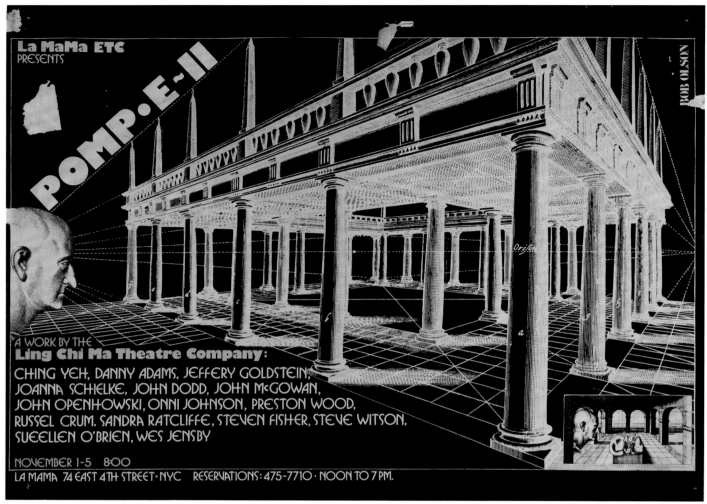

La MaMa ETC PRESENTS

POMP·E·II

BOB OLSON

A WORK BY THE
Ling Chi Ma Theatre Company:
CHING YEH, DANNY ADAMS, JEFFERY GOLDSTEIN,
JOANNA SCHELKE, JOHN DODD, JOHN McGOWAN,
JOHN OPENHOWSKI, ONNI JOHNSON, PRESTON WOOD,
RUSSEL CRUM, SANDRA RATCLIFFE, STEVEN FISHER, STEVE WITSON,
SUEELLEN O'BRIEN, WES JENSBY

NOVEMBER 1-5 8:00
LA MAMA 74 EAST 4TH STREET·NYC RESERVATIONS: 475-7710 · NOON TO 7 PM.

17.5" × 23.75"

FIG. 71: *Pompeii*, directed by Ching Yeh. Photostat poster by Bob Olson. La MaMa opening: November 1, 1972.

In 1975 Ellen Stewart took on the role of director for the first time. Calling herself a stager and working alongside choreographer Larl Becham, Stewart conceived an evening of black popular entertainment that evoked the fascinating rhythm and blues of Harlem's renowned Cotton Club, circa the late 1920s. For this show, Stewart sought out the legendary tap dancers known as "the original hoofers" (including Chuck Green and Buster Brown) and invited them to participate in a gala reunion performance on her stage. The *Cotton Club Gala* was replete with leggy chorus girls, smoky blues singers, and variety acts. Stewart transformed the Annex space into a cabaret — theater seats were removed and replaced by café tables set with linen at which audience members sat, ordered coffee, and at intermission got up to dance, accompanied by the

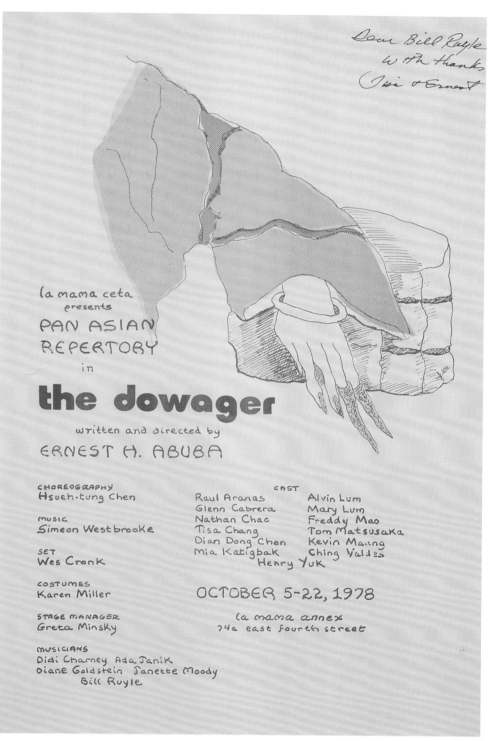

Dear Bill Royle
with thanks
Tisa & Ernest

la mama ceta
presents
PAN ASIAN
REPERTORY
in

the dowager

written and directed by
ERNEST H. ABUBA

CHOREOGRAPHY
Hsueh-tung Chen

MUSIC
Simeon Westbrooke

SET
Wes Cronk

COSTUMES
Karen Miller

STAGE MANAGER
Greta Minsky

MUSICIANS
Didi Charney Ada Janik
Diane Goldstein Janette Moody
Bill Royle

CAST
Raul Aranas Alvin Lum
Glenn Cabrera Mary Lum
Nathan Chao Freddy Mao
Tisa Chang Tom Matsusaka
Dian Dong Chen Kevin Maung
Mia Katigbak Ching Valdes
 Henry Yuk

OCTOBER 5-22, 1978

la mama annex
74a east fourth street

17" × 11"

FIG. 72: *The Dowager,* presented by the Pan Asian Repertory, written and directed by Ernest H. Abuba. Poster signed "J. Wu." La MaMa opening: October 5, 1978.

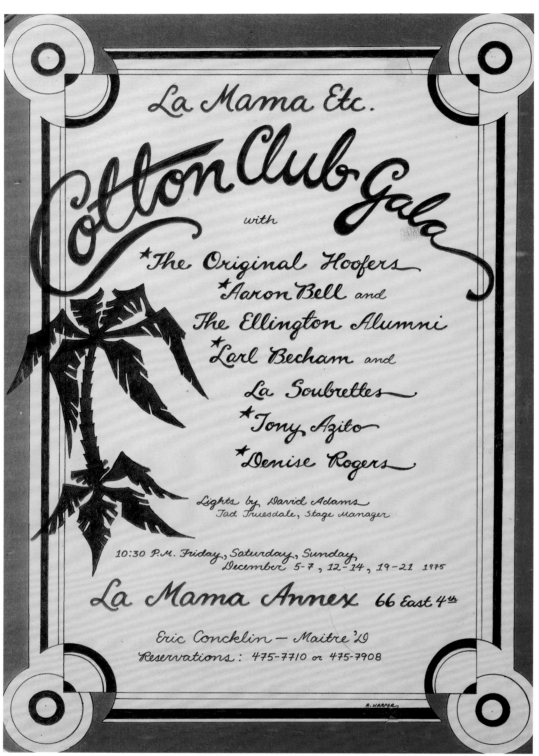

28" × 20"

FIG. 73: *Cotton Club Gala*, conceived and directed by Ellen Stewart, choreographer
Larl Becham, conductor, Aaron Bell. Poster design: Annette Harper, 1975.

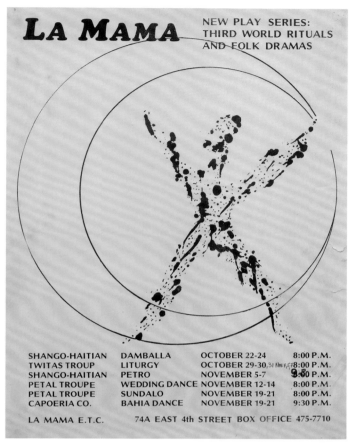

SHANGO-HAITIAN	DAMBALLA	OCTOBER 22-24	8:00 P.M.
TWITAS TROUP	LITURGY	OCTOBER 29-30,31 Nov 1, 5	8:00 P.M.
SHANGO-HAITIAN	PETRO	NOVEMBER 5-7	9:30 P.M.
PETAL TROUPE	WEDDING DANCE	NOVEMBER 12-14	8:00 P.M.
PETAL TROUPE	SUNDALO	NOVEMBER 19-21	8:00 P.M.
CAPOERIA CO.	BAHIA DANCE	NOVEMBER 19-21	9:30 P.M.
LA MAMA E.T.C.	74A EAST 4th STREET BOX OFFICE 475-7710		

23.5" × 17.5"

FIG. 74: New Play Series / Third World Rituals and Folk Dramas. These were TWITAS productions. October-November 1976.

big-band sound of conductor Aaron Bell and his Ellingtonians. Because of its popularity after its initial run, beginning January 17, 1975, the *The Cotton Club Gala* was scheduled for two additional runs at La MaMa in 1975; Tony Azito, a La MaMa alumnus, originated the role of the dapper emcee, which was later assumed by Tony Award winner Andre de Shields. The show toured France, Austria, Germany, England, Holland, and Italy in 1976. The International Theatre Institute of the United States (ITI) designated this production an "American Revolution Bicentennial theatre event." Martha Coigney, director of ITI, described *The Cotton Club Gala* as "an extraordinary living record of the performing genius of Black Americans."

An important development in Stewart's mission to foster cross-cultural exchange was the establishment of the Third World Institute of Theatre Arts Studies (TWITAS) with Philippine artist Cecile Guidote-Alvarez, who directed TWITAS from 1971 to 1986. The organization was founded to connect multicultural companies in the United States (such as the Native American Theatre Ensemble and the Pan Asian Repertory Theatre) with international

artists and companies both at La MaMa in New York and at international sites. The goal was creative collaborations between disparate groups from around the world. TWITAS frequently worked in conjunction with the International Theatre Institute and Martha Coigney, who was a strong advocate for TWITAS projects and programs.

HARVEY FIERSTEIN (excerpt from a film interview, courtesy of the La MaMa Archive, 1987): The first time I met Ellen Stewart, we ran into each other in the lobby and I was in drag — I was in a play and I had red hair. She thought I was Rochelle Owens. She said, "Oh, Rochelle, you look wonderful." I didn't know who Rochelle was at that time. The next day she told me, "Mr. Fierstein, you have something very special. But you have to get rid of those bloomers and then you'll be okay." That went on for seven-eight years. That was the basis of our relationship — me putting on a dress, her trying to get me out of it. The first time I got out of a dress, I did a one-man show in the basement here. It was an evening of H. M. Koutoukas' poetry, *One Man's Religion / The Pinotti Papers* [January 1975]. The only way she would agree to let me perform in that piece was in men's clothing. She came and fitted me personally in a tuxedo. On opening night she came backstage and wiped the makeup off my face. She said, "I know you, Mr. Fierstein, you put on that tuxedo and you think you're Marlene Dietrich." And she wiped off the makeup and let me do my show.

ELLEN STEWART (2005): When I was a young girl, my mother created ball gowns for boys — you call them gay now — boys that dressed like women. This was in Chicago. The boys liked "teddies" the most. My mother made them bosoms and behinds. She made beautiful things. I made doll clothes out of the satin and lace scraps.

Harvey Fierstein transitioned from performer into playwright at La MaMa in 1978 with *International Stud*, a play that was named after a gay leather bar in the West Village. A landmark in gay theater history because of its wide appeal to mainstream as well as gay audiences, this possibly autobiographical play explored how a gay man (played by the inimitable Fierstein — his voice was described as evoking a "truck driver in drag") negotiated the trials and tribulations of a love affair with a bisexual man. *International Stud* consisted of short scenes and monologues that were interlaced with torch songs of the

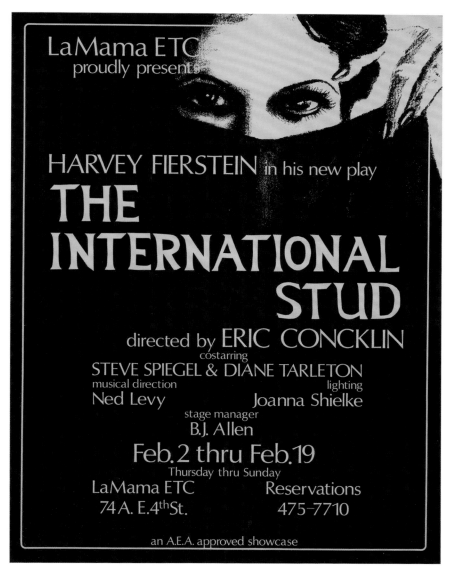

LaMama ETC
proudly presents

HARVEY FIERSTEIN in his new play

THE
INTERNATIONAL
STUD

directed by ERIC CONCKLIN
costarring
STEVE SPIEGEL & DIANE TARLETON
musical direction lighting
Ned Levy Joanna Shielke
stage manager
B.J. Allen

Feb. 2 thru Feb. 19
Thursday thru Sunday
LaMama ETC Reservations
74 A. E.4thSt. 475-7710

an A.E.A. approved showcase

20" x 15"

FIG. 75: *International Stud*, written by and starring Harvey Fierstein; poster by Churchill Rifenberg, graphic on poster from a photo of Fierstein by KISCH. La MaMa premiere, February 2, 1978.

1920s and 1930s sung live by a female singer with piano accompaniment. This was the first play in Fierstein's critically acclaimed *Torch Song Trilogy*; all three plays premiered at La MaMa and were directed by Eric Concklin. Stewart brought *International Stud* back for an additional run within a month of its closing; the production then moved directly Off-Broadway to the Players Theatre. *International Stud*, *Fugue in a Nursery*, and *Widows and Children First* were ultimately produced as one evening (*Torch Song Trilogy*) on Broadway. The play won the Tony Award for Best Play and the Drama Desk Award for Outstanding New Play in 1983.

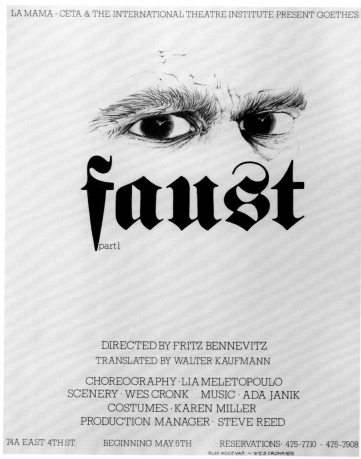

LA MAMA - CETA & THE INTERNATIONAL THEATRE INSTITUTE PRESENT GOETHE'S

faust
part1

DIRECTED BY FRITZ BENNEVITZ
TRANSLATED BY WALTER KAUFMANN

CHOREOGRAPHY · LIA MELETOPOULO
SCENERY · WES CRONK MUSIC · ADA JANIK
COSTUMES · KAREN MILLER
PRODUCTION MANAGER · STEVE REED

74A EAST 4TH ST BEGINNING MAY 5TH RESERVATIONS: 475-7710 - 475-7908
RUDI KOCEVAR — WES CRONK 4/78

16.75" × 13"

FIG. 76: *Faust Part 1*, directed by Fritz Bennewitz. Rudy Kocevar and Wes Cronk poster artists. Kocevar drew the piercing image of the upper half of the face on the poster. He was also a playwright and set designer at La MaMa. Cronk was the typographer of this poster and also a set designer at La MaMa.

The acclaimed East German director of the National Theatre of Weimar, Fritz Bennewitz, was invited by Ellen Stewart to direct a TWITAS production of Brecht's *Caucasian Chalk Circle* at La MaMa in 1977. The production featured a large, multiracial, international cast. For his second production at La MaMa, *Faust Part 1*, Bennewitz worked with La MaMa CETA performers and cast African American actresses in the leading roles of Gretchen and Martha. As Gretchen, Christine Campbell felt the production broke through "the walls of racism." For his production of *Faust Part 1* Bennewitz used Princeton University professor Walter Kaufman's translation. The production toured to Princeton University following its La MaMa run.

Ellen Stewart first introduced U.S. audiences to the work of Polish director Tadeusz Kantor and his company, Cricot 2, in 1979. Kantor's first production at La MaMa, *The Dead Class*, won an Obie Award but remained relatively "under the radar" with the exception of a core group of critics, academics, and devotees of experimental theater who raved about the production. In Kantor's

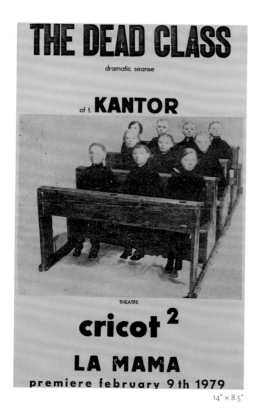

THE DEAD CLASS

dramatic seanse

of t. **KANTOR**

THEATRE

cricot ²

LA MAMA

premiere february 9 th 1979

14" × 8.5"

FIG. 77: *The Dead Class*, Cricot 2.
Directed by Tadeusz Kantor. La MaMa
premiere, February 9, 1979.

theatrical landscapes, ghostlike humans and militaristic marionettes enact brutal and sexual violence brought about by war. Theatrical action is heightened by the stunning, disturbing imagery created by objects and fragments from Poland's fraught past. Kantor sets his rhythmic and balletic nightmare-visions to music, which functions as a relentless counterpoint to the action. For *The Dead Class*, as in all of his productions, Kantor, who was first a renowned and highly provocative painter and creator of site-specific installations, placed himself on the stage during performances. He was sometimes a still witness and sometimes a bunraku-esque puppeteer, shaping and manipulating the actors and the action, while imperceptibly signaling sound cues. In *The Dead Class* an assemblage of ancient men and women maniacally parade on stage to sit at school benches. Strapped to their backs are mannequins of themselves as young students with which they endlessly struggle. The obsessive repetition of these images renders them unforgettable. Each of Kantor's plays performed at La MaMa received a larger and more enthusiastic reception than the last. These were *Wielopole, Wielopole* (1982), which also won an Obie Award, *Let the Artists Die* (1986), and *I Shall Never Return* (1988), which was the title Stewart chose for this work of Kantor's. Kantor's last play, *Today Is My Birthday* (1991), was produced posthumously at La MaMa by the Cricot 2 company. Kantor died in Poland, December 7, 1990.

FIG. 78: Ellen Stewart, 1981.
Yutaka Higashi, photographer,
courtesy of La MaMa Archive.

THE 1980s

"Ellen Belongs to Everywhere"

In the 1980s, Stewart's impact on international theater continued to grow — by encouraging exchange between artists of different countries and by continuing to present artists from around the world in New York. Stewart and La MaMa were formally recognized for and supported in these efforts, receiving numerous awards and grants from public and private funding organizations. Peter Brook presented his works with the CIRT (Centre International de Recherche Théâtrale), *L'Os/Ubu*, *The Ik*, and *The Conference of the Birds*, at La MaMa in 1980. In 1981 Stewart received a Special Obie Citation for the three-month festival that marked La MaMa's twentieth-anniversary celebration, during which La MaMa presented plays from its first two decades. In 1985 Stewart was awarded the prestigious MacArthur Fellowship (colloquially known as the "genius" grant). Along with Stewart, critic Harold Bloom, choreographer Merce Cunningham, and poet John Ashbery were among the recipients, who, according to the MacArthur Foundation's statement, are "outstandingly talented and creative people," who could use the grant "to pursue whatever they feel is important and relevant." Stewart used the fellowship to fund the creation of a center for artists near Spoleto, Italy. La MaMa Umbria International became the site of La MaMa's annual summer directors,' actors', and playwrights' workshops beginning in 2000, which were organized by Stewart, Mia Yoo, and David Diamond.

Dario D'Ambrosi, a performer, director, playwright, and filmmaker, founded a theatrical movement called *teatro patologico*, or pathological theater. He works extensively with the mentally disabled and seeks to illuminate and examine their perspectives through his art; he often features disabled actors in productions. D'Ambrosi cites aesthetic influences on his work as diverse as Antonin Artaud, George Bataille, and commedia dell'arte.

FIG. 79: Ellen Stewart and Peter Brook at *The Conference of the Birds*, 1980. Henry Grossman, photographer, courtesy of La MaMa Archive.

DARIO D'AMBROSI (2005): Ellen looks at theater in very, very simple ways. If you have no money, she would say, what costumes can we find? If we don't have lights, we can perform during the day. She enjoys making theater — almost like a child. I love that childlike philosophy she has. She is always fresh with the work, enjoys it day after day.

Ellen Stewart was an early, enthusiastic supporter and presenter of the work of butoh artists in New York in the 1980s. Audiences at La MaMa were among the first in the United States to witness several of the legendary butoh masters onstage. Terayama's *Directions to Servants*, a "stunningly grotesque" theatrical work (according to John Corry in his *New York Times* review), contained dance elements that would later be recognized as derived from butoh. Critic Thomas Ryan wrote: "It marries violence and erotics with energy and precision, giving us a series of images which are often uncomfortable, always exciting and usually beautiful . . . a little as if Genet were being performed by the inmates of Charenton under the direction of the Ballet des Trocadero with a dash of Kung Fu."

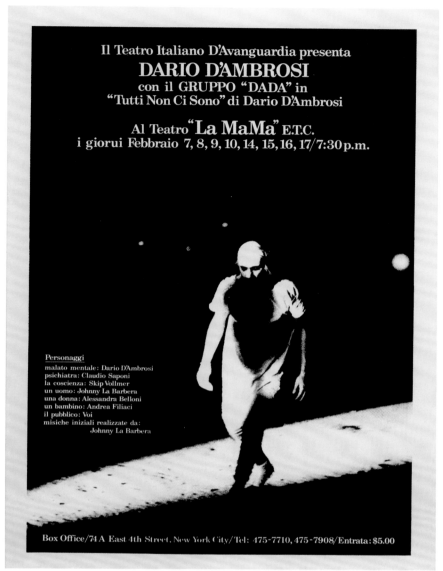

FIG. 80: Dario D'Ambrosi's production of *Tutti Non Ci Sono* (*All Are Not Here*), poster unattributed. La MaMa opening, February 7, 1980.

Inspired by Artaud's manifestos on the Theater of Cruelty, Terayama published his own manifesto in the program to *Directions to Servants.*

MANIFESTO: In order to give meaning to his stage presence, the actor must be able to invent his own language. In order to express a magical situation, he must possess the power, for instance, to jump without feet.

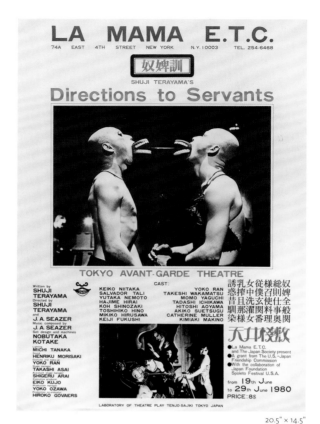

20.5" × 14.5"

FIG. 81 (*right*): *Directions to Servants*, written and directed by Shuji Terayama. Photos on poster by Terayama.

FIG. 82 (*below*): An unattributed poster commemorating the seventy-fifth birthday celebration in honor of Samuel Beckett, presenting his new play, *Rockaby*, with poster photo of Beckett by Guy Suignard.

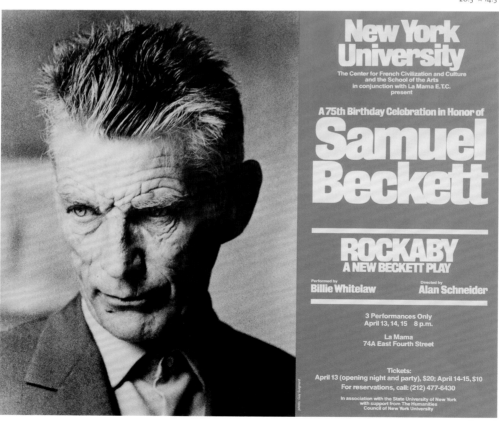

17" × 20.5"

La MaMa presented the New York City premiere of Samuel Beckett's *Rockaby* with British actress Billie Whitelaw, directed by Alan Schneider. The production, celebrating Beckett's seventy-fifth birthday, was coproduced with New York University and SUNY Buffalo. In the *New York Times* Mel Gussow writes: "As an intuitive emotional experience, 'Rockaby' is overpowering, hypnotizing the audience in its spotlighted gaze, but, in common with all of Beckett's plays, it also has narrative and intellectual substance, some of it subliminal. . . . From the opening second, we cannot avert our eyes from the actress and her 'famished eyes.'"

An international pioneer of butoh dance, Kazuo Ohno gave his first U.S. performance in the summer of 1981 when he presented his important works *My Mother* and *Admiring La Argentina* at La MaMa. Ankoku butoh ("the dark dance") is a Japanese modern dance form first developed by Tatsumi Hijikata. Ohno originally created his butoh works in response to the horrors of World War II, which he experienced firsthand as a Japanese intelligence officer and later as a prisoner of war. Renowned as a solo performer, Ohno's work has been described by international critics as "ethereal, feminine, and ecstatic." Ohno, who last performed publicly in 2007, and died in 2010 at age 103, "frequently reduced his audiences to tears."

———————

PING CHONG (2012): Ellen loved *A.M./A.M.* There was a voice-over at the top of the show, which was a quote from the Bible. It was Christ in the Garden, before he was crucified. That was all the text there was in the show. When I see Ellen's work, I see why she loved *A.M./A.M.*—it's visual, it's musical, it's kinesthetic. She would have loved *Angels of Swedenborg* (1985/2011). I'm sorry she didn't get to see that.

———————

Humboldt's Current was the first production of Ping Chong's Fiji Company at La MaMa, in 1978. The premier won an Obie Award when it was produced at Lee Nagrin's Studio in 1977.

———————

PING CHONG: I first met Ellen when I was working with Meredith Monk's company on *Quarry*. In the seventies I had a very close relationship with Lee Nagrin, an older friend who was a theater person. It was Lee that brokered the meeting with Ellen to do my work. Although I met Ellen through Meredith Monk, it was Lee who made it possible for me to do my work at La MaMa.

La Mama ETC
presents

KAZUO OHNO

First American
performances ever
by the seventy-five
year old master
and legendary
father of Japanese
avant-garde dance

'This is a poetry
more than poetry'
- poet
Kazuko Shiraiashi

JULY 28 - AUGUST 2
at 8:00p.m.

LA MAMA
74A East 4th Street
New York City

$8 TDF accepted
Information &
reservations
212/475-7710
475-7905

Photo: Ikegami

Two Programs:

July 28,29 & August 1
- 'Admiring La Argentina'

July 30,31 & August 2
- 'My Mother'

Assisted by Dance Theater Workshop, Inc.

16" × 11"

FIG. 83: *My Mother* and *Admiring La Argentina* by Kazuo Ohno.
Photograph on poster by Ikegami. La MaMa premiere: July 28, 1981.

MADE POSSIBLE BY GRANTS FROM THE NATIONAL ENDOWMENT FOR THE ARTS, THE NEW YORK STATE COUNCIL ON THE ARTS, & MEET THE COMPOSER.

PING CHONG'S
A.M./A.M.

A New Theater Work Presented By
La MaMa E.T.C. And The Fiji Company
Including New Music By Meredith Monk
At La MaMa 74A East 4th Street

PREVIEWS: Jan 23, 24, & 27 at 7:30 PM
Admission $7 or TDF plus $3

OPENING: Jan 28 at 7:30 PM

PERFORMANCES: Jan 28-30 at 7:30 PM
Jan 31 at 3 PM & 7:30 PM
Feb 3-6 at 7:30 PM
Feb 7 at 3 PM & 7:30 PM
Admission for all performances
$6 or TDF plus $4

RESERVATIONS: 475-7710 or 475 7908

6.75" × 20.75"

I was afraid of Ellen, at first. She was a powerful, known person. I was very young, timid, and not very assertive. I was insecure. I knew La MaMa as an important venue. I was never any good at putting myself forward. Mama is very casual. We met. It was brief. If she were here today she'd say her "beeps" went off and she knew that I was going to make it. She said that all the time. She said, "I had to push him." That was Mama's take on it.

Once you're in Mama's door, you're one of Mama's babies. She really loved Asians. But until the battles of multiculturalism were fought in the eighties, I would never have gotten a leg up if it weren't for Mama. I still say, to this day, it's a white theater world — including the downtown avant-garde scene.

Mama was a pioneer in all kinds of ways. In terms of bringing international theater to New York, she was ahead of her time. She was ahead of her time in terms of cross-dressing and gender bending. She was completely open. If you were as crazy as the hills, she gave you a shot if you thought you could do something. Mama would let you fail. She was amazing. But she was so informal. There were never contracts; it was all done on a handshake.

Once Ellen took you in and once she respected your vision, then you were just part of the family. There was no pressure to be someone else. Mama never made demands of any kind. I understand she has gone into other people's shows and functioned in an editorial way, but I never saw that. She never once came in and said, "You know, you should change that." Never.

The seventies was a very strong time for La MaMa in terms of who was there. There was a decline in the late 1980s and 1990s. It's amazing that La MaMa survived the nineties. I never understood how La MaMa survived.

FIG. 84: Ping Chong designed this poster for his production of *A.M./A.M.*, which opened January 28, 1982.

East Fourth Street has really become a downtown theater row — and Mama was the first one there. There was no theater on East Fourth Street until Mama was there — except for Club 82, and that was a gay strip club — a nightclub [it featured lavish club revues performed by female impersonators]. Fourth Street was a pretty grungy street when Mama moved in.

I was a stable artist at La MaMa, but I also had an independent life outside, which I think Mama respected. I wasn't hanging on to her skirts. I would never want that. She had invited me out to La MaMa Umbria for the longest time, but I just wouldn't go. I'm an urban person, I'm used to autonomy. I said to her, "I can't get around there. I'm going to be claustrophobic." I don't drive. Finally she convinced me to go and I loved it. When I was in Umbria I saw more of Mama than I normally do. Usually, here, I see her and I say, "Mama, have you got availability in December?" In Umbria I was around her all the time and she was so loving to me. I was so moved. She put me up in the best apartment. And I saw how the inner family was. It was so beautiful. It's not about you, about yourself. Students are there, but it's about serving. I've told Mama, and I said it at an awards ceremony when I presented Ellen with an award a few years ago, "I wouldn't be anywhere if it weren't for you, Mama." And it's true.

The Ping Chong and Company offices have been in La MaMa's rehearsal building on Great Jones Street for over twenty years. For most of that time, the rent never went up. Mama was always about being inclusive. It's no surprise to me that a black woman supported a Chinese boy. As far as I'm concerned, this society is still incredibly bigoted and biased. Of course she had her prejudices — "No green in the theater!"— but they weren't like that. She looked at individuals; she didn't look at race.

———————

ELLEN STEWART: (2003) Why I don't like green . . . no green lights, no green costumes. It was bad luck. I learned this from people who had worked in London during the vaudeville days. And on the few occasions when there has been some green onstage, it has been disastrous. People who have worked here with me have adopted this aversion to green.

————

La MaMa archive director Ozzie Rodriquez explains that the rationale behind Stewart's prejudice against green was her understanding that green makeup historically contained lead and therefore was poisonous. A green light was used in minstrel shows in the nineteenth and early twentieth centuries

to accentuate "blackness"—it heightened the contrast between blackface makeup and the white makeup used for eyes and lips.

PING CHONG: Like Mama, I love diversity, exploring different cultures and languages. I'm fascinated by difference, as opposed to being threatened by it. She was nurturing in a very simple way to me: she gave me access to a place I could work.

The most important thing to keep in mind as we grow Mama's legacy is that she was above all generous in spirit and inclusive, as opposed to exclusive. If you look at the history of the world — that has always been the problem. The other thing I want to say about Mama is that she was very empathetic to those that did not fit into society and to people who needed direction in their lives. I've spoken to people whose lives were completely changed by her.

ELLEN STEWART (2003): My work is everybody's — it belongs to everybody. There were blacks who wanted me to do black theater only. But Amiri Baraka loved me.

Celebrated and controversial poet, activist, and Obie Award–winning playwright Amiri Baraka was a leader of the Black Arts movement in the 1960s (he was known then as Le Roi Jones). Baraka left the downtown New York arts scene to join forces with black nationalists in Harlem in the mid-1960s. His acclaimed short plays *Dutchman*, *The Slave*, and *The Toilet*, while not produced at La MaMa, were presented at East and West Village venues. By the 1970s, however, Baraka had established himself in Newark, New Jersey, where he engaged in community activism, worked for educational reforms, and supported African Americans in politics. Baraka taught at George Washington University, Rutgers University, and at SUNY Stonybrook in the 1980s and published widely on African American music and particularly jazz. *Money: A Jazz Opera* was created in collaboration with composer George Gruntz; Baraka wrote the libretto.

AMIRI BARAKA (2005): Ellen was very, very free and open, but at the same time, she was determined to do things her own way. It was an inter-

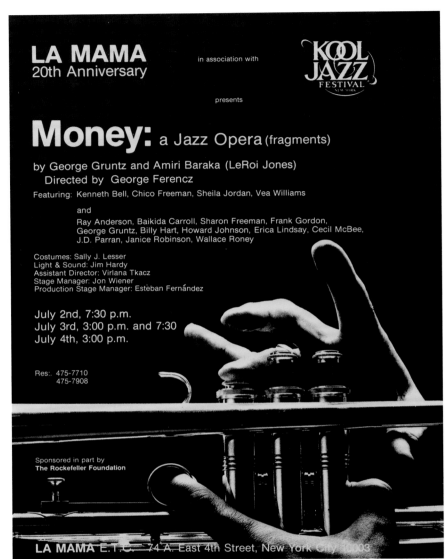

LA MAMA
20th Anniversary

in association with

KOOL JAZZ FESTIVAL NEW YORK

presents

Money: a Jazz Opera (fragments)

by George Gruntz and Amiri Baraka (LeRoi Jones)
Directed by George Ferencz

Featuring: Kenneth Bell, Chico Freeman, Sheila Jordan, Vea Williams

and

Ray Anderson, Baikida Carroll, Sharon Freeman, Frank Gordon,
George Gruntz, Billy Hart, Howard Johnson, Erica Lindsay, Cecil McBee,
J.D. Parran, Janice Robinson, Wallace Roney

Costumes: Sally J. Lesser
Light & Sound: Jim Hardy
Assistant Director: Virlana Tkacz
Stage Manager: Jon Wiener
Production Stage Manager: Estèban Fernández

July 2nd, 7:30 p.m.
July 3rd, 3:00 p.m. and 7:30
July 4th, 3:00 p.m.

Res:. 475-7710
 475-7908

Sponsored in part by
The Rockefeller Foundation

LA MAMA E.T.C. 74 A. East 4th Street, New York City 10003

11" × 8.5"

FIG. 85: Amiri Baraka's *Money:
A Jazz Opera (fragments)*, presented
in honor of La MaMa's twentieth
anniversary in association with
the Kool Jazz Festival. La MaMa
premiere: July 2, 1982.

esting contradiction. It gave people the sense that with Ellen they could do
whatever came into their minds as long as it wasn't in conflict with what
was in Ellen's mind. She was unbelievably productive. She'd give you a space,
tell you, "Now this is what I expect — go!" It wasn't anarchy. . . . With that,
nothing happens, except maybe Happenings. You have to set a form or a
direction for the whole thing, and that's what Ellen did. She was producing
work from all over the world. There were misses and hits.

Many things happened that no one found out about. She was all over the
place. But this was a very positive thing. Broadway and Off Broadway were
like penitentiaries that depended on private money. Ellen depended on

grants, of course, but she always had a kind of personal integrity and a personal need to do what she had to do. I think it would be very, very difficult for Ellen to start something up now, in this period of time. Back in the sixties there was an opening up, a space for work that we don't have today.

Village Voice critic William Harris, writing about John Jesurun's *Red House* in 1984, describes "this 33-year-old sculptor and filmmaker by training . . . as the most original conceptualist now working in experimental theater." He describes *Red House* as "an electronic morality tale" with many of Jesurun's "stylistic trademarks: fragmented dialogue, repetitions, witty non sequiturs and pop culture references, often spoken by tape recorders and video monitors to the performers onstage; a startling use of space, playfully cinematic, disorienting, and vibrating with a sense of motion even when the actors are standing still." *Red House* was a departure for Jesurun in its focus on rock culture and its use of a live band. *Dog's Eye View* was Jesurun's first production at La MaMa, in January 1984. With *Red House* Jesurun's goal seemed to be "a heightened sense of claustrophobia," according to critic Catherine Bush. Jesurun is the recipient of a Guggenheim Fellowship and a MacArthur Fellowship (1996), among other prestigious awards.

JOHN JESURUN (2013): I didn't know too much about La MaMa — I didn't study theater. I studied art — painting and sculpture. That was my background. I got into doing films while I was getting an MFA in sculpture at Yale. Making a poster was part of the work I did. Making posters was how we got people to see the work. I was making short films, but because they were so expensive, it became very frustrating, so I decided instead to stage film. It was a crazy experiment. We staged a different episode every week; we wanted it to look like film or television. The language was very cinematic. I think some theater people were completely horrified by it.

In 1983 I was doing my serial show, *Chang in a Void Moon*, at the Pyramid Club on Avenue A and Seventh Street. This was the show with which I made my mark. It was always packed with people. Ellen wanted to know what was going on there. All of a sudden people were saying, "Ellen Stewart is here, Ellen Stewart is here." A ripple went through the crowd. People were shocked that she showed up there. Avenue A was pretty rough at that time. She was one of the first people to recognize that something important was happening — it wasn't just drugs and drag queens. John Kelly was in the show, as was Ethyl Eichelberger, Steve Buscemi. After Ellen came to a performance, she said she'd love to have me do something at La MaMa.

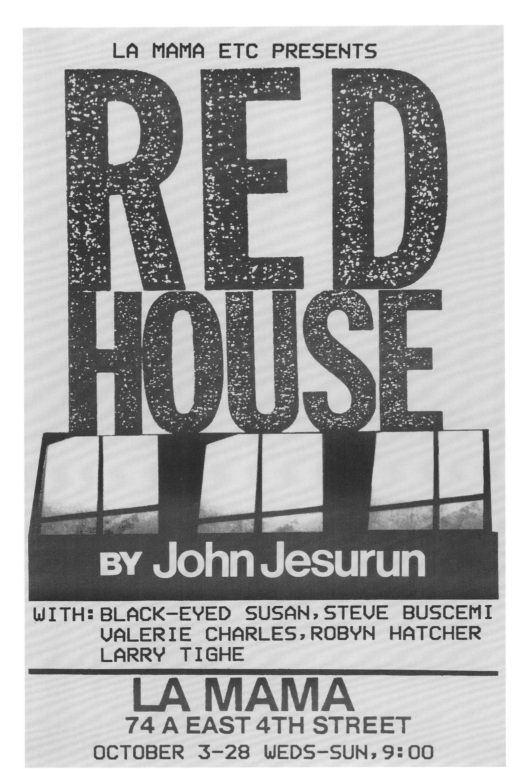

21.5" × 13.5"

FIG. 86: *Red House* poster designed by playwright and director John Jesurun.
La MaMa opening, October 3, 1984.

Red House was the first play I worked on with Black Eyed Susan, who was a big name at the time — a downtown icon. This might have been the first time Black Eyed Susan had been in a play by somebody else. Steve Buscemi and Valerie Charles, too, were a powerhouse duo. Larry Tighe was another of my main actors at the time. *Red House* was a kind of signature piece for me.

I designed all the posters for my plays. It was cheaper that way. I had a knack for doing it. It seemed like a waste of time to explain to people what I wanted when I could do it myself at home. I made the posters very quickly. There was no money involved. They were "downtown" looking or crude looking. But that was the aesthetic anyway. They were pretty basic. It was handwork. We used letters that you would buy and cut out and paste up.

For the *Red House* poster, I remember using the images of the windows, which were cut out of a contact sheet to look like a film strip. It looks as if it is moving a little bit. I got advice on this from all sorts of people about what the poster should look like. Using a different typeface for every element on the poster — the play title, the actors' names — definitely related to my work — which includes many different elements. The letters R-E-D H-O-U-S-E look the way they do, made up of large dots, because I blew them up really large. But this actually fit the play quite well because in the first scene there is a big snowstorm outside the bar where the action takes place. It wasn't deliberate, but as I blew it up I saw that I liked it. It looked like snow. What looks like Magic Marker is actually type letters from a very strange typewriter I bought. It was cheap — a kind of an early computer — a word processor type of thing. It gave an early computer/digital look to the type it produced. The type would actually burn into the paper — there was no ink in it. You had to buy a special kind of heat-sensitive paper for it. Whenever I see that lettering I can always identify what time of my life it was from. It marked those few years when I had that typewriter.

At the very bottom of the poster I cut the lettering off of another La MaMa poster and pasted it on. When I look now at the *Red House* title it looks very childish to me, but also animated. I think this kind of poster was not, generally, the kind of poster people were making at the time. I think there might have been people who were horrified by the poster. But not Ellen — she said, whatever you want, baby.

The sound element was very important in *Red House*. The show had a band in it. I didn't list the band members on the poster. I didn't list the composer's name. I think I left the names out because I made the poster so quickly. I always try to give everyone credit.

I am pretty sure I took the poster over to a printing place way west in the thirties — a crazy printing plant that would print up a lot of things very

quickly and you didn't worry about detail very much. There were no comments, no drama there. It was an industrial kind of place, ridiculously cheap. I went there for a number of my shows, starting in 1983. It was fun to go to this crazy place, and it worked perfectly. I remember someone at La MaMa saying, "Why don't you silkscreen it?" "Silkscreen!?" I said. "We don't have enough money for that. Are you kidding me?"

I didn't do the poster for the last show we did at La MaMa—Discovering Oz did it. *Stopped Bridge of Dreams*. It was very nice, but not really my style at all.

I remember getting a computer in '88 or '89. There wasn't much you could do graphically on it yet. But I did have an assistant who was already starting to explore these things and make them go faster. I think it wasn't until the nineties that things really changed. I think by then my posters and others' began to have a cleaner look to them. The letters are all printed out on a computer by that time — there was consistency. Things started to shift for me around that time. I wanted things to move faster. I wanted a faster computer — I welcomed the technology and the digital age because it helped me do the work quicker. But, of course, there are so many people now that have no idea how much work it took to make some of this stuff. What takes me ten minutes now would take me ten hours then. People are getting further and further away from the physicality of it. They don't work with their hands. Everyone is so clean now. I find it worrisome. . . .

My work is very different from what they did at La MaMa, but Ellen never doubted me. She always said to me, "Do exactly what you want and don't let anybody get in your way." She said she never knew what I was doing, she didn't understand it, but she believed what was there was interesting and important. So this was a great thing to remember. Because I have learned from that not to judge others' work. The point is to get a sense of it — you don't have to understand everything. So I was always grateful to her for that, for saying, just do whatever you want.

She never tried to change what I was doing at all. It was great to have someone who had that belief in you — when everything around you looks completely different from what you are doing. I never had any arguments with her — she always accepted my actors, too, who were not La MaMa actors at all. I think she enjoyed that these were outsiders, too. In 1986 we performed *Deep Sleep* in the Annex. It was my first Annex show. Steve Buscemi was in it. It was very successful. I remember actually only one argument with her — she thought a chair was green and I thought it was turquoise. In typical Ellen style, this was on opening night. Half an hour before we went up. She said to me — you could use any other chair, just not that chair. And

30.75" × 21.75"

FIG. 87: *Alpha*, Sławomir Mrożek, playwright; director, John Beary; poster artist: Visual Thinking. La MaMa opening: October 1, 1984. The flying figure in the illustration bears a striking resemblance to Polish leader and Nobel Prize winner Lech Wałesa. Poland has a rich and diverse history of achievements in poster art, beginning in the late nineteenth century and continuing through today.

I said I'm using that chair. So she said, "All right John, I love you. We'll just hope for the best." That was the only disagreement Ellen and I ever had.

La MaMa presented the first English-language production of *Alpha*, by Sławomir Mrożek, in conjunction with the Polish Theatre Institute, a New York–based performing arts organization. The play centers on the manipulation and subjugation of a captive leader of an unnamed country; the national hero strongly resembles Lech Wałesa.

ELLEN STEWART: Julian Beck called me "Mama." He did Beckett here. He was sick and bedridden, but he wanted to do the Beckett play. They had to tie him to a post so he could do it. All you saw was his face in the light; he was moving his lips. It looked as if he was floating very high up in the air. He felt very close to this place, to La MaMa.

FIG. 88: *Theatre I, Theatre II, That Time*, with Julian Beck, George Bartenieff, Fred Neumann. Gerald Thomas was the director and poster artist. La MaMa opening: March 6, 1985.

28" × 22"

LA MAMA E.T.C.
PRESENTS

The Talking Band in
BIG MOUTH

With William Badgett, Sheila Dabney
Ellen Maddow, Harry Mann, and
Paul Zimet

Written by Sidney Goldfarb
Directed by Tina Shepard
Sets and Masks by Mary Frank
(with Watoku Ueno and Barbara Pollitt)
Music by Ellen Maddow and Harry Mann
Costumes by Sally J. Lesser
Lights by Beverly Emmons
Stage Manager, Ruth Kreshka

APRIL 26-MAY 19
WED.-SUN. 7:30
LA MAMA 74A E. 4th ST. NYC
RESERVATIONS: (212) 475-7710 /475-7908
TICKETS $8.00

This production made possible in part by
The New York State Council for the Arts and
The National Endowment for the Arts

14" × 17"

FIGS. 89, 90, and 91: The Talking Band's *Big Mouth*, written by Sidney Goldfarb and directed by Tina Shepard. La MaMa opening: April 26, 1985. Poster design by visual artist Mary Frank, who also designed masks, scrolls, and panels for the production (with assistance from designer Barbara Pollitt). The central monochromatic image—black on white—is of two naked figures entwined, at the end of a road. They are framed in a rectangle that resembles a door frame. The style of the poster is spare, gestural. Poster printed by Ragged Edge Press. The drawing by Frank is of Paul Zimet and actors in rehearsal. Frank also designed the lion mask for the production, worn here by her husband Leo Treitler. Mary Frank is the recipient of two Guggenheim Fellowships, among other awards, and is represented by DC Moore, New York, NY and by Elena Zang, Woodstock, NY.

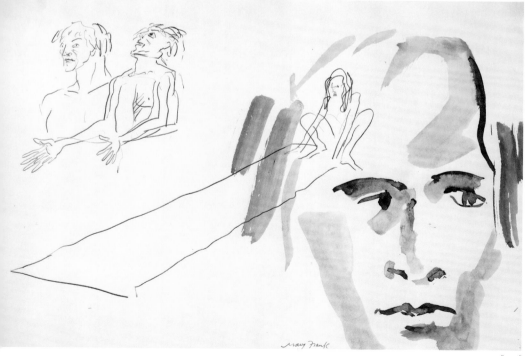

11" × 17"

Director, actor, playwright, and designer Julian Beck cofounded the Living Theatre with Judith Malina in 1947. The Living Theatre remains the longest extant avant-garde theater company in the United States. Beck, with veteran "downtown" theater artists George Bartenieff and Fred Neumann, performed in the American premiers of three Beckett plays at La MaMa, *Theatre I, Theatre II,* and *That Time,* directed by Gerald Thomas. Stephen Holden of the *New York Times* described the cast as "three patriarchs of experimental theater." Beck died of stomach cancer a few months after this run at La MaMa, at the age of sixty.

———————

PAUL ZIMET (2012): Mary Frank would come to a lot of our rehearsals. We knew her through Joe [Chaikin]. She would come to Open Theatre rehearsals, Talking Band and Winter Project rehearsals. And she would draw all the time. She would have us come up to her studio, too, and she would draw us. We were models for her sometimes. We had an ongoing relationship. This began in the late 1960s and early 1970s.

Most of the posters created in our first twenty to thirty years evolved out of working with a designer who was already involved in the production. This was the case with Mary — she designed the set and the mask for *Big Mouth.* The poster design refers to the use of framing on the set, which was a motif in the production. She made large, life-size figures out of cardboard and screens with landscapes on movable wooden frames. She also designed an incredible lion mask that I wore. It opened up and my face appeared inside.

———————

MARY FRANK (2013): The poster design for *Big Mouth* came out of the process of working on the play in the rehearsals with the actors. Making the masks that I made came about because of what I was seeing in rehearsal. I was often around La MaMa. The spaces at La MaMa were so beautiful. I think all the work I did in the theater had a big effect on my art work. I made sculptures that were based on things I saw in rehearsals or performances. When you draw the theater, you're not just drawing portraits. You're watching people kill each other. You see people in fits of jealousy and joy and doing very physical and emotional things that you don't get to see in real life.

———————

38" × 26"

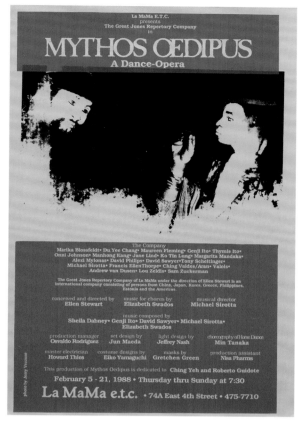

24" × 16"

ELLEN STEWART (2004): This [pointing to Paul Zimet] is one of my kids. I've told him from the first he was a great artist. . . . My kids are everybody here. They're the ones who will follow me, the ones who stay.

PAUL ZIMET (2004): "Nurtured" is the most appropriate word to describe how it is, working at La MaMa. I think of Ellen as family as well. She scolds me, she pushes me, she worries about me. Ellen sweeps her stage and the sidewalk outside her theater because she has such respect for her artists, for her audience, for her theater.

The Talking Band was founded in 1974 by Paul Zimet, Tina Shepard, and Ellen Maddow, who were members of the Open Theatre with Joe Chaikin in the 1960s and early 1970s. They continued to work with Chaikin on the

FIGS. 92 and 93: *Mythos Oedipus*, conceived and directed by Ellen Stewart. The International Meeting / Symposium of Ancient Greek Drama poster was designed by Jannis Voreadis, 1985. The figure of Oedipus (played by Min Tanaka, butoh dancer) appears at the base of the Greek ampoules on the poster. The New York premiere poster features a high-contrast Jerry Vezzuso photograph of actors Manhong Kang and Shelia Dabney, 1988.

Winter Project at La MaMa in the 1970s. Zimet, Shepard, and Maddow, hence, share one of the longest ongoing artistic relationships with La Mama as performers and theater makers during each decade of the past half century. The Talking Band is known for collaborations (with poets, puppet makers, designers, composers, musicians) that explore the relationships between language, theater, and music. Beyond its collective work with the Open Theatre, the Talking Band focuses on the energy and immediacy of language — with powerful poetical and political intent.

The premiere performances of Stewart's *Mythos Oedipus* were presented as part of the International Symposium of Ancient Greek Drama celebrating the beginning of world culture in Greece in June 1985. The first performance was in the ancient stadium in Delphi on June 12. The U.S. premiere, at La MaMa in New York, was on February 5, 1988.

Michael Sirotta, La MaMa musical director and resident composer, first worked at La MaMa on Elizabeth Swados's *Jerusalem* in 1983. He describes the first performances on tour of Stewart's *Mythos Oedipus* in the following interview.

MICHAEL SIROTTA (2005): In 1985 we did *Mythos Oedipus* at a festival at Delphi [site of the Delphic oracle]. That was my first experience seeing Ellen at work outside. In Delphi the festival was conducted in an outdoor stadium with a J-shaped seating area, a football field and a half. The audience was meant to be situated, according to the festival setup, at the bottom of the "J." Ellen told them no. She wanted to use the stone seats for our playing area. The audience, she told them, would be down on the ground. But they didn't believe her. So they sat the audience in the seats in front of the stage they had created at the bottom of the J-shape. Ellen arrived and we started the music. "Why are they starting?" she yelled. She started yelling at the audience: "You are sitting on our stage. You must come down here or we will not start the play." And they started booing and chanting, and Genji Ito [one of the La MaMa's resident composers] turned to me and said, "We are this far from a soccer riot." They had come in their high heels and they were not going to get down on the dusty ground. Several hundreds of them left immediately. But those that remained came up to us and said, "They haven't done Greek theater like this in two thousand years. This must be the way they used to do it."

[About the next performance, SIROTTA recounts]: When Oedipus [butoh master Min Tanaka] climbed up to his exaltation at the end, he climbed a real mountain. And the stars were shining and the lights were

on him and the music was singing him up. It was so overwhelmingly big. . . .
It was truly unforgettable. . . . Sometimes, even in a dress rehearsal or during
the run of a show, before a performance, Ellen will say to me, "Michael,
you're going to be mad at me. But we need
a new song here." And that means that in the middle of the show, or right
before the show, I'd have to work out and teach somebody a new song! . . .

Whenever she yells or gets mad, it only belongs to the work, to the
world of the work. There isn't a soul that doesn't escape it. . . . Working at
La MaMa has been a love affair; it's been a hate affair. I'm a creative person
and music is in my core. This is the place where I can do what I want to
do. I prefer this insanity to the insanity of the commercial world. It's been
fun, let's put it that way.

With *Mythos Oedipus*, Stewart assumed the primary artistic directorial role
of the Great Jones Repertory Company. When Stewart began to conceive,
adapt, and direct her own productions in the mid-1980s, she used the hands-
on experience and knowledge she had absorbed working with O'Horgan, the
Plexus Group, Serban, and Swados. She was not formally trained in choreog-
raphy, composition, playwriting, or stagecraft. In rehearsals and design meet-
ings Stewart's take was intuitive rather than scholarly or technical. She had a
unique, innate awareness of and sensibility for style, rhythm, color, and har-
mony. She would often call upon one or more company members to jump in
to assist, improvise, and demonstrate. Company members with special skills
were selected to bring in specific ideas or choreography to rehearsal.

Yukio Tsuji is a La MaMa resident composer whose first show at La MaMa
was *Tibetan Book of the Dead*, an adaptation by Jean-Claude van Itallie in 1983.

YUKIO TSUJI (2005): Regular musicians cannot work with Ellen. I'm a
composer and an arranger, and Michael Sirotta is too. She trusts us. She
sings a melody, we write it down. Then everything after that is up to us. It
can be anything we want to do. If it doesn't work, she says [he yells], "IT
DOESN'T WORK!!" Then we change it. She's not a musician, but when
she sings, she always sings on pitch. It's amazing. We know what she wants.
We adjust ourselves. She always has a story. We've been working with Ellen
for a long time. Musicians have egos. She knows that she needs to find a
certain kind of voice for the story. She doesn't do auditions. She just finds
people. . . . Ellen belongs to everywhere. She doesn't do outdoor perfor-

mance in New York. But internationally we are outdoors always. And we are moving, moving. After outdoor performances, nobody wants to come back in. . . .

Before I joined with Ellen I didn't know what experimental theater was. She is a person who knows about color; she is full of color. No one can do what she can do. All countries, all languages, all colors come together. She makes something new, a mix of cultures. More Europeans understand this kind of work than Americans do. Here it is much more conservative. I learned a lot from her. Skin color doesn't matter; culture, where you come from, doesn't matter. It's a blend. I can study one thing or another, but that stays in one place, doesn't change. . . . With Ellen it is always a new beginning.

The Greek myths were Stewart's starting point. Her primary source materials were the myths themselves, rather than existing classical plays. "Why is Oedipus (or Antigone or Perseus) important?" is the question that sparked the creation of each of her productions. Stewart researched and created her own versions of the Greek stories.

STEWART (2005): Why aren't my interpretations as valid as Sophocles and Euripides?

Critics responded enthusiastically. Alisa Solomon, in the *Village Voice*, compared Stewart's production with Serban's *Fragments of a Trilogy*. In the *New York Times*, D. J. Bruckner wrote, "Miss Stewart is doing much more than filling us in on background mythology. 'Mythos Oedipus' is a splendid, barbaric spectacle resonant with chants, and music that has an almost ancient, oriental quality. On multitiered stages at opposite ends of the auditorium and in the space between (the audience occupies balconies on the two longer walls of the room), 21 members of this international cast dance, chant and enact the stories of lust, betrayal, murder and vengeance that make this troubling myth irresistible."

Safe Sex, which opened at La MaMa on January 8, 1987, moved directly from the sold-out La MaMa run to a Broadway production. According to an article in the *New York Post* covering the transfer, production posters were being "snatched off restaurant walls as souvenirs" when they were first displayed. Harvey Fierstein did not see *Safe Sex* as an "AIDS play" in the way that William Hoffman's *As Is* and Larry Kramer's *A Normal Heart* were, because *Safe Sex* was not about people living with AIDS. *Safe Sex* consists of three short plays: the first, about someone who is a carrier of the virus, the second, about two lovers who are afraid to have sex, and the third, about two people

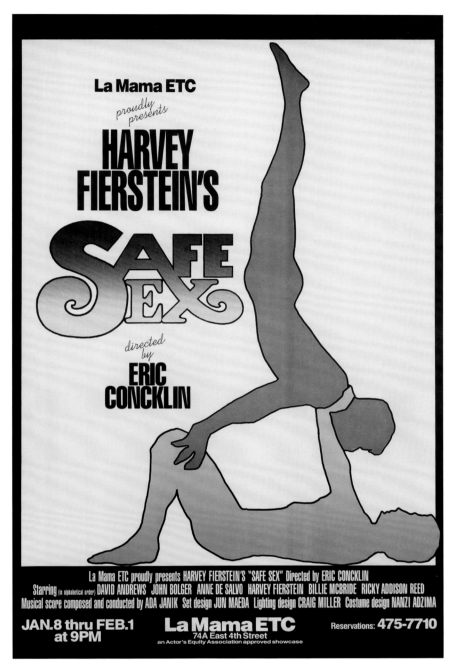

22" × 14"

FIG. 94: *Safe Sex*, written by and starring Harvey Fierstein. Directed by Eric Concklin, 1987. Graphic image on poster by Fierstein, poster design by G2. Fierstein designed the two male figures on the poster in a muscular, acrobatic pose. They are carefully balanced; the relationship between the two bodies signifies "safe sex"—but also reveals tension between the two figures.

who have lost a loved one to AIDS. Fierstein stated that this play was much more autobiographical than *Torch Song Trilogy*.

The final play in the trio was adapted for HBO a year later, starring Fierstein and Stockard Channing. Titled *Tidy Endings*, the television production received strong reviews.

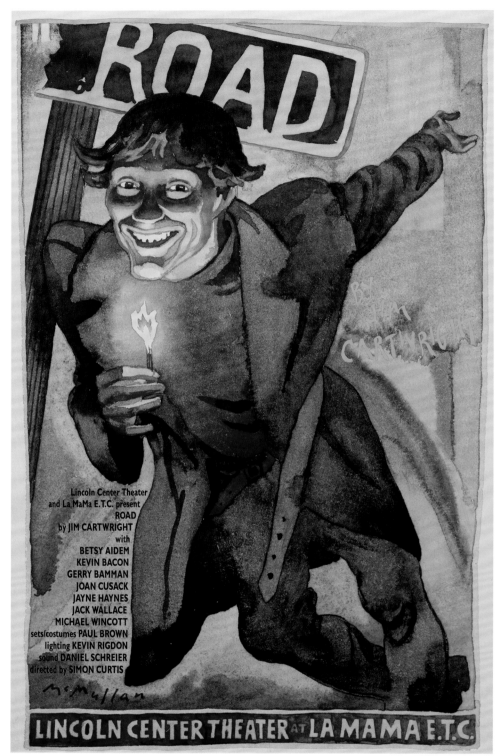

FIG. 95: *Road*, by Jim Cartwright. Coproduction of La MaMa and Lincoln Center Theater. Opened July 28, 1988. Director: Simon Curtis. Poster by James McMullan, a renowned international artist who designed over fifty posters for Lincoln Center, including the acclaimed revivals of *Anything Goes*, *South Pacific*, and *Carousel*.

22" × 14"

Fierstein's dedication, a kind of manifesto, was printed in the La MaMa program and in the Broadway playbill for *Safe Sex*. An excerpt from his statement is printed here.

AUTHOR'S DEDICATION: For my darling Court Miller

Sex is good. It is not wrongful or unhealthy. AIDS has blinded us from this simple truth. It has poisoned the joy of affection. It has banished the spontaneity of loving. It imbues lovers with guilt, strangers with distrust, and victims with shame. I curse this disease and any virus-like person who would call it God-given. I mourn for the promised lives it has stolen and exalt those now fighting for their right to live.

These plays are dedicated not only to our lost loved ones, but to those who stood bravely by their sides. To all who work toward the annihilation of this threat and to those now threatened.

Actors Kevin Bacon, Joan Cusack, and Betsy Aiden were featured in the cast of *Road*, a coproduction with Lincoln Center for the Performing Arts. *Road* was staged environmentally in the La MaMa Annex, where designer Paul Brown constructed a mean street in Lancashire, England, evoking the "road" in the title of the play. The audience was invited to follow the action of the ne'er-do-wells peopling this dreary landscape, whether it was watching a young couple make love in a bed inches away or buying fish and chips from a roadside stand. The Annex space was selected and La MaMa approached for a coproduction because it would be highly suitable for British director Simon Curtis's staging of what has been described as a "promenade" performance — where actors perform among spectators, and spectators stand and move in close proximity to the actors.

JAMES MCMULLAN (interview with Thomas Cott, 1998): My feeling about posters—and I think I've made this mistake occasionally—is not to try to get too clever with the concept of the poster. If you try to say too much, if you try to be too metaphorical, if you try to make it too much of an intellectual game, it probably complicates the poster too much. And it sets up the wrong kind of tension in the viewer's mind. I think when my posters are more successful is when they're fairly simple and emotionally very direct.

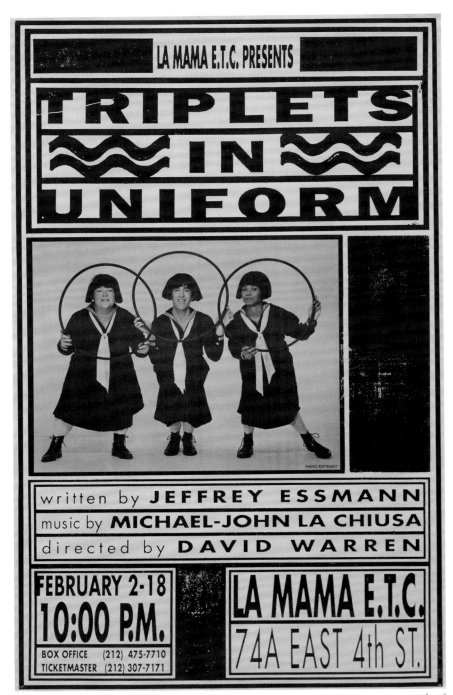

FIG. 96: *Triplets in Uniform*, written by Jeffrey Essman with music by Michael John La Chiusa, directed by David Warren. La MaMa Club opening: February 2, 1989. Photograph on poster by Roy Blakey, featuring, left to right, Kathy Kinney, Jeffrey Essman, and Kim Sykes. Blakey gained renown for his coverage of the 1970s–1980s New York City theater and dance scene, and for his self-published 1972 book on the male nude, *He*. The photograph of the three performers evokes the Three Stooges comedians dressed in little-girl drag; the poster is chock full of typography, and highlights especially the streamlined art deco typography of the 1930s.

19.5" × 12"

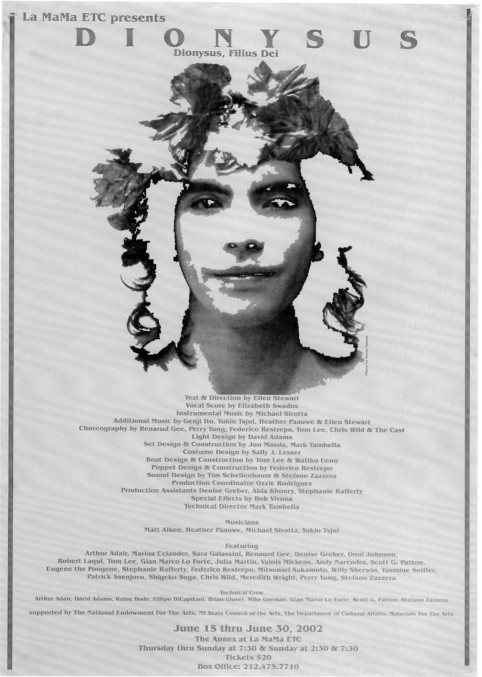

FIG. 97: *Dionysus Filius Dei*, conceived and directed by Ellen Stewart. This was her second production as director of the Great Jones Repertory Company. Poster from the 2002 production; photo by David Adams featuring performer Tom Lee as Dionysus. John Kelly played Dionysus in the original production, which premiered on February 25, 1989.

19" × 13"

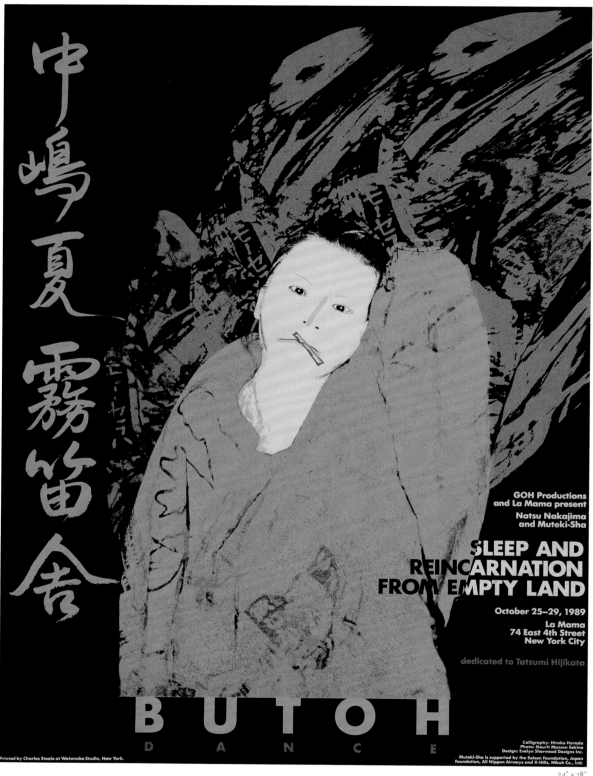

中嶋夏 霧笛舎

GOH Productions
and La Mama present

Natsu Nakajima
and Muteki-Sha

SLEEP AND
REINCARNATION
FROM EMPTY LAND

October 25–29, 1989

La Mama
74 East 4th Street
New York City

dedicated to Tatsumi Hijikata

BUTOH
DANCE

Printed by Charles Steele at Watanabe Studio, New York.

Calligraphy: Hiroko Harada
Photo: Nourit Masson Sekine
Design: Evelyn Sherwood Designs Inc.
Muteki-Sha is supported by the Saison Foundation, Japan
Foundation, All Nippon Airways and X-Hills, Nikoh Co., Ltd.

24" × 18"

Performer and playwright Jeffrey Essman and composer Michael John La Chiusa were frequent collaborators on La MaMa Club shows beginning in January 1988. Essman was famous for taking on eight or nine characters in his performances; his portrayal of Sister Bernice, "still teaching fourth grade," was a Club favorite. Sister Bernice tells the audience: "You will burn if you are not nice; that's how you can remember my name, boys and girls." La Chiusa wrote music and lyrics for and performed in the La MaMa Club show *Triplets in Uniform* in 1989, which became a cult classic. After working successfully in diverse styles Off-Off- and Off-Broadway, La Chiusa went on to make striking and unusual choices as a composer-lyricist on Broadway and in film, television, and opera. La Chiusa breaks down walls between genres and has published frequently and controversially on the state of contemporary musical theater. La Chiusa's Broadway productions include *Marie Christine* and *The Wild Party* and, Off-Broadway, *See What I Wanna See*.

Sleep and Reincarnation from Empty Land had its New York premier at La MaMa on October 26, 1989. Butoh artist Natsu Nakajima, artistic director of the Muteki-sha Dance Company, dedicated this work to her teacher, the founder of butoh dance, Tatsumi Hijikata, who described butoh as "the ancient dance step of utter darkness." This piece features solo performances by Nakajima and her partner-collaborator, Yukio Waguri, as well as duets. *New York Times* critic Jennifer Dunning praised Nakajima for her "gift of stillness . . . her face registers emotion with extraordinary subtlety and detail, through just the blinking of eyelids and widening and rounding of her mouth."

FIG. 98 (*facing*): *Sleep and Reincarnation from Empty Land*. Choreographed by and featuring Natsu Nakajima. Poster calligraphy: Hiroko Harada, photograph on poster: Nourit Masson-Skine, design: Evelyn Sherwood Designs, printed by Charles Stecle at Watanabe Studio, NYC. The poster was offset printed but imitates silk-screening. The central figure in the poster is taken from a photograph of butoh dancer-choreographer Natsu Nakajima performing in the production. At least three ghostly figures loom behind her. The dancer's head tilts to the left, as do the ghosts' heads, conveying a sense of the slowed-down, attenuated movements and the intensity of butoh dance.

FIG. 99: Ellen Stewart in front of the
La MaMa box office, circa 1990s.
Photographer unknown, courtesy
of La MaMa Archive.

THE 1990s

La MaMa Turns Thirty

Throughout the 1990s, La MaMa Experimental Theatre Club, like many other nonprofit U.S. arts institutions large and small, struggled to survive in the face of severe funding cuts on the federal, state, and city levels. A Thirtieth Anniversary Benefit in April 1992, hosted by Harvey Fierstein, was one of several events, including tributes to Stewart, that were designed to raise much-needed funds for La MaMa. The 1991–92 season featured many returning artists and veteran performers, but the 1990s also launched the work of U.S. and international solo performers, "makers," and ensembles at La MaMa as well as new and novel collaborations between artists in the United States and abroad.

In 1980 Peggy Shaw and Lois Weaver (who met while performing with the multicultural troupe Spiderwoman Theater in New York City) founded Split Britches, named after their first production, with performer-playwright Deb Margolin. In 1982 Shaw and Weaver cofounded the performance space WOW Café, which celebrates lesbian performance. They collaborated with female impersonators Bette Bourne and Paul Shaw, cofounders of the London-based group Bloolips, to create *Belle Reprieve,* "a queer *Streetcar Named Desire,*" which was produced first in London and then in the United States at La MaMa on February 14, 1991. Alisa Solomon (February 19, 1991) writes in the *Village Voice* that Split Britches and Bloolips opted to do the project because all of the actors wanted to play the iconic "femme" role of Blanche DuBois — except Peggy Shaw, who, as a "butch" performer, wanted to play Stanley Kowalski. Ultimately, Bette Bourne played Blanche, Peggy Shaw played Stanley, Weaver played Stella, and Precious Pearl (Paul Shaw, in his first male role onstage) played Mitch. The play contains only small fragments of the original Tennessee Williams play, and the style is highly theatrical. At one point in the script Bourne stops the action and complains that he's had enough of the "avant-garde" and wants "to be in a real play." In response,

FIG. 100: *Belle Reprieve.* Conceived and performed by Split Britches and Bloolips. Produced in the Club at La MaMa, 1991. Poster design: Spark Ceresa. Photograph on poster by Amy Meadow.

Weaver retorts that "as gays and women, realism works against us." Peggy Shaw, playing Kowalski, couldn't bring herself to perform the rape of Blanche in the penultimate scene in Williams's play; instead, the company staged a rousing group musical number. Responses from spectators were enthusiastic, if "exhilaratingly confused" (Peggy Shaw reported that she received messages and mail from infatuated gay male fans). High points in *Belle Reprieve* included "I'm A Man," sung by Peggy Shaw, and "The Man I Love," sung by Paul Shaw (no relation between the two actors).

LA MAMA ETC proudly presents

HARVEY FIERSTEIN
JASON WORKMAN
in
ROBERT PATRICK'S
Landmark Comedy
'THE HAUNTED HOST'
Directed by
ERIC CONCKLIN
Production Design by Production Stage Manager
DAVID ADAMS JOE MCGUIRE
MARCH 1 thru 17
La Mama ETC 74A. East 4th Street 475-7710

22" × 14"

FIG. 101: *The Haunted Host*. Robert Patrick, playwright, Eric Concklin, director. With Harvey Fierstein and Jason Workman.

Veteran Caffe Cino and La MaMa playwright Robert Patrick (who wrote the award-winning Broadway play *Kennedy's Children* in 1974) was represented on La MaMa stages again with his play *The Haunted Host* in 1991. Harvey Fierstein played the "openly gay" character that broke ground in 1964 when Patrick performed the role in the Caffe Cino premier of *The Haunted Host*. Jason Workman played opposite Fierstein in the role playwright William Hoffman (*As Is*) originally played at Caffe Cino. Eric Concklin directed the La MaMa production.

First a collaboration of NYC street performers (Matt Goldman, Phil Stanton, and Chris Wink) in the 1980s, Blue Man Group: *Tubes* evolved into a commercial franchise playing in cities around the world. The multisensory work, where three actors covered in shiny blue paint perform what Jason Zinoman in the *New York Times* describes as "high-tech vaudeville" and construct "a singularly strange and alluring event," premiered at La MaMa on April 8, 1991, before opening at the Astor Place Theatre (also in New York's East Village) in November of that year. Thus began a continuously successful open run, attracting tourists and a boisterous multigenerational crowd. Blue Man Group gave a benefit performance for La MaMa in 1992.

FIG. 102: Blue Man Group: *Tubes*. Poster artist: Jonathan Epstein. Photograph on poster by Mark Seliger, 1991. American portrait photographer Mark Seliger established the poster style for Blue Man Group in this early shot for *Tubes*. The three performers' straight-faced expressions are juxtaposed with "paint action"—a dollop of green paint "leaps" from a canvas being held by one of the blue men in the foreground toward the chest of another blue man on the poster. Seliger shot more than 125 *Rolling Stone* magazine covers from 1992 to 2002. Mick Jagger, Paul McCartney, Barack Obama, Jay Z, the Dalai Lama, and the cast of *Mad Men* are only a few of the luminaries who sat for his portraits, which have also appeared in *Time*, *GQ*, and *Vanity Fair*.

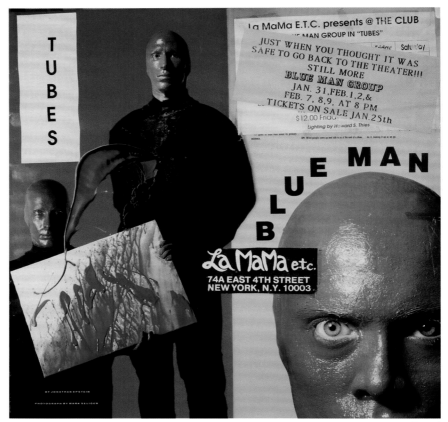

31" × 27.5"

Hibiscus, a musical memoir about George Harris III, premiered in the Club at La MaMa on April 22, 1992. Directed by Jacque Lynn Colton (an original member of Tom O'Horgan's La MaMa Troupe), the revue, loosely framed around postcards Harris had sent home to his family, celebrated the glittery, gay life and times of Harris (aka Hibiscus), who died of AIDS in 1982 at the age of thirty-two (at a time when the as-yet-unnamed disease was known as "the gay cancer"). The script and most of the show's music and lyrics were written in collaboration with members of Harris's family (his brother, sisters, and mother), who also performed in the original production. Hibiscus, who gained fame producing and touring musical drag shows rich with social and political satire, was a onetime child actor who had participated in a Young Playwrights' Series at La MaMa, and was a close friend of gay artists such as Allen Ginsberg and Jack Smith. He founded "genderfuck" groups such as the Cockettes in San Francisco, Angels of Light, and Hibiscus and the Screaming Violets.

Multidisciplinary performing artist, teacher, and playwright Rhodessa Jones premiered *Big Butt Girls, Hard-Headed Women* at La MaMa on November 5,

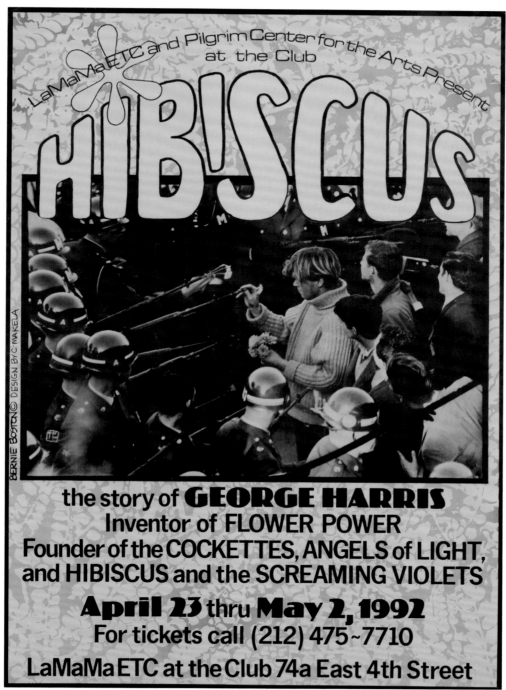

25.25" × 18"

FIG. 103: *Hibiscus*. Jacque Lynn Colton, director. Written by W. Michael Harris, Vida M. Benjamin, and Rebecca Stone. Poster artist: Christine Makela, 1992. The *Hibiscus* poster features the Bernie Boston photograph of George Harris from *Life Magazine* in 1967, when Harris's image became synonymous with "flower power"—capturing the moment when, as an angelic-faced young man, Harris placed a flower in the barrel of a National Guardsmen's gun at an anti–Vietnam War demonstration in front of the Pentagon.

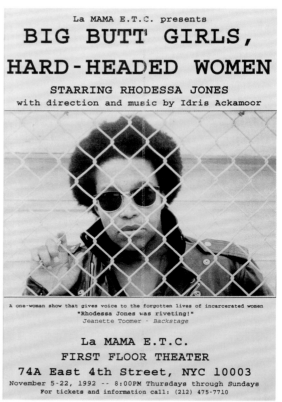

La MAMA E.T.C. presents

BIG BUTT GIRLS, HARD-HEADED WOMEN

STARRING RHODESSA JONES
with direction and music by Idris Ackamoor

A one-woman show that gives voice to the forgotten lives of incarcerated women
"Rhodessa Jones was riveting!"
Jeanette Toomer - *Backstage*

La MAMA E.T.C.
FIRST FLOOR THEATER
74A East 4th Street, NYC 10003
November 5-22, 1992 -- 8:00PM Thursdays through Sundays
For tickets and information call: (212) 475-7710

17" × 11"

FIG. 104: *Big Butt Girls, Hard-Headed Women*, written and performed by Rhodessa Jones with stage direction and musical accompaniment by Idris Ackamoor. Photograph on poster by Lorraine Capparell, 1992.

1992. Jones served as director of TWITAS at La MaMa in 1986. This solo performance, a series of monologues "based on the lives and times of real women who are incarcerated," was inspired by Jones's experiences leading workshops with women prisoners in the San Francisco City Jail beginning in 1987. The performance won a Bessie Award in 1993. Jones, who has collaborated with her brother, dancer-choreographer Bill T. Jones, also founded (in 1989) and directs the award-winning Medea Project: Theater for Incarcerated Women. The poster photograph of Jones caught behind bars evokes the spine of Jones's work, which was seeing the world from a female inmate's perspective. In her program note for *Big Butt Girls*, Jones describes this as "another world populated by wild, wounded, crazed, cracked, carefree, dangerous, devious, destructive but colorful women." In 2010 Jones and Idris Ackamoor's multicultural arts company Cultural Odyssey celebrated its thirtieth anniversary in the San Francisco Bay Area.

Theater artist and multimedia director Theodora Skipitares first worked in New York theater as a costume designer (at the Performing Garage and BAM) in the 1970s. By 1976 Skipitares had begun to create performance art — solo pieces that built on her love of objects and the visual that were focused

on social commentary. Her puppet work evolved out of this phase and an interest in moving beyond her self, her story, her body on stage. In 1991 she created *Radiant City* about Robert Moses, New York City's "power broker," which was presented at the American Place Theatre, Off-Broadway, in midtown Manhattan. In 1992 she returned to her downtown roots, settling into the venue where she presented most of her work from that time forward, La MaMa. Her first piece in La MaMa's First Floor Theatre was the puppet play *Underground*, an exploration of subterranean stories, including one scene based on Ralph Ellison's *Invisible Man* and another situated in a fallout shelter (depicted in the photograph on the production poster). *Under the Knife: A History of Medicine* and *Under the Knife II* in 1994 and *Under the Knife III* in 1996 were grand environmental multimedia shows, in which fifty spectators per performance explored exhibits throughout La MaMa's Annex theater and then sat on bleachers to witness a multitude of bizarre and sometimes disturbing scenes from medical science past, present, and future. In 2001, Margo Jefferson in the *New York Times* wrote of Skipitares's imaginative use of the La MaMa Annex space again in *Optic Fever*, describing the work as "delicious and extravagant" and Skipitares as "a sculptor and designer who uses fable and history to create a kind of theater that might be called documentary fantasy." In the late 1990s and early 2000s Skipitares and Stewart toured internationally and created theater together, collaborating with artists and communities in India, Cambodia, and Vietnam.

THEODORA SKIPITARES (2003): Ellen maintains an incredible balance in her life, between creating all her shows, whenever she wants and in whatever country she wants, and running the theater, and running Spoleto. It's amazing. . . . She's someone who has always traveled extensively and can fit into any culture. I remember one night when we were in Bangalore [in 1999] and somebody came by to listen to our rehearsal. He leaned over and said to me, "I can't believe it. The music she's created sounds exactly like Bangalore music."

ELLEN STEWART (2005): People cannot conceive or imagine how I do the things I do . . . I close my eyes, I go inside, and the music comes out.

THEODORA SKIPITARES: If you think of some of the amazingly high-end directors that go places to create stuff, you'll never find somebody who has done what Ellen has done. She can find access, go into any kind of community, and make it work. No woman has done what she's done.

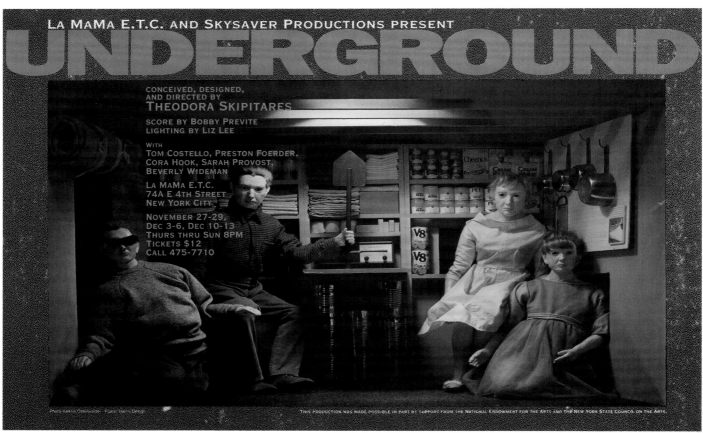

LA MaMa E.T.C. AND SKYSAVER PRODUCTIONS PRESENT

UNDERGROUND

CONCEIVED, DESIGNED,
AND DIRECTED BY
THEODORA SKIPITARES

SCORE BY BOBBY PREVITE
LIGHTING BY LIZ LEE

WITH
TOM COSTELLO, PRESTON FOERDER,
CORA HOOK, SARAH PROVOST,
BEVERLY WIDEMAN

LA MaMa E.T.C.
74A E 4TH STREET
NEW YORK CITY

NOVEMBER 27-29,
DEC 3-6, DEC 10-13
THURS THRU SUN 8PM
TICKETS $12
CALL 475-7710

THIS PRODUCTION WAS MADE POSSIBLE IN PART BY SUPPORT FROM THE NATIONAL ENDOWMENT FOR THE ARTS AND THE NEW YORK STATE COUNCIL ON THE ARTS.

12.5" x 20"

In Bangalore the darker-skinned Southern Indians totally bonded with her. The same was true in Cambodia and Vietnam. . . .

It took me a while to realize that she was teaching me things. I learned how one boldly goes into a new community: she would go into and get hold of a situation. That was really great.

For the past couple of years since I've settled at La MaMa, I haven't really worked much anywhere else. She is supportive of my work. She'll tell you honestly whether she likes one show less than another. She does do what a mother-type does in a large family.

She distracts herself with her work. She'll get herself through the really painful part of her sickness. She can heal herself. That's impressive. I've learned from that. She has a huge appetite for life. She really does. . . . That's what keeps her going now.

Stewart met Brazilian writer and performance artist Denise Stoklos at an international festival in Montevideo, Uruguay, in 1986 and invited Stoklos to

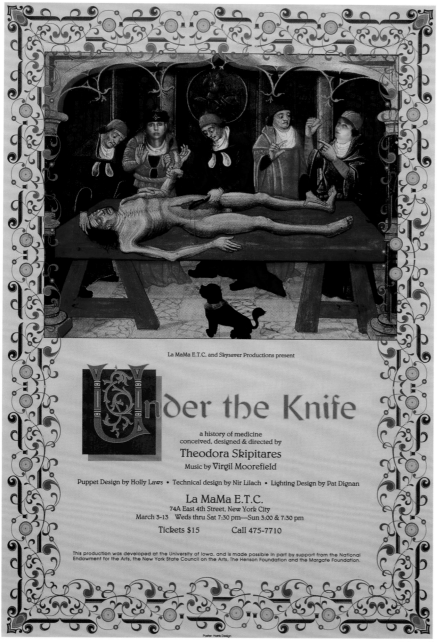

La MaMa E.T.C. and Skysaver Productions present

Under the Knife

a history of medicine
conceived, designed & directed by
Theodora Skipitares
Music by Virgil Moorefield

Puppet Design by Holly Laws • Technical design by Nir Lilach • Lighting Design by Pat Dignan

La MaMa E.T.C.
74A East 4th Street, New York City
March 3-13 Weds thru Sat 7:30 pm—Sun 3:00 & 7:30 pm

Tickets $15 Call 475-7710

This production was developed at the University of Iowa, and is made possible in part by support from the National Endowment for the Arts, the New York State Council on the Arts, The Henson Foundation and the Margate Foundation.

18.5" × 11.5"

FIGS. 105 (*facing*) and 106: *Underground* was conceived and directed by Theodora Skipitares. George Harris poster design. Photograph on poster by Valerie Osterwalder. Premiered November 27, 1992. *Under the Knife: A History of Medicine* was conceived and directed by Theodora Skipitares with George Harris poster design. Premiered March 3, 1994. Two contemporary faces are inserted onto figures in the illuminated manuscript represented on the poster; Theodora Skipitares's face is the second from the left and the face of the production dramaturg, Andrea Balis, is inserted on the far right. The original work from which the poster was adapted is *Teaching at the Dissection Table*, a page from "Le Livre des Proprietes des Choses" by Barthelemy l'Anglais (vellum), a fifteenth-century illuminated manuscript in the Bibliothèque Nationale de France in Paris.

perform at her theater in New York. The next year Stoklos presented the U.S. premiere of *Mary Stuart* to acclaim at La MaMa. Subsequently Stewart encouraged Stoklos to present a new work at La MaMa every year. Some of the provocative, powerful works that Stoklos premiered in the 1990s include *Casa* (1990) and *500 Years: A Fax from Denise Stoklos to Christopher Columbus*, "a play about the discovery of America," as Stoklos puts it. *500 Years* premiered in

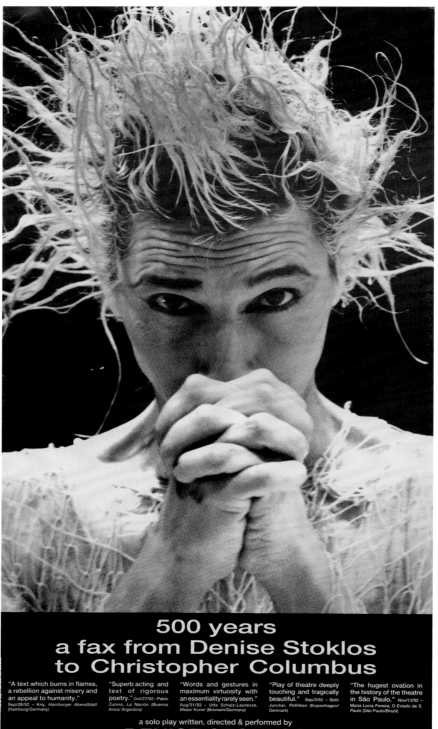

FIG. 107: *500 Years: A Fax from Denise Stoklos to Christopher Columbus.* Writer and solo performer, Denise Stoklos. Photograph on poster by Flander de Souza, 1993.

20.75" × 11.5"

Germany in 1992 and at La MaMa in New York on January 28, 1993. Stephen Holden in the *New York Times* described *500 Years* as "a feverish stream of consciousness monologue that begins in rage and slowly metamorphoses into an ecstatic assertion of freedom and love." Holden interprets Stoklos's staging of Columbus's encounter with the New World as "a metaphorical shipwreck," which was reflected in Stoklos's encasing La MaMa's stage and herself in fishnet in the performance.

Stoklos calls her performance practice "Essential Theatre," which is also the title of her book/manifesto describing "a theatre made only with body, voice and mind/intuition." In the *Village Voice*, Laurie Stone writes: "Her appendages are so spirited, they're like possessed animals." The poster photograph of Stoklos by Flander de Souza captures the performer's highly charged emotional intensity and displays the performer's body wrapped in fishnet.

In a *Village Voice* article in 1993, Richard Schechner hails East Coast Artists as his "ensemble for the 90s." Founding director of the radical theater collective The Performance Group and a renowned performance scholar, editor, and teacher, Schechner melded Goethe's and Marlowe's versions in *Faust/Gastronome* and "transformed Faust into a metaphysically frustrated culinary wizard," according to *Village Voice* writer Charles McNulty. *Faust/Gastronome* premiered at La MaMa on February 18, 1993. East Coast Artists produced *Three Sisters* at La MaMa in 1995 and again in 1997. Schechner staged each of Chekhov's four acts in a different style and historical period of twentieth-century theater. The first act, in the style of naturalism, reflects the work of Stanislavsky and his actors in the Moscow Art Theatre in the first decade of the century. The second act, set in postrevolutionary Russia, incorporates Vsevolod Meyerhold's gestural system of "biomechanics" in the staging. In the third act, set in a Soviet gulag in the 1950s, the actors engage in the Sisyphusian task of moving cinder blocks from one part of the stage to the other. For the fourth act, actors stand in the foreground of the stage at microphones, amplified but unconnected (in any naturalistic way) to each other, yet directly addressing the audience. Peter Marks writes in the *New York Times*: "Where else in Manhattan could you find Stanislavsky, Meyerhold and Stalin hovering over the same stage?"

RICHARD SCHECHNER (2010): Now in 1968 Grotowski was coming to New York to do his famous three performances — *Acropolis, Apocalypsis,* and *Constant Prince*. At the same time, the Soviets invaded Czechoslovakia, and they put down the uprising there as they had twelve years earlier in 1956 when they invaded Hungary. At which point the State Department

FIG. 108 (*right*): *Faust/Gastronome*, directed by Richard Schechner. Presented by East Coast Artists. Chris Muller designed the set and poster, 1993. Muller is an internationally acclaimed exhibition designer whose museum work includes exhibits at the Whitney Museum of American Art, the Jewish Museum, and the Children's Museum of Manhattan. Muller is also a storyboard artist for film and television and a children's book illustrator.

FIG. 109 (*below*): *YokastaS* premiered March 20, 2003. Photographer and graphic designer, Olivier Massot. Note the mention of "on-line ticketing" on the 2003 poster—this was one of the first production posters to display this option for buying tickets.

11" × 8.5"

13.5" × 11.5"

canceled Grotowski's and his troupe's visas. Poland was a satellite of the Soviet Union and so it was a way of punishing the Soviet Union. And I do remember that Ellen and La MaMa were very active in protesting that. Grotowski had come to New York in 1967 for a NYU graduate acting workshop. He came back to New York with his troupe in 1969.

I think that's when I became aware of Ellen. But La MaMa on East Fourth Street was really a world away. I was involved in the Performing Garage and in the development of Soho. . . . I did see Kantor's *The Dead Class* at La MaMa in 1979. I saw Serban there. I saw the Open Theatre's work there too.

When I left the Performance Group and the Performing Garage in 1980 I had no place to do my work. I worked outside New York; I did *Richard's Lear* at the University of Wisconsin in '82. I directed in India and in South Africa in the mid-eighties and in mainland China in 1989, right around the time of Tiananmen Square.

I had done a number of these independent productions, and something made me think to convene a group and work on *Faust*. I believe I went to Ellen and asked if we could use the First Floor Theatre. I know we did *Three Sisters* first in the smaller theater and then in the Annex.

I have no memory of Ellen coming to rehearsals. She did ring the bell, but not every night. And we were very friendly to each other. I appreciated having the venue and her generosity. What I didn't like was not in her control. [The Equity Showcase Code regulates, among other things, the monies that Equity actors need to be paid working on a production, that an Equity stage manager must be hired, and that an Equity deputy be chosen. It also controls the total number of performances of a show.] I felt and still feel that the Annex is a great, great space.

What was unique about La MaMa was that you could do good productions on small budgets. Even though the production could only run for sixteen performances [per Code], I could rehearse it for seven or eight months. Even though the rehearsals were not as long as I wanted them to be (because you had to be out at nine), we could rehearse at Great Jones Street [which was free], and that was good.

YokastaS was first done in the First Floor Theatre, I believe, and *Yokastas Redux* in the Annex. The difference between the two is not so much in the text, but I cleaned up the production quite a bit. I don't like to do productions all at once. That's why I did *Three Sisters* twice — I like to do a piece, put it away, and then redo it. That's what I did at the Garage. It took a long time to do these productions.

It was hard to load in so quickly, to come in on Monday morning and have an audience there Wednesday night. It takes a lot of advance planning

and I'm not comfortable with it because I like to make changes. La MaMa's great, but it's almost like being in a touring house. I've directed three shows at La MaMa and I would have loved to do *Swimming to Spalding* [produced December 2009 at HERE in New York City] in the First Floor Theatre, but they didn't have the space available.

When I see Ellen I say, "Hi, Mama" as well as "Hi, Ellen." I've always thought of this "family" idea as a kind of fiction and yet also an honor that she is due. I have a great deal of respect for what she's done, and what she's doing for New York theater. Her iconic status, her position. I don't see anyone else that functions as she does in the New York theater. I knew Bernie Jacobson, the head of the Shubert Organization. But no one would call him "Pop." That kind of relationship within the theater is rare. Actually it's unique. I've never heard of it anywhere else.

In honor of Mabou Mines' twenty-fifth anniversary, the company "came home" to La MaMa in 1994, presenting Patricia Spears Jones's adaptation of Gorky's 1906 novel *Mother* in the Annex. Gorky's story centers on a mother, her son, and his revolutionary comrade at the turn of the twentieth century. The Mabou Mines production collapses and plays with time, with aural and visual imagery and text that spin spectators forward to the turn of the twenty-first century. Audience members watch the action from seats in small kitchen units surrounding the playing space where they can enjoy a beer or soda from the kitchen refrigerator as they watch TV. They are also supplied with "walkmen," which provide an ongoing distraction to the play's narrative. Alisa Solomon in the *Village Voice* (November 8, 1994) describes this work as "Po Mo Bo — post-modern Bolshevism yearning to fill avant-garde formalism with revolutionary meaning yet appropriately cynical about the reliability of any truth it might claim." D. J. R. Bruckner in the *New York Times* called *Mother* "a perfect emblem of this innovative company" and Ruth Maleczech in the title role "the most dedicated rebel in an age of revolution."

John Kelly calls himself a "hybrid artist"— indeed, Kelly is a performance artist/choreographer/writer/composer/director who creates visually and orally stunning works that represent great artists of different centuries, styles, and

FIG. 110 (*facing*): *Mother*, written by Patricia Spears Jones, directed by John Edward McGrath, presented by Mabou Mines, with Ruth Maleczech as The Mother. Poster painting by Kathleen Connolly, photograph by Becket Logan, graphic art by John Dib. Premiered October 21, 1994. This poster contains a cleverly manipulated image of a photograph of a round-shaped canvas painting of "MOTHER." She wears Walkman earphones (as do members of the audience in this production) and is placed in front of striped wallpaper, wearing a floral-patterned crimson robe, dress, or jacket, with a yellow-patterned blouse or scarf underneath. The image seems to be shoved into a narrow space and balanced atop the graphic title.

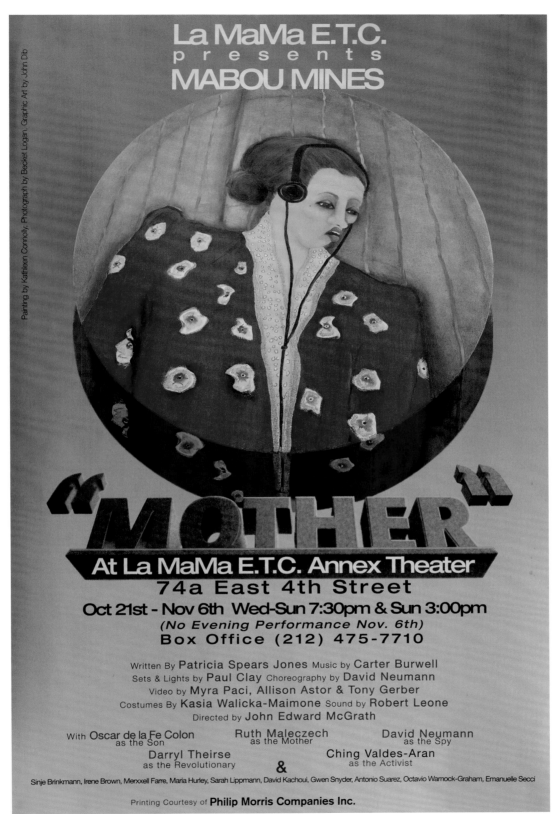

La MaMa E.T.C.
p r e s e n t s
MABOU MINES

Painting by Kathleen Connolly. Photograph by Becket Logan. Graphic Art by John Dib

"MOTHER"
At La MaMa E.T.C. Annex Theater
74a East 4th Street
Oct 21st - Nov 6th Wed-Sun 7:30pm & Sun 3:00pm
(No Evening Performance Nov. 6th)
Box Office (212) 475-7710

Written By Patricia Spears Jones Music by Carter Burwell
Sets & Lights by Paul Clay Choreography by David Neumann
Video by Myra Paci, Allison Astor & Tony Gerber
Costumes By Kasia Walicka-Maimone Sound by Robert Leone
Directed by John Edward McGrath

With Oscar de la Fe Colon Ruth Maleczech David Neumann
 as the Son as the Mother as the Spy
 Darryl Theirse Ching Valdes-Aran
 as the Revolutionary & as the Activist

Sinje Brinkmann, Irene Brown, Merxxell Farre, Maria Hurley, Sarah Lippmann, David Kachoui, Gwen Snyder, Antonio Suarez, Octavio Warnock-Graham, Emanuelle Secci

Printing Courtesy of **Philip Morris Companies Inc.**

24" x 16"

genders. From December 1994 through January 1995, he performed *Pass the Blutwurst, Bitte* at La MaMa, a meditation on the life of Austrian expressionist painter Egon Shiele. The work had premiered at Dance Theatre Workshop in 1986, winning an Obie Award. Described in the *Village Voice* as a "postmodern homage," Kelly and his small company of performers (including two "alter Egons") evoked the short life and starkly figural work of the fin de siècle Viennese painter through film, dance, and music. Ben Brantley of the *New York Times* called the work "captivating." Kelly trained in visual art at Parsons School of Design and in ballet at American Ballet Theatre, and honed his skills as a drag artist and a vocalist in New York's East Village club scene in the 1980s. Kelly cites dancer-choreographer Larry Ree as an influence, with whom he performed in the original Trocadero Gloxina Ballet Company. Kelly presented *Ode to a Cube* at La MaMa in 1988, in which he personified Leonardo da Vinci as well as Mona Lisa. In *Akin* (1992), also presented at La MaMa, Kelly depicted the trials of a troubadour of love in the time of AIDS. Kelly's unique and expressive voice has been described in the *New York Times* as "a pungent countertenor." Kelly revived what he refers to as the final, definitive version of *Pass the Blutwurst, Bitte* at La MaMa in December 2010. He called this remount "a gift to Ellen, who's been very good to me throughout my career."

In *Firmament*, "a work in progress," according to the program, Joseph Chaikin directed a company of La MaMa veterans, many of whom had worked with him before, either as part of the Open Theatre, which he directed in the 1960s through the early 1970s or with the Winter Project (founded in 1976). Performers Paul Zimet, Tina Shepard, Robbie McCauley, and Roger Babb shared these connections to Chaikin, as did several of the designers and other collaborators on the production, including Mary Frank, the poster artist. Critic Bevya Rosten writes that with *Firmament* "Chaikin has created an alternative not only to commercial theatre but also to the world of so-called 'experimental' theatre." Chaikin, the author of *The Presence of the Actor*, suffered a debilitating stroke in 1984 that left him aphasic. Continuing to work, sometimes fighting depression, he found solace thinking about the heavens and the stars.

With *Firmament*, a theatrical exploration with music composed by Richard Peeslee and movement choreographed by Douglas Dunn, Chaikin expresses that "at the center of all of this chaos . . . is a sense of wonder" (Bevya Rosten, *Theatre Journal*). This idea is crystallized in the image of the central figure in Mary Frank's poster illustration.

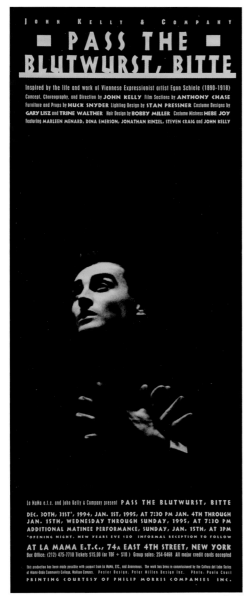

24" × 9"

FIG. 111: *Pass the Blutwurst, Bitte*, conceived, directed, and choreographed by John Kelly. Poster design, John Kelly; photograph on poster by Paula Court. Premiered December 30, 1994. Court is known for photos that document the exploding punk, hip-hop, and rock scenes of the late 1970s and 1980s in New York City. Keith Haring, David Byrne, Lou Reed, Patti Smith, Jim Jarmusch, Steve Buscemi, Willem Dafoe, and Madonna were among her portrait subjects.

MARY FRANK (2013): I showed Joe some drawings that I had made after a rehearsal and he selected a drawing. I remember we talked about the stars. He loved the stars. We came up with a simple figure for the poster. After the stroke, he had to fight to speak, but he had an astonishing way of speaking — the pauses were just as important as the words. His disability was used in how he made art.

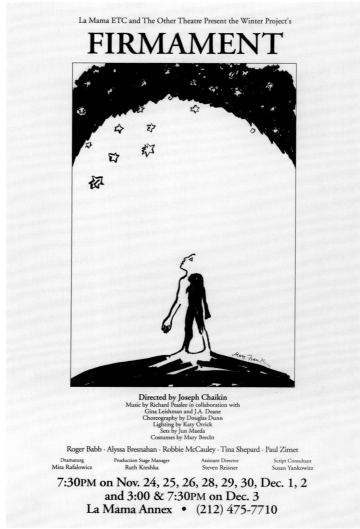

La Mama ETC and The Other Theatre Present the Winter Project's

FIRMAMENT

Directed by Joseph Chaikin
Music by Richard Peaslee in collaboration with
Gina Leishman and J.A. Deane
Choreography by Douglas Dunn
Lighting by Katy Orrick
Sets by Jun Maeda
Costumes by Mary Brecht

Roger Babb · Alyssa Bresnahan · Robbie McCauley · Tina Shepard · Paul Zimet

| Dramaturg | Production Stage Manager | Assistant Director | Script Consultant |
| Mira Rafalowicz | Ruth Kreshka | Steven Reisner | Susan Yankowitz |

7:30PM on Nov. 24, 25, 26, 28, 29, 30, Dec. 1, 2
and 3:00 & 7:30PM on Dec. 3
La Mama Annex • (212) 475-7710

17" × 11"

FIG. 112: *Firmament*, a work in progress by the Winter Project, directed by Joseph Chaikin with text by the company, including selections from Stephen Hawking, Ronnie Gilbert, Carl Sagan, and Emily Dickinson. Susan Barras, poster design. Poster illustration by Mary Frank. Premiered November 24, 1995.

Yara Arts Group was founded in 1990 and became a resident company of La MaMa with its first production, *A Light from the East*. For this work Virlana Tkacz, an American theater director and scholar of Ukrainian heritage, gathered documentary materials on the life and legacy of a theater director from Kiev in the 1920s. Like all of Yara Arts productions, this was a collage work with an international, multilingual cast, melding Eastern and Western traditions. *A Light from the East* included text fragments, dreamlike imagery, and folk music performed in English and Ukrainian. *Virtual Souls*, an experimental opera, was created by Yara Arts in 1997. In this production, technology and Buryat folk traditions are in dialogue with an investigation of Eastern and Western cultures that incorporates music, movement, multimedia, and

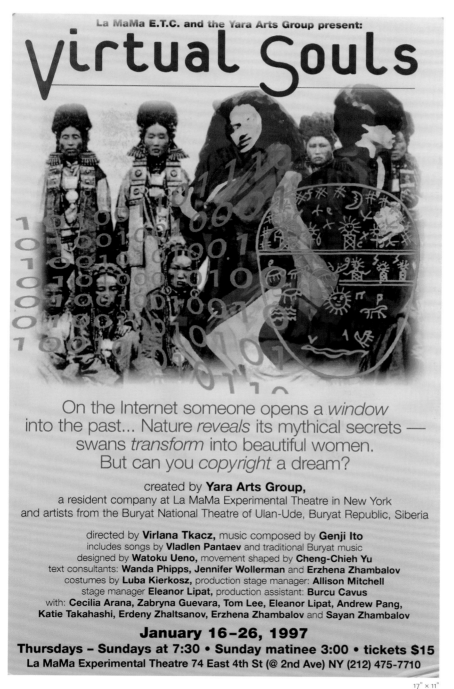

FIG. 113: *Virtual Souls*, created by
Yara Arts Group, directed by Virlana
Tkacz. Carmen Pujols, poster artist.
Premiered January 16, 1997.

17" × 11"

striking visual imagery. The piece imagines an Internet encounter between
young people from the United States and Buryat who share a fascination with
a Buryat swan myth. Reflecting this clash or meld of cultures, the poster design
combines the fading calligraphy of letters and characters from ancient lan-
guages with emerging twenty-first-century computer programming languages.

FIG. 114: Ellen Stewart at La MaMa Umbria, 2006. Kaori Fujiyabu, photographer, courtesy of La MaMa Archive.

THE 2000s

The Ellen Stewart Theatre | The Ellen Stewart Way

PAUL ZIMET (2004): She brought work from over seventy countries to
La MaMa. Particularly in this climate, where people are so fearful, she has
created a world culture. We desperately need this now.

ELLEN STEWART (2005): We've got to tell the story because time is
marching on.

La MaMa's fifth decade was a time of continued expansion and growth in
programming and touring and of great international recognition for Stewart
and her theaters. The MacArthur Fellowship that Stewart was awarded in
1985 continued to reap benefits for La MaMa and affiliated artists around
the globe. A fourteenth-century convent, which consisted of a complex of
buildings near Spoleto, Italy, that Stewart had purchased and renovated with
the MacArthur grant, was transformed into a mecca and a haven for inter-
national theater artists and students. Beginning in 2000, La MaMa Umbria
International launched its official program of workshops for directors, play-
wrights, and performers each summer. Artists teaching at the symposium
have included Richard Schechner, Rhodessa Jones, Włodzimierz Staniewski,
Anne Bogart, John Jesurun, Joanne Akalaitis, Jean Guy Lecat, Tina Landau,
Ping Chong, Liz Swados, and Mac Wellman. During a decade when many
arts institutions struggled with reduced government and foundation spend-
ing on the arts, in the *New York Times*, January 2010, Oskar Eustis of New

York's Public Theater and Todd London of New Dramatists particularized the impact of the economic downturn on not-for-profit theaters. Nonetheless, La MaMa continued to make good on its commitment to produce emerging and international artists during the first decade of the 2000s.

Ellen Stewart received numerous honors and awards throughout her life, but two of particular significance in her last decade include the Tony Honor for Excellence in the Theatre in 2006 and the prestigious Praemium Imperiale from the Japan Arts Association in 2007.

In 2004, at the age of eighty-four, Stewart produced *SEVEN* (seven adaptations of Greek tragedies) in the Annex theater with members of the Great Jones Company in a rotating repertory. In 1974 Andrei Serban, working with composer Elizabeth Swados, had originally adapted and directed *Medea*, *Electra*, and *The Trojan Women*, when Stewart presented these works together as *Fragments of a Trilogy*. The other four plays in *SEVEN* were Stewart's adaptations: *Antigone*, *Mythos Oedipus*, *Seven Against Thebes*, and *Dionysus Filius Dei*.

From 2004 to 2008 Stewart directed full productions in the Annex with the Great Jones Repertory Company that toured Taiwan, Croatia, Slovenia, and Japan. Performers who worked with the Great Jones Company were often resident artists who also continued to create their own work at La MaMa; these included Federico Restrepo, Maureen Fleming, Perry Yung, Min Tanaka, Tom Lee, and John Kelly.

In September 2009, Stewart appointed Mia Yoo, a member of the Great Jones Repertory Company since the 1990s, to serve with her as co-artistic director. Yoo's father, Korean director Duk-Hyung Yoo, had been a resident artist at La MaMa in the 1970s. In November 2009, in celebration of Stewart's ninetieth birthday, the Annex was renamed the Ellen Stewart Theatre.

Stewart's health deteriorated over the last two years of her life, but her connection to the theater remained integral. In her loft abode at 47 Great Jones Street she and La MaMa resident artists and companies had previously spent countless hours rehearsing new works. Throughout this period a constant stream of international "family" members visited Stewart.

Stewart died on January 13, 2011, at the age of ninety-one. Her funeral, held at St. Patrick's Cathedral, New York City, was an extraordinary gathering of artists, patrons, and fans from every corner of the international theater community. The majestic space was filled with a colorful, emotional crowd. There were Broadway, television, and film actors, designers, directors, composers, and producers, as well as downtown playwrights, dancers, musicians, and students — many were members of Ellen Stewart's extended family. Many had flown across the globe to pay their respects. The overflowing, diverse, multigenerational crowd wept and sang the praises of the woman who had

FIG. 115: Mia Yoo as Electra, 2007.
Richard Greene, photographer,
courtesy of La MaMa Archive.

arrived in New York and said her prayers at this very cathedral sixty years
earlier. As she had related many times to many different people, when she
first arrived in New York City she sought solace, and a path to follow, at St.
Patrick's. Directly across the street, Stewart had found her first employment
in New York City at Saks Fifth Avenue.

On October 17, 2011, at the gala event marking the fiftieth anniversary
of La MaMa, Mayor Michael Bloomberg honored Ellen Stewart's legacy by
officially renaming East Fourth Street between Second and Third Avenues
Ellen Stewart Way. Stewart made fundamental and lasting changes to the
arts scene of New York's East Village. From this home base she imagined
and forged a rich global network of multidisciplinary and innovative artists.
Ellen's "babies" experimented with movement, music, autobiography, folk
tales, canonical literature and mythology, puppetry, and dance, creating sin-
gular hybrid forms that redefined performance and multicultural and inter-
cultural theater across the globe.

PAUL ZIMET (2012): Nic Ularu is a Romanian-born theater artist and re-
nowned set designer who designed the poster for *Painted Snake in a Painted
Chair*. He worked on a number of our productions at La MaMa and did
quite a bit of scene painting for us. Nic would bring proposals to us and we
would work through several iterations before we came to the final version.

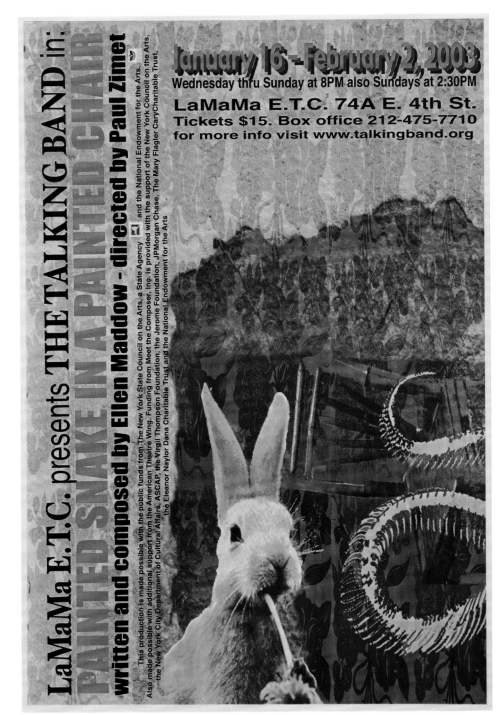

17" × 11"

FIG. 116: *Painted Snake in a Painted Chair* premiered January 16, 2003. Performed by the Talking Band. Written and composed by Ellen Maddow, directed by Paul Zimet. Poster and set design by Nic Ularu. Ularu has extensive design credits in America and Europe, including theaters in Sweden, Northern Ireland, and Romania.

ELLEN MADDOW (2012): Wallpaper is a big part of the play [*Painted Snake*]. The play takes place in a house where this group of friends gets together. They are close friends. They notice the wallpaper is peeling and they start to rip off the wallpaper. There is something strange behind it — and they discover that what's behind the wallpaper is a painting of them. This is a snake [she points to the white image of the snake on the poster].

PAUL ZIMET: It's like a ghost of a snake. A skeleton of a snake. And there's a song about a snake.

ELLEN MADDOW: The snake is found under the floorboards and it's also in the picture they find behind the wallpaper. We worked with a real rabbit. I wanted there to be a representation of something on stage that wasn't "acting," if you know what I mean. One of the characters had a bunny as a pet. And some of the characters had monologues to the bunny. They talked to it. My daughter had the bunny for many years. It was named Bernard — even though it was a female. The house was a character in the play also. And, of course, Nic helped create the house. We had a lot of conversations with Nic about how the set was related to the story, and what the function of the set was.

PAUL ZIMET: There was a heightened quality to everything in this house. The front of the stage of La MaMa's First Floor Theatre was outside the house, and there was grass and a croquet game that we played on. The entrance to the house was a kind of liminal space with a special quality of light. Inside the house, objects sang — if you picked up the soup pot, it sang. The kitchen sink was actually an aquarium. The house was very alive. I think we got thirteen Obie Awards for this production — Nic got one too.

Federico Restrepo, founding director of LOCO7, is a dancer, puppet designer, choreographer, and director who worked closely with Ellen Stewart and performed in many of the Great Jones Repertory Company plays she directed. Restrepo conceives works that take the form of dreamscapes rich with music, dance, and unusual, evocative puppet creations. He was a frequent collaborator with composer Elizabeth Swados. In 2002 he launched LOCO7's ten-year exploration of the immigrant experience in urban America. Deborah Jowitt in the *Village Voice* writes admiringly of the mystery and the power of Restrepo's relationship with his "puppet-self," describing this as "utterly thrilling." Re-

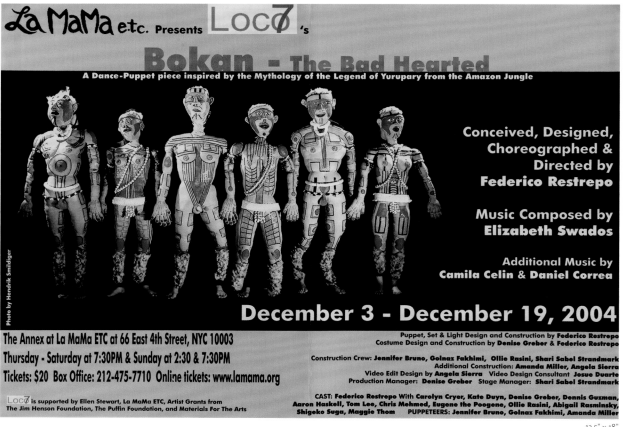

La MaMa e.t.c. Presents Loc7's

Bokan - The Bad Hearted

A Dance-Puppet piece inspired by the Mythology of the Legend of Yurupary from the Amazon Jungle

Conceived, Designed,
Choreographed &
Directed by
Federico Restrepo

Music Composed by
Elizabeth Swados

Additional Music by
Camila Celin & Daniel Correa

December 3 - December 19, 2004

Photo by Hendrik Smildiger

The Annex at La MaMa ETC at 66 East 4th Street, NYC 10003
Thursday - Saturday at 7:30PM & Sunday at 2:30 & 7:30PM
Tickets: $20 Box Office: 212-475-7710 Online tickets: www.lamama.org

Loc7 is supported by Ellen Stewart, La MaMa ETC, Artist Grants from
The Jim Henson Foundation, The Puffin Foundation, and Materials For the Arts

Puppet, Set & Light Design and Construction by **Federico Restrepo**
Costume Design and Construction by **Denise Greber & Federico Restrepo**

Construction Crew: **Jennifer Bruno, Golnaz Fakhimi, Ollie Rasini, Shari Sabel Strandmark**
Additional Construction: **Amanda Miller, Angela Sierra**
Video Edit Design by **Angela Sierra** Video Design Consultant **Josue Duarte**
Production Manager: **Denise Greber** Stage Manager: **Shari Sabel Strandmark**

CAST: **Federico Restrepo** With **Carolyn Cryer, Kate Duyn, Denise Greber, Dennis Guzman,
Aaron Haskell, Tom Lee, Chris Mehmed, Eugene the Poogene, Ollie Rasini, Abigail Rasminsky,
Shigeko Suga, Maggie Thom** PUPPETEERS: **Jennifer Bruno, Golnaz Fakhimi, Amanda Miller**

12.5" × 18"

FIG. 117: Loc07's *Bokan, The Bad Hearted*. Conceived, designed, directed, and choreographed by Federico Restrepo, 2004. The poster designer is Denise Greber. The photograph on the poster by Hendrik Smildiger centers on the human-sized puppet figures designed by Restrepo for the production. The white, black, and red ceremonial decoration on the puppet figures is echoed in the coloration of the typography on the poster—white, black, and red on a light blue background.

strepo was born and trained as a dancer in Bogotá, Colombia, before coming to the United States and developing his striking multidisciplinary art at La MaMa. *Bokan, The Bad Hearted*, which premiered December 3, 2004, and was produced with funding from the Jim Henson Foundation, is a puppet-dance work based on an Amazon Yurupary legend about the transformation of the jungle's matriarchal society into a power-hungry patriarchy.

Maureen Fleming's *Decay of the Angel* was the culmination of several workshops in Japan and the United States between 2001 and 2004. Fleming was a student of butoh masters Min Tanaka and Kazuo Ohno. Combining Fleming's unique style of slow, sculptural movement inspired by butoh with ikebana (flower arrangement), design, and multimedia, *Decay of the Angel* follows the ancient Japanese myth about an angel whose lost wings are rescued by a fisherman. In performance, Fleming descended into La MaMa's Annex as the Angel/Fisherman, circling downward from the high ceiling. Anita Gates in the *New York Times* describes this solo work as "visually amazing." Stewart introduced Fleming to Min Tanaka in 1985, which was instrumental in Fleming's pursuit of the study of butoh. Fleming's American butoh

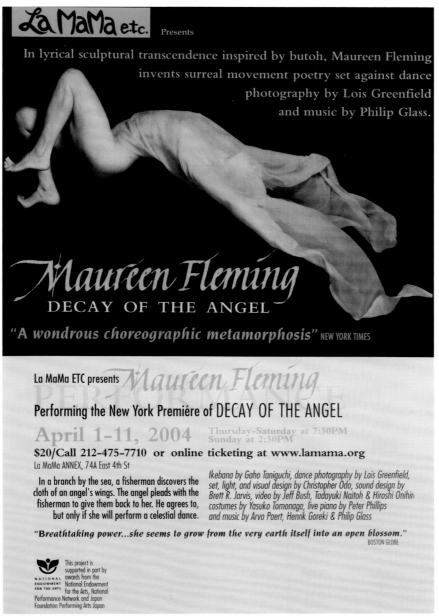

FIG. 118: *Decay of the Angel*, choreographed and performed by Maureen Fleming. Premiered April 1, 2004. Photograph on poster by Lois Greenfield. Greenfield is a renowned American photographer of movement and dance. She writes on her website (2013): "I never recombine or rearrange the dancers within my images. Their veracity as documents gives the images their mystery; and their surreality comes from the fact that our brains don't register split seconds of movement. I see the collaboration as between the dancers and myself, as well as between the two media, dance and photography. There is a dynamic tension between dance and photography. I exploit photography's ability to fragment time and fracture space, translating 360 degrees into a 2 dimensional image, and depicting moments beneath the threshold of perception."

performance work began at La MaMa with *Water on the Moon* in 1989 and *Sphere* in 1993. This poster image of Fleming captures the powerful elegance of her movements.

ELLEN STEWART (2004): I don't cast my plays. . . . In the Great Jones Repertory Company, I'm still working with people from the original group, people from 28 years ago, and now, I'm also working with their children.

———————

In 2004 Stewart took on the challenge of directing seven Greek plays simultaneously, which were presented in rotating repertory in the La MaMa Annex. *Antigone* was a new adaptation by Stewart and a new production for the Great Jones Company. Casting, design, choreography, vocal scoring, and orchestration decisions were made during rehearsals for each of the seven productions. Out of a company of sixty-seven (including musicians, technicians, and child performers) only eleven individuals were new to the Great Jones Company with the *SEVEN* project.

Stewart's *Antigone* begins with the fatal battle between the two brothers of Antigone, Eteokles and Polyneikes — a thrilling gymnastic rope-dance, which was choreographed and performed by Chris Wild and Billy Clark. In the aftermath of the brothers' deaths, Creon appears with a new character, Eteokles's wife. Including Eteokles's wife in the production is an example of one of Stewart's unusual, unexpected choices for her version of *Antigone*. As was her practice in adapting Greek myths and plays, when working on *Antigone* Stewart highlighted aspects of the plot and characters that are not mentioned or seen in other versions. In creating her plotlines and librettos Stewart studied various source materials (not just existing plays in translation), including books and artworks (sculpture, vases, bas-reliefs) provided by translator Marina Kotzamani and research assistant Charles Allcroft, among many others.

ELLEN STEWART (2004): [While doing research for *Antigone*] I found a drawing of Eteokles's wife, but there is nothing written about her. Shawneeka Woodard was a student who came to watch our rehearsals from the Borough of Manhattan Community College. I knew her teacher. If she hadn't come to us, there wouldn't have been an Eteokles's wife. . . . I want every person . . . who is with me to feel as if they are entering into what we are doing — I want them to feel part of it — and I try to create situations where we can do that.

Designer, director, performer, and puppet master Tom Lee studied Greek vases as well as other art and literature of the archaic and classical periods

FIG. 119: *SEVEN: Seven Against Thebes*, photography by Richard Greene, courtesy of La MaMa Archive, 2004. Ellen Stewart directed, with the Great Jones Repertory Company.

(including the *Iliad* and the *Odyssey*) in preparation for this imagistic, unusual multimedia work, in which he integrated shadow and bunraku puppets with animation and haunting music. The experiences of the Greek foot-soldiers (hoplites) in the Trojan War were Lee's primary inspiration. The piece was described by Elias Stimac in *Backstage* as "quietly disturbing."

Double Edge Theatre and its director, Stacy Klein, draw on the work and teachings of Jerzy Grotowski for inspiration. *The UnPOSSESSED* received accolades on its premier at La MaMa's Annex theater on October 28, 2004. *New York Times* critic Liesl Schillinger describes *The UnPOSSESSED* as "fervid and otherworldly" and the stage images as "indelible." Klein combined aerial work, shadow puppets, stilt walking, and commedia dell'arte in this performance celebrating the four hundredth anniversary of Cervantes's novel *Don Quixote*.

STACY KLEIN (2005): Being at La MaMa was a totally satisfying experience for us, a perfect space for our art. We had the right kind of support, and we had the freedom to do what we wanted artistically. Ellen was extremely emotionally supportive, and I feel like that's what she does best — support or give courage to the artists that work for her. . . . We got a huge amount of touring work based on the La MaMa performances. A lot of people came who wanted to show our work. . . .

There's really not anything comparable in this country to La MaMa. There are places in other countries. Gardzienice is similar to the way La

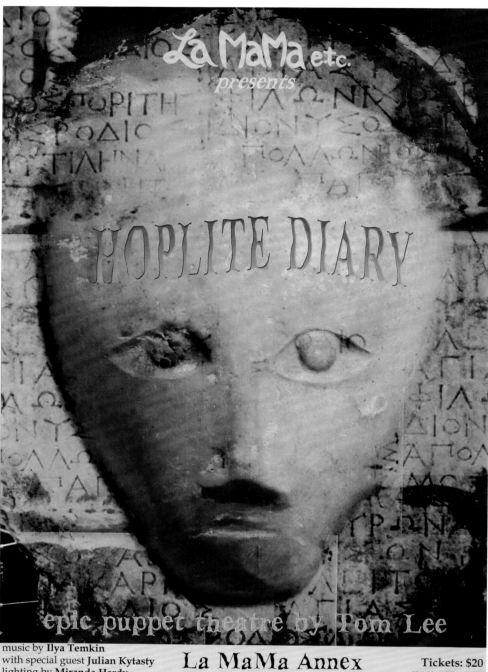

FIG. 120: *Hoplite Diary* premiered September, 30, 2004. This epic puppet work was conceived and designed by Tom Lee with support from the Jim Henson Foundation. Poster artist: Brian Snapp.

FIG. 121: *The UnPOSSESSED*, Double Edge Theatre, directed by Stacy Klein, 2004. Flyer by Justin Handley. Handley worked as composer, musical director, and associate director of Double Edge Theatre from 1998 to 2006. He joined the company as a graphic and sound designer, musician, and fund-raiser. He composed the score for the *UnPOSSESSED*; Liesl Schillinger of the *New York Times* referred to Handley's music as a "haunting score."

11" × 8.5"

MaMa runs, Odin Teatret too. There is a powerful figure in charge who helps you and who also understands that you're an artist. Not a business-person, a client, or a servant. Ellen doesn't allow rules to get in the way of the work you're doing. If you say you need more rehearsal time, she wouldn't worry about the eleven o'clock cut-off. She understands that you need to do your best in your work.

A lot of theaters become institutionalized and they're just institutions. But Ellen creates an environment that is artistic. As a producer she's an artist, in any case. . . . A lot of us have had to make masks in order to fit in or to get ahead. She is really genuine in who she is. And that is something special.

WŁODZIMIERZ STANIEWSKI, director of Gardzienice Theatre (2005): When [Stewart] was in Gardzienice with the company last June [2004] doing *The Trojan Women*, we had several hundred people in the audience who had come from all over Poland. It was very rainy and she was running

the whole performance with a stick. She looked like an incredible magician. She interacted with the audience — moved them from here to there — big crowds responding to the movement of her big stick. When some of the local women from the village came too close to the action, it was as if she suddenly cast a spell on them and magically they would move to the proper place for the performance in a matter of seconds. It was an astonishing thing, seeing a great artist in the act of creation. And she was totally wet, totally wet from the pouring rain. Many of the performers said it was the best performance they had ever played.

Before founding Gardzienice Theatre in the tiny town in eastern Poland from which the company takes its name, Staniewski worked with Jerzy Grotowski from 1971 to 1977. Director, scholar, and editor Richard Schechner described Gardzienice as "one of the world's most important experimental and community-based performance groups." Staniewski's actor-collaborators practice a technique that cultivates a visceral, intense musicality in performance. Through their creation of a unique oral soundscape, the company strives to forge an intimacy with spectators. Another precept of the company's work is mutuality — their intense connection with each other, performer to performer. For *Elektra*, Staniewski and Gardzienice Theatre worked closely on a classical play text, which was a first for the company. Staniewski describes the process in creating this production as a "dramaturgy of gestures." Staniewski's debut production at La MaMa was *Metamorphoses* in 2001.

ELLEN STEWART during rehearsals for *Perseus* (2005): I'm making this up right now. [She calls to Michael Sirotta, musical director] Michael! We need cymbals here!

Stewart described *Perseus* as a dance opera. All of her Great Jones Repertory productions are almost entirely danced and sung; the few words spoken are usually in Greek or Latin. Stewart's roots as a fashion designer persist throughout her oeuvre; her productions are always rich with spectacle, using virtually every inch of the Annex space. Her color palate ranges from vibrant primary colors and Vegas glitter to understated elegance and opulence. In reference to the costumes for *Perseus*, she told me, "Some of it was last minute, last ditch, honey. I got in my wheelchair and I mixed and matched."

At one point in rehearsal for *Perseus* Stewart and Federico Restrepo devised a way to move an important prop, a treasure chest, across the room, transported on the rolling bodies of dancers on the floor, slowly, as if by magic.

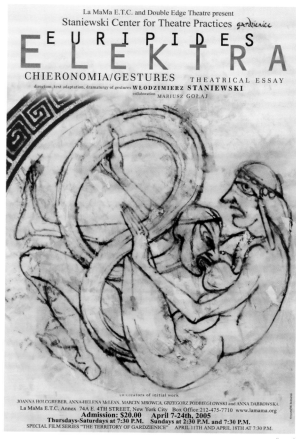

17" × 11"

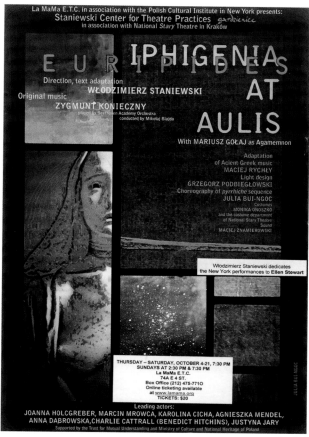

24" × 16.5"

FIG. 122 (*left*): Euripides's *Elektra*, adapted and directed by Włodzimierz Staniewski, with cocreator Mariusz Golaj, premiered at La MaMa April 7, 2005. *Elektra* poster by Krzysztof M. Bednarski, a Polish-born sculptor, installation and poster artist. The poster illustration suggests a fragment or shard of a shield or pottery depicting a snake with a human face suckling and violently coupling with a woman.

FIG. 123 (*right*): Euripides's *Iphegenia*, adapted and directed by Włodzimierz Staniewski, premiered at La MaMa on October 4, 2007. *Iphegenia* poster by Julia bui-Ngoc, sculptor, director, and dancer who also choreographed the "pyrrhic sequence" in the production. Bui-Ngoc's poster is compositionally complex; the red band around the girl's neck in the illustration, signifying Iphegenia's imminent sacrifice, is reflected in the red horizontal streak and the red lettering of *Euripides* on the poster.

STEWART: I'll have to have a huge piece of cloth. OK, ladies, roll! . . . My feet are gone (pointing to her swollen feet and ankles). But my brain is not.

FEDERICO RESTREPO (2005): The most important exercise we do with Ellen is creating the work very quickly. Something new must be created *now*, a new character, a new song, a new movement. "Help me with this," she'll say. And then we [members of the Great Jones Repertory Company] must

help someone else, too, to find the steps, to learn the movement, because she doesn't have the time to think or to allow others to think. That state of mind is very difficult, but very strengthening too. She can get very upset if you repeat something. "You did that already," she'll say. It's easy, of course, to do the same choreography with a different dress and you think she'll never notice it but she does — right away.

STEWART (2005): Andromeda was an African princess. I think if human-kind could begin to tell the truth — this history of Andromeda has been covered over. Can you imagine? All this time, no one acknowledged that she was Ethiopian, that she was black and her parents were black.

An important agenda for Stewart in this production was establishing that Perseus's wife Andromeda (the daughter of the king of Ethiopia) was a dark-skinned, African woman, not fair, as she has been depicted in artists' render-ings throughout history. Stewart cast Prisca Ouya, a dark-skinned African American actress-dancer as Andromeda opposite Chris Wild, a golden-haired white man, as Perseus.

STEWART: Chris [Wild] was perfect for Perseus. He's gorgeous. And he had to be blonde. I made him blonde.

According to the family tree Stewart inserted in the *Perseus* program, An-dromeda and Perseus had five children whose descendants included those who established the great Persian civilization as well as pivotal characters in Greek mythology and culture.

With *Perseus*, Stewart's goal was to draw attention to what she viewed as a long-held racial bias; in her onstage epilogue, which included her multiracial company in procession around the Annex portraying the major characters in Greek mythology, she represented Western culture though a more multi-cultural, multiracial lens.

Thirteen-foot puppets portray the lives of contemporary women (of Kenya, Afghanistan, and Zimbabwe) in Skipitares's play, whose experiences, sadly, reflect the oppression and brutality of Euripides's characters in *The Trojan Women*. Scenes from Euripides's play are performed by actors with puppets strapped to their backs. In the *New York Times* Ken Jaworowski singles out Skipitares's marvelous puppets and extolls the "glimmer of hope" in her pro-duction: the character of Hecuba speaks of the power of life, not death.

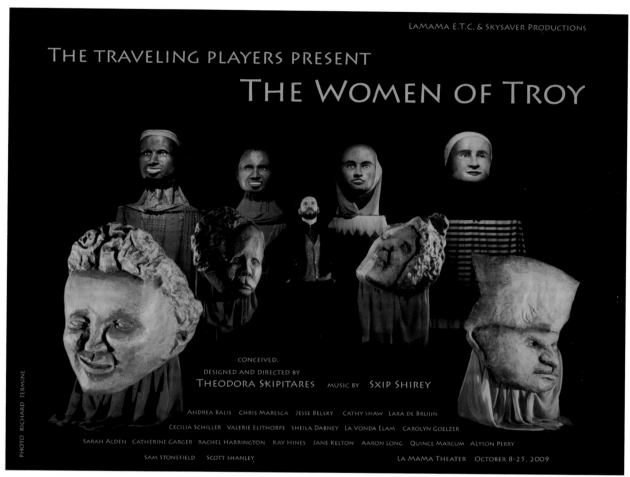

FIG. 124: *Women of Troy*, written and directed by Theodora Skipitares, premiered October 8, 2009. Poster design by Skipitares, photo on poster by Richard Termine. Termine is an accomplished Broadway and Off-Broadway photographer who served for twenty years as the production photographer on *Sesame Street* and for the Muppets. Termine is also known for portrait photography; his celebrated subjects include Bill and Hillary Clinton, Václav Havel, Elie Wiesel, Leontyne Price, and Maya Angelou.

RICHARD TERMINE, photographer (2013): When I photograph Theodora Skipitares's work, I'm not consciously thinking in terms of a poster. I'm capturing still images of a moving production. We don't start out to create a poster image, but her work is so wonderful to photograph — it's so visual, animated, and sculptural — that it easily inspires many possibilities for poster art.

THEODORA SKIPITARES (2012): There came a point for me when posters weren't very important anymore. That was when we moved fully into a

digital age. I still send out postcards. Now, in terms of big posters, I make fewer of them. But they're really important in representing the show.

I remember there were times when Ellen would see a production poster — or even a photo of mine — and she would demand a copy for herself to put in the [La MaMa] archive. She used to grab things and collect things like that. They were really important to her. Posters were very important to her legacy.

Ellen would put her two cents in about everything else. But not about the design of the posters.

Poignantly, in January 2011, the month of Stewart's death, two groundbreaking performance events exploded on La MaMa's stages, emblematic of La MaMa's ongoing, dynamic spirit and mission. On January 5, the artist-activists of the Belarus Free Theatre (political refugees from the dictatorship based in Minsk) opened the first of three plays presented in repertory at La MaMa, a coproduction with the Public Theater's Under the Radar Festival. *Being Harold Pinter* (with excerpts from Pinter's works, highlighting his controversial Nobel Prize acceptance speech and his short play *Ashes to Ashes*), *Zone of Silence*, and *Discover Love* are performed in Belarusian and Russian with projected English supertitles. The works are steeped in shattering documentary material and the startling sounds and riveting images of the brutal violence in Belarus from which the company had recently escaped. Ben Brantley, writing in the *New York Times*, states: "They should be seen by everyone who wants confirmation of the continuing relevance and vitality of theater as an art form."

On January 15, 2011, Taylor Mac's play *The Walk Across America for Mother Earth* was presented by La MaMa, a coproduction with The Talking Band. Directed by Paul Zimet, with music by Ellen Maddow, this commedia dell'arte-inspired work, which Christopher Isherwood in the *New York Times* called "one of the ten best plays of 2011," movingly and theatrically evokes the journey of a ragtag band of activists struggling to maintain their idealism, radicalism, and collectivity on a road trip to a Nevada protest. Isherwood writes that the work reflects Ellen Stewart's empathy and support for artists and the spirit of inclusiveness at La MaMa throughout its history: "theater that makes no concessions to cut-and-dried forms or cultural norms," as he put it.

PAUL ZIMET (2012): The designer from Discovering Oz that worked with us on *The Walk Across America for Mother Earth*, Kanan Shah, had a very

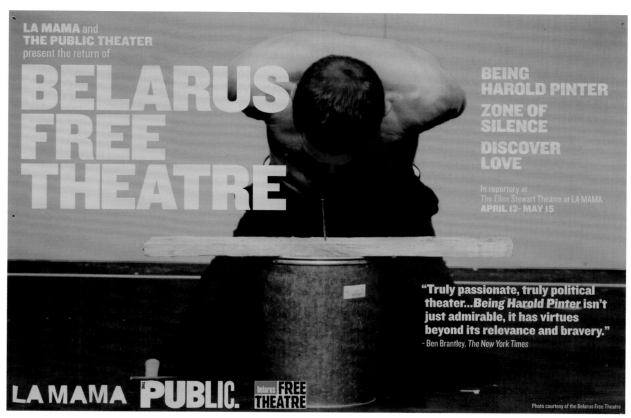

LA MAMA and
THE PUBLIC THEATER
present the return of

BELARUS FREE THEATRE

BEING
HAROLD PINTER

ZONE OF
SILENCE

DISCOVER
LOVE

In repertory at
The Ellen Stewart Theatre at LA MAMA
APRIL 13- MAY 15

"Truly passionate, truly political
theater...*Being Harold Pinter* isn't
just admirable, it has virtues
beyond its relevance and bravery."
- Ben Brantley, *The New York Times*

LA MAMA THE PUBLIC. belarus FREE THEATRE

Photo courtesy of the Belarus Free Theatre

12" × 18.5"

pop sensibility that we liked. There were a lot of different characters repre-
sented on the poster — we had picked and chosen the ones we liked.

ELLEN MADDOW (2012): She came to rehearsal a bit. She videotaped some
of the work.

PAUL ZIMET: The poster image for *Walk Across America* was also used as
the show image for our website, for our e-blasts, on Facebook — it was about
finding an image that represents the show — and that wasn't the same for
the earlier shows and posters.

ELLEN MADDOW: This poster was created on a computer, of course [refer-
ring to *Walk Across America*], and it was very different in the Mary Frank
era. At that time we had someone on our board who was a printer and had

FIG. 125: *Being Harold Pinter, Zone
of Silence*, and *Discover Love* by
the Belarus Free Theatre, co-
productions with the Public
Theater, were performed in reper-
tory in the Ellen Stewart Theatre.
Being Harold Pinter premiered at
La MaMa on January 5, 2011. Poster
photograph courtesy of Belarus
Free Theatre and the La MaMa
Archive.

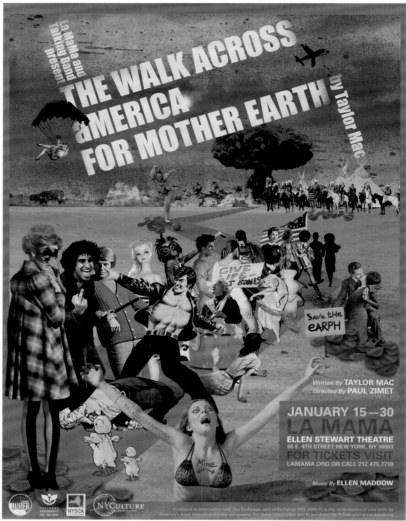

FIG. 126: *The Walk Across America for Mother Earth* by Taylor Mac, a coproduction of La MaMa and the Talking Band, premiered on January 15, 2011. Paul Zimet, director; music by Ellen Maddow. Poster design by Kanan Shah at Discovering Oz. Shah is an award-winning designer and illustrator who was born and raised in Mumbai, India.

24" × 18"

a small press — Ragged Edge Press — and we would have our posters printed there. And in those days you could only use a few colors because it was really expensive. We still send out mailings — postcards — people still like it. There's so much email now that it's lost its impact. We'll keep sending the cards out until the post office goes out of business!

The idea behind the poster was that there was a walk to a nuclear test site. None of the characters depicted here on the poster were actually represented in the play.

PAUL ZIMET: But there was a kind of Wizard of Oz feeling, which is represented here, a kind of yellow brick road. The walk was incredibly strange — that's what I like about the poster. Old people, crazy people, people of color — a very diverse collection of people went on this walk. It was

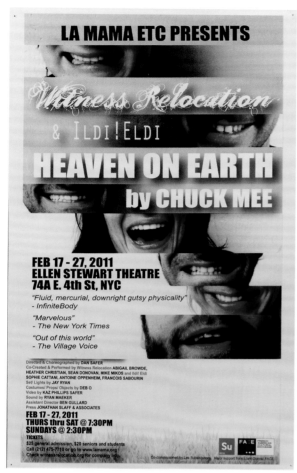

19" × 11.25"

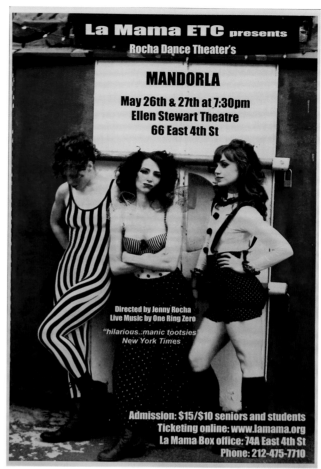

17" × 11"

radical and anarchistic but also very American in a way. The idea of a pastiche, very theatrical — was very much part of the production.

Choreographer-director Dan Safer and the company Witness Relocation produced original works at La MaMa, beginning in 2006 with *Dancing VS. The Rat Experiment*. Claudia La Rocco writes in the *New York Times* that this ensemble "aggressively blurs genres and makes high-low culture distinctions obsolete." In February 2011 Witness Relocation collaborated with members of the French collective Ildi! Eldi and playwright Chuck Mee on *Heaven on Earth*, a collage work that cites the last act of Thornton Wilder's *Our Town* and includes a mash-up of song, dance, and film.

La MaMa Moves Dance Festival celebrated its fifth year in 2010, with an expanded program in honor of Stewart's ninetieth birthday; all three of La Ma-Ma's theaters featured innovative, thematically curated dance performances.

FIG. 127 (*left*): Collaborative dance/ theater: Chuck Mee's *Heaven on Earth*, performed by Witness Relocation and Ildi! Eldi with direction and choreography by Dan Safer, premiered on February 17, 2011. Poster designer Kaz Philips Safer.

FIG. 128 (*right*): The La MaMa Moves production of Rocha Dance Theatre's *Mandorla* premiered May 26, 2011. Directed by Jenny Rocha with live music by One Ring Zero. Photo and poster design by Joseph Ribas.

Нью-Йорк Ля МаМа эксперименталдык театрынын Яра Артс Тобу сунуштайт:

Түштүн көпүрөсү
түш көрүү чегине саякат

Украин акыны Олег Лешеханын «Түш» атту поэмасынын негизде, жана Уильям Шекспирдин «Жайкы түндө көргөн түш» комедиясынан үзүндүлөр киргизилген, эксперименталдуу театралдык оюн. Оюнга америкалык жана кыргыз актерлору катышат. Оюнду койгон режиссер Вирляна Ткач.

Актерлор: Эндрю Колто, Кенжегуль Сатыбалдиева, Ильгис Жунусов, Умарбек Кадыров, Эльдияр Жарашев, Бактыгуль Акматалиева, Эрнис Боронбаев жана Нурзат Саламатова. Котормосу Кенжегуль Сатыбалдиева, Вирляна Ткач жана Ванда Фиппстики. Музыкалаштырган Нурбек Серкебаев, жарык берүүчү Бегаим Турумбекова. Костюмдар Айнура Асанбекованыкы.

30 -31- июлда (ишемби жана жекшемби күндөрү) 2011 –жылы саат 18:30
Сүрөтчүлөр союзунун галереясы, Карасаев 1, (мурдагы Б'арт борбору, Дружба көчөсү) Кирүү акысыз, алдын ала тел. (312) 59-06-41 боюнча жазылса болот.

Оюндун демөөрчүлөрү жана колдоочулары Американын Кыргызстандагы Элчилиги, Кока Кола Фонду, Б'Арт борбору, Б.Кыдыкеева атындагы жаштар театры, Яра Артс топторунун досторунун колдоосу менен ишке ашырылган.

16.5" × 11"

FIG. 129: *Dream Bridge*, created by Virlana Tkacz with the Yara Arts Group, 2011. Kyrgyz-language production poster designed by Bakai Tashiev of Toi Art Design in Bishkek. The top half of the poster presents images of three fish. The original art may have been done on delicate paper; sea plant life on the poster is painted in olive green. The logos crediting the sponsorship of this production by the Coca-Cola Company and the U.S. Embassy are prominently displayed on the bottom of the poster.

Rocha Dance Theatre's *Mandorla*, which critic Amy Lee Pearsall calls "enchanting and hilarious," was a highlight of the 2011 La MaMa Moves season. Pearsall describes Jenny Rocha's choreography as "a no-holds-barred mixture of modern, hip-hop, and jazz, rife with lifts, spins, body rolls, athletic extensions, beautiful lines."

La MaMa resident director Virlana Tkacz, of the Yara Arts Group, created *Dream Bridge* with Yara artists from New York, Kyrgyzstan, and Ukraine. Based on a poem by Oleh Lysheha, the production uses fragments from Shakespeare's *A Midsummer Night's Dream* (mentioned in the poem), as well as the dreams and nightmares of the participants. In the United States the work is performed in English, Ukrainian, and Kyrgyz. The poster reproduced here is from the Kyrgyz language production, which premiered July 30, 2011.

———————————

VIRLANA TKACZ (2013): I had told Bakai that our production, which was based on a poem by Oleh Lysheha, had an ensemble of fish in it. We agreed that fish might be a good image for the show. I mentioned that I was fascinated with *gyotaku*, the Japanese art of making fish prints [*gyo* means fish and *taku* means to rub in order to get an impression]. Bakai really liked the idea and we went to a food market and bought fish, both fresh and dry, and started to experiment. We also picked some grass along the way to use as seaweed. We tried various colors and shapes till we hit on a combination we liked. I think the impressions we used were from the dried fish. Bakai manipulated these impressions for his poster design.

———————————

On Sunday, October 16, 2011, from 1:00 to 6:00 p.m. La MaMa hosted an eclectic, multicultural street party with the Blue Man Group, Douglas Dunn and Dancers, a gospel choir, beat box performers, puppeteers, Gypsy punk-rock band Bad Buka, Circus Amok, Nicky Paraiso, and Silver Cloud Native American Drummers and Singers entertaining the flowing, exuberant crowd. Activities for children included mask making with Ping Chong, hula dancing and lei making with the Pua Ali'I 'Ilima company, and puppet and flute making. La MaMa archive director Ozzie Rodriguez conducted tours of the La MaMa Archive and Ellen Stewart's private collection throughout the day.

The culminating event of the block party was renaming, by city officials, East Fourth Street between Second Avenue and Third Avenue "Ellen Stewart Way," and the stirring, joyful noise of a neighborhood-wide bell ringing. The local event was enhanced by the bell ringing of churches, mosques, and temples around the world, via video link, in celebration of La MaMa's golden

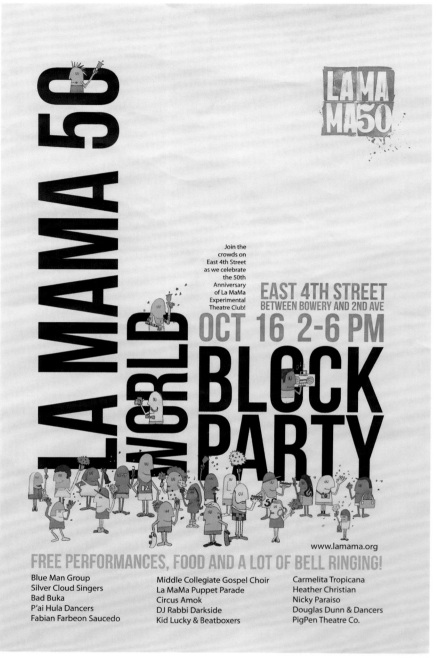

FREE PERFORMANCES, FOOD AND A LOT OF BELL RINGING!

Blue Man Group
Silver Cloud Singers
Bad Buka
P'ai Hula Dancers
Fabian Farbeon Saucedo

Middle Collegiate Gospel Choir
La MaMa Puppet Parade
Circus Amok
DJ Rabbi Darkside
Kid Lucky & Beatboxers

Carmelita Tropicana
Heather Christian
Nicky Paraiso
Douglas Dunn & Dancers
PigPen Theatre Co.

FIG. 130: October 16, 2011: La MaMa
50 Block Party, poster designer
Marc Bovino, Discovering Oz.

36" × 33"

anniversary and of its founder, Ellen Stewart, who began many performances at her theaters by ringing a bell, summoning audiences to attention. A gala celebration followed on the evening of October 17, attended by Mayor Michael Bloomberg and theater and film luminaries. These events officially launched La MaMa's fiftieth-anniversary season. Ping Chong's revival of

Angels of Swedenborg, performed by the Great Jones Repertory Company, was the opening production of the season. Elizabeth Swados's *La MaMa Cantata* celebrated what would have been Stewart's ninety-second birthday. Forty-plus other artists including Theodora Skipitares, Dario D'Ambrosi, Split Britches, Virlana Tkacz and the Yara Arts Group, Yoshiko Chuma, Meredith Monk, Mario Fratti, Ozzie Rodriguez, the Talking Band, Scott Whitman, and John Jesurun produced revivals and new works at La MaMa from October 2011 to June 2012, in tribute to the fiftieth-anniversary year and the season La MaMa titled "Homecomings."

Mia Yoo decided to begin the first season after Stewart's passing with *Angels of Swedenborg* (1985, premier; La MaMa debut, October 27, 2011) and spoke of the similarities between Ping Chong's and Ellen Stewart's artistic visions — especially the multidisciplinarity of their work and their interest in exploring ancient and modern myths. Ping Chong's dance-theater-multimedia piece was inspired by the writings of eighteenth-century philosopher and scientist Emanuel Swedenborg. Chong has been a resident artist at La MaMa since 1978; this marked the first time in four decades (since Serban's tenure as director) that the Great Jones Company worked with a director other than Ellen Stewart.

La MaMa Cantata was Elizabeth Swados's exhilarating love letter to Ellen Stewart — a moving and alternately hilarious tribute to La MaMa and a unique La MaMa manifesto. An excerpt was presented first at the La MaMa fiftieth-anniversary gala on October 17; the piece was performed next in its entirety on what would have been Stewart's ninety-second birthday (November 7). Swados's work moves smoothly from one musical tradition to another; the performance is staged as a concert, with seventeen young, sexy singers. Stewart herself is voiced and embodied by six performers (including one young man) because, Swados claimed, one actor could not possibly play "such a vast, multifaceted, incomprehensible character." Swados's rhythmic, melodious, and richly detailed portrait of Stewart and the history of La MaMa is built on materials meticulously gathered from the La MaMa Archive, including interviews with and written texts by and about Stewart. Stewart, the force of nature, and Swados's exuberance resonate throughout — passionate, feisty, and provocative.

Mia Yoo's work as a member of the Great Jones Repertory Company, first under Serban's direction and later Stewart's, was extensive; her arresting, lyrical performances as Electra, Medea, and Jocasta (in *Seven Against Thebes*) were particularly memorable. Yoo's leadership role at La MaMa began in 2005 when she and Stewart participated together in a TCG Mentor/Mentee Fellowship Award program. Stewart formally passed the baton of La MaMa artistic director to Yoo in 2009. After Stewart's death, Yoo's interest in and

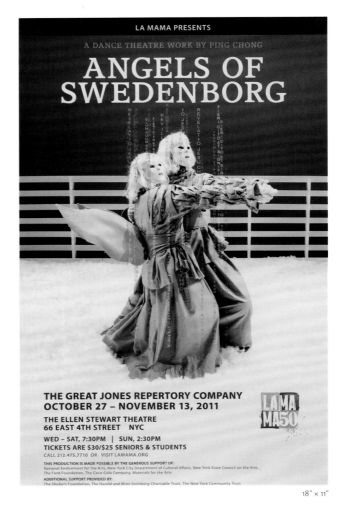

LA MAMA PRESENTS

A DANCE THEATRE WORK BY PING CHONG

ANGELS OF SWEDENBORG

THE GREAT JONES REPERTORY COMPANY
OCTOBER 27 – NOVEMBER 13, 2011

THE ELLEN STEWART THEATRE
66 EAST 4TH STREET NYC

WED – SAT, 7:30PM | SUN, 2:30PM
TICKETS ARE $30/$25 SENIORS & STUDENTS
CALL 212.475.7710 OR VISIT LAMAMA.ORG

THIS PRODUCTION IS MADE POSSIBLE BY THE GENEROUS SUPPORT OF:
National Endowment for the Arts, New York City Department of Cultural Affairs, New York State Council on the Arts,
The Ford Foundation, The Coca-Cola Company, Materials for the Arts

ADDITIONAL SUPPORT PROVIDED BY:
The Shubert Foundation, The Harold and Mimi Steinberg Charitable Trust, The New York Community Trust

18" × 11"

FIG. 131: *Angels of Swedenborg*, by Ping Chong. Poster design, Discovering Oz. Poster photograph, Damia Cavallari, 2011.

support of initiatives that embrace community connections and intergenerational programming at La MaMa have been key to her imprint as artistic director. The high-tech emphasis of CultureHub, a joint venture with the Seoul Institute of the Arts, was launched in 2009. This program speaks to the move beyond disciplinary, cultural, and aesthetic boundaries, to the innovation and creativity that are integral to Mia Yoo's vision for La MaMa. Billy Clark, Great Jones Repertory Company member and CultureHub director, connects the program's mission directly to Stewart's legacy and the history of La MaMa.

BILLY CLARK (2013): Ellen always embraced experimentation — people like John Jesurun found a home at La MaMa. If she believed in you — the person — it didn't matter what you did. The technology, and why we

FIG. 132: *La MaMa Cantata* composed and directed by Elizabeth Swados. Tour photograph, Raffael Toledo, 2011. Courtesy of La MaMa Archive.

focused on this particular technology [telepresence], came about because of the goal to have greater interaction and to grow relationships. The ultimate goal is to find new methodologies and new forms for making art.

Connecting people together through these new technologies directly follows Ellen's mission, which is to make the world better by furthering your understanding of people who are not exactly like you.

We use motion-capture technology; we collaborate with animators. We're not just working with audio and visual data. We are working with real and virtual environments. We can have "real" performance work happen simultaneously in two different spaces. We are able to have dancers in Seoul dancing together with dancers in New York.

La MaMa artists in our Co-Lab program — like Federico Restrepo and others — work with young people on how to use these technologies in making performance. Our interest, Ellen's interest, Mia's interest — is not just in emerging artists but in supporting, developing, and expanding an intergenerational dialogue on an international level.

CultureHub is actually an extension of Ellen's practice of designing spaces and making them available to artists — large and flexible spaces — in which experimentation can happen. The Annex — now called the Ellen Stewart Theatre — is a perfect example of this. We're bringing the principles that Ellen has always worked with into a new kind of work space, and looking at how we can expand our collaborations across time, space, geography. We're providing artists with access to a set of tools in order to help them work together.

FIG. 133: Ellen Stewart and Harvey Fierstein, celebrating the opening of *Hairspray* on Broadway, 2002. Unattributed photo courtesy of La MaMa Archive.

It still boils down to personal relationships, and mentorship, which will continue to be a real focus for CultureHub and for La MaMa. There is such a rich, diverse community of artists at La MaMa — in New York and around the world — and this technology facilitates meetings and collaborations that could never have been possible before. This moves young people, young artists, beyond the initial connections they make through social media to a new way of connecting through art. To tie this back to Ellen: it's really all about the cross-pollination. There's nothing she loved better than bringing people together to form unique combinations. For example, an African dancer performs with a Japanese flute player and an Indian drummer. Ellen was among the first to work in this way, and it's what we will continue to do, moving forward.

BIBLIOGRAPHY

Allain, Paul. *Gardzienice: Polish Theatre in Transition*. London: Harwood Academic
 Publishers, 1997.
Banes, Sally. *Greenwich Village 1963: Avant-Garde Performance and the Effervescent
 Body*. Durham, NC: Duke University Press, 1993, 51.
Baraka, Amiri. Phone interview with author. January 19, 2005.
Barnes, Clive. "Stage: Café La Mama II." *New York Times*. April 5, 1969.
Barnes, Clive. "'A Rat's Mass' Weaves Drama of Poetic Fabric." *New York Times*.
 November 1, 1969, 39.
Barnes, Clive. "Serban's Trilogy Is an Event." *New York Times*. October 20, 1974, 64.
Bottoms, Stephen J. *Playing Underground: A Critical History of the 1960s Off-Off-
 Broadway Movement*. Ann Arbor: University of Michigan Press, 2004.
Brainard, Joe. *The Collected Writings of Joe Brainard*. Edited by Ron Padgett. New
 York: Library of America, 2012.
Brantley, Ben. "Egon Shiele Seen from Many Angles." *New York Times*. December 12,
 2010.
Brantley, Ben. "From Belarus: Dynamic Drama with Limited Means." *New York
 Times*. April 18, 2011.
Brown, Kathan. *Ink, Paper, Metal, Wood: Painters and Sculptors at Crown Point Press*.
 San Francisco: Chronicle Books, 1998.
Bruckner, D. J. R. "Stage: 'Mythos Oedipus' at La Mama." *New York Times*. February
 11, 1988.
Bruckner, D. J. R. "Cleaning, Worrying, Rebelling." *New York Times*. October 27,
 1994.
Brukenfeld, Dick. Review of "Horse Opera." *Village Voice*. December 23, 1974, 88.
Bryant-Jackson, Paul K. and Lois More Overbeck, Eds. "Adrienne Kennedy: An Inter-
 view." In *Intersecting Boundaries: The Theatre of Adrienne Kennedy*. Minneapolis:
 University of Minnesota Press, 1992, 3–12.
Bush, Catherine. "View from the top: John Jesurun's cinematic theatre." *Theatre
 Crafts*. August/September 1985, 46–49, 70–72.
Byrd, David. Phone interview with Elise LaPaix. November 5, 2013.
Byrd, David. "David Edward Byrd." *David Edward Byrd*. N.d. Web. January 1, 2014.
 http://www.david-edward-byrd.com/
"Cafes & Coffeehouses." *Village Voice*. July 26, 1962, 13.
Chong, Ping. Interview with author. New York. January 18, 2012.
Clark, Billy. Phone interview with author. July 6, 2013.
Clurman, Harold. Review of *The Architect and the Emperor of Assyria*. *Nation*. June 19,
 1976.

Coigney, Martha. Interview with author. New York. May 27, 2005.

Collins, Glenn. "In 'Safe Sex,' Harvey Fierstein Turns Serious." *New York Times*. April 5, 1987.

"Copiers." *Carbons to Computers*. N.d. Web. January 1, 2014. http://www.smith sonianeducation.org/scitech/carbons/copiers.html

Corry, John. "Stage: 'Directions to Servants' of Shuji Terayama at La Mama." *New York Times*. June 21, 1980.

Crespy, David A. *Off-Off Broadway Explosion: How Provocative Playwrights of the 1960s Ignited a New American Theater*. New York: Back Stage Books, 2003.

Crespy, David A. "A Paradigm for New Play Development: The Albee-Barr-Wilder Playwrights Unit." *Theatre History Studies* 26 (2006): 31–51.

Curley, Nick. "Egon, Baby, Gone." *City Arts*. November 24–December 7, 2010, 14.

Dace, Tish. "Wilford Leach: It's a Short Step from La Mama to Broadway." *Village Voice*. May 10, 1976, 143.

D'Ambrosi, Dario. Phone interview with author. June 6, 2005.

De Jong, Cees W., Alston W. Purvis, and Martijn F. LeCoultre. *The Posters: 1000 Posters from Toulouse-Lautrec to Sagmeister*. New York: Abrams, 2010.

Drukman, Steven. "'The Three Sisters' Across Time." *New York Times*. January 19, 1997, sec. 2, 7.

Dunning, Jennifer. "Death-Life Celebration By Muteki-Sha Troupe." *New York Times*. October 29, 1989, 63.

Eng, Alvin. "'Some Place to Be Somebody': La Mama's Ellen Stewart." In *The Color of Theatre: Race, Culture and Contemporary Performance*, edited by Roberta Uno. London: Continuum, 2002, 135–44.

Fischer, Iris Smith. *Mabou Mines: Making Avant-Garde Theater in the 1970s*. Ann Arbor: University of Michigan Press, 2011.

Foster, Paul. Interview with author. New York. August 13, 2003.

Frank, Mary. Interview with author. New York. January 30, 2013.

Gallo, Max. *The Poster in History*. Translated by Alfred Mayor and Bruni Mayor. New York: Norton, 2002, 10.

Greber, Denise. Email correspondence with the author. August 20, 2015.

Gussow, Mel. "The Stage: Fragments." *New York Times*. June 26, 1974, 27.

Gussow, Mel. "Stage: Good-Natured 'Horse Opera.'" *New York Times*. December 19, 1974, 57.

Gussow, Mel, and Bruce Weber. "Ellen Stewart Dies at 91; Put Off Off Broadway on Map." Obituary. *New York Times*. January 14, 2011, B9.

Gussow, Mel. "Stage: World Premiere of Samuel Beckett's 'Rockaby' at State U." *New York Times*. April 4, 1981. Web. December 31, 2013. http://www.nytimes .com/1981/04/12/theater/stage-world-premiere-of-samuel-beckett-s-rockaby-at -state-u.html.

Harris, William. "Looking for a Better Song." *Village Voice*. October 23, 1984, 113.

Healy, Patrick. "Playwrights' Nurturing Is the Focus of a Study." *New York Times*. January 14, 2010. Web. June 30, 2015. http://www.nytimes.com/2010/01/14 /theater/14playwrights.html

Hearn, Michael Patrick. *The Art of the Broadway Poster*. New York: Ballantine Books, 1980.

Henderson, Mary C. *Broadway Ballyhoo: The American Theater Seen in Posters, Photographs, Magazines, Caricatures, and Programs.* New York: Abrams, 1989.

Henderson, Mary C. *Theater in America: 200 Years of Plays, Players, and Productions.* New York: Abrams, 1991.

Henderson, Mary C. *The City and the Theatre: The History of New York Playhouses. A 250 Year Journey from Bowling Green to Times Square.* New York: Back Stage Books, 2004.

"History." *Sharpie/Permanent Markers, Highlighters, Fabric Markers, Pens and More.* N.d. Web. January 1, 2014. http://www.sharpie.com/enMY/SharpieInfo/Pages /History.aspx

Hodge, Alison. "Włodzimierz Staniewski: Gardzienice and the Naturalized Actor." In *Twentieth Century Actor Training*, edited by Alison Hodge. London: Routledge, 1999, 224–44.

Holden, Stephen. "Theater: Two Aspects of Polish Heroism at La Mama." *New York Times.* October 20, 1984.

Holden, Stephen. "Beckett Trilogy at La Mama Annex." *New York Times.* March 8, 1985.

Holden, Stephen. Review of "Triplets in Uniform." *New York Times.* February 24, 1988.

Holden, Stephen. Review of *500 Years: A Fax from Denise Stoklos to Christopher Columbus. New York Times.* February 3, 1993.

Horn, Barbara Lee. *Ellen Stewart and La Mama: A Bio-Bibliography.* Westport, CT: Greenwood Press, 1993.

Huntsman, Jeffrey, and Hanay Geiogamah. *New Native American Drama: Three Plays by Hanay Geiogamah.* Norman: University of Oklahoma Press, 1980.

Ikegami, Naoya. "Ohno Kazuo Photo Exhibition: Photographers' Beloved Butoh Dancer (Group)." *ARTLINKART | Chinese Contemporary Art Database.* N.d. Web. January 1, 2014. http://www.artlinkart.com/en/artist/exh_yr/c1ebAyto /be2eyzu

Institut Neerlandais. "Gare Du Nord: Dutch Photographers in Paris, 1900–1968." Press release for exhibition May 24–July 29, 2012. Web. January 1, 2014. http:// www.institutneerlandais.com/tentoonstelling/PDF/Gare_du_Nord/DEFPress releaseGareduNordDutchphotographersinParis2012.pdf

Isherwood, Charles. "Protesters Armed with Wigs and Sequins." *New York Times.* January 20, 2011.

Jaworoski, Ken. "Pain, Old and New, with Glints of Hope." *New York Times.* October 16, 2009.

Jefferson, Margo. "Theatre: The Space Can Make the Stage." *New York Times.* January 14, 2001.

Jesurun, John. Phone interview with author. January 23, 2013.

John, David G. "The First Black Gretchen: Fritz Bennewitz's *Faust I* in New York." *Monatshefte* 94, no. 4 (2002): 447–463.

Jong, Cees De, Alston W. Purvis, and Coultre Martijn F. Le. *The Poster: 1,000 Posters from Toulouse-Lautrec to Sagmeister.* New York: Abrams, 2010.

Jowitt, Deborah. "Transformations of Space, Community and Body Spirits Rising." *Village Voice.* October 9, 2002.

"Julia Bui-Ngoc and Mai Bui-Ngoc." *Centrum Sztuki Współczesnej Zamek Ujazdowski*. Project Room, Center for Contemporary Art, Ujasdowski Castle. 2012. Web. January 1, 2014. http://csw.art.pl/index.php?action=aktualnosci

Kaufman, David. *Ridiculous! The Theatrical Life and Times of Charles Ludlam*. New York: Applause, 2002.

Killacky, John. From "Meredith Monk in Conversation." La Mama. January 23, 2012.

Klein, Stacy. Phone interview with author. January 14, 2005.

Kley, Elizabeth. "Alter Egon." N.d. Web. January 2, 2013. http://www.artnet.com/magazineus/features/kley/john-kelly.asp

Kramer, Hilton. "Postermania." *New York Times Magazine*. February 11, 1968, 30.

Lahr, John. "The Pathfinder: Sam Shepard and the Struggles of American Manhood." *New Yorker*. February 8, 2010, 68–70.

La Rocco, Claudia. "Caught in a Whirlwind: Mad Scientists and a Butterfly." *New York Times*. January 20, 2009.

Leverett, James. "Tadeusz Kantor 1915–90: Creator of Incomparable Works for the Stage." *Village Voice*. January 1, 1991, 83.

Lewallen, Constance. *Joe Brainard: A Retrospective*. With essays by Carter Ratcliff and John Ashbery. Berkeley: University of California, Berkeley Art Museum; New York: Granary, 2001.

Ludlam, Charles. *Ridiculous Theatre: The Scourge of Human Folly*. New York: Theatre Communications Group, 1992.

Maddow, Ellen. Interview with author. New York. November 29, 2012.

Magie Domenic Collection of Caffe Cino Materials, Billy Rose Theatre Collection, New York Public Library for the Performing Arts. *T-Mss 2011–252.

Marks, Peter. "A Chekhov Production Unrelated to Any Other." *New York Times*. January 21, 1997, C11.

McMullan, James. "Lincoln Center Theater: James McMullan." Transcript of an interview with Thomas Cott on December 16, 1998. *Lincoln Center Theater: James McMullan*. N.d. Web. January 1, 2014. http://www.lct.org/showMain.htm?id=89

McNulty, Charles. "After the Fall: East Coast Artists, An Ensemble for the '90s." *Village Voice*. June 1, 1993, 88.

Meggs, Philip B. and Alston W. Purvis. *Meggs' History of Graphic Design*. Hoboken, NJ: John Wiley & Sons, 2011.

Melfi, Leonard. *Encounters: Six One-Act Plays*. New York: Samuel French, 1967, v–x.

"Milestones — Chronology." *History of Kodak*. N.d. Web. January 1, 2014. http://www.kodak.com/ek/US/en/Our_Company/History_of_Kodak/Milestones_-_chronology/Milestones-_chronology.htm

"Mirko Ilic." *Observer Media: Design Observer*. N.d. Web. January 1, 2014. http://observermedia.designobserver.com/audio/mirko-ilic/37338/

Monk, Meredith. From "Meredith Monk in Conversation." La Mama. January 23, 2012.

Monk, Meredith. Phone interview with author. February 25, 2013.

Nelson-Cave, Wendy. *Broadway theatre posters*. New York: Smithmark Publications, 1993.

New Dramatists. N.d. Web. January 3, 2014. http://newdramatists.org/taylor-mac/walk-across-america-mother-earth

"New Set of 'Drips' Installed at Mark Ravitz's 200 Seventh Avenue — HOME — Here's Park Slope." N.d. Web. January 1, 2014. http://www.heresparkslope.com/home/2012/4/30/new-set-of-drips-installed-at-mark-ravitzs-200-seventh-avenu.html

Novick, Julius. "An Old Story With Kinky New Twists." *New York Times*. February 26, 1993, 77.

O'Horgan, Tom. "The New Troupe." *Players Magazine* 45 (June–July 1970): 211–15, 250–51.

O'Horgan, Tom. Interview with author. New York. July 1, 2003.

Patrick, Robert. Letter to La MaMa recalling "BbAaNnGg!, a Benefit Gala." 1965. Courtesy of La MaMa Archive.

Pearsall, Amy Lee. Review of *Mandorla*. Web. January 3, 2014. http://www.nytheatre.com/Review/amy-lee-pearsall-2011-5-27-mandorla

"Pepe Ramírez Gallery." *Pepe Ramírez Gallery*. N.d. Web. January 1, 2014. http://www.miamibuenavistalions.com/old_site/pepe.htm.

"Peter Moore, 61, Dies; Photographer of Dance." *New York Times*. October 2, 1993. Web. January 1, 2014. http://www.nytimes.com/1993/10/02/obituaries/peter-moore-61-dies-photographer-of-dance.html

"Photographers. Photographer: Maria Austria." *Robertwilson.com*. N.d. Web. January 1, 2014. http://robertwilson.com/archive/photographers?photog=1596

Poland, Albert, and Bruce Mailman, editors. *The Off-Off Broadway Book: The Plays, People, Theatre*. New York: Bobbs-Merrill, 1972.

"Randy Barcelo, 48, A Stage Designer." *Obituaries. New York Times*. December 17, 1994. Web. January 1, 2014.

"Randy Barceló Collection, Cuban Heritage Collection, University of Miami Libraries." *Randy Barceló Collection, Cuban Heritage Collection, University of Miami Libraries*. N.d. Web. January 1, 2014. http://merrick.library.miami.edu/cubanHeritage/chc0454/

Reaves, Wendy Wick. *Ballyhoo! Posters as Portraiture*. Washington, DC: National Portrait Gallery, Smithsonian; Seattle: University of Washington Press, 2008.

Reed, Aileen. *Theatre Posters*. Leicester, UK: Magna Books, 1993.

Remington, R. Roger. *American Modernism: Graphic Design, 1920–1960*. New Haven: Yale University Press, 2003.

Resnick, Mark. *The American Image: U.S. Posters from the 19th to the 21st Century*. Rochester, NY: Cary Graphic Arts Press, 2006.

Restrepo, Federico. Interview with author. New York. May 23, 2005.

"Robert U. Taylor." *American Theatre Wing*. January 2013. Web. January 1, 2014. http://americantheatrewing.org/biography/detail/robert_u_taylor

Robertson, Nan. "Third World Moves into La Mama." *New York Times*. November 11, 1983, C3.

Rodriguez, Ozzie. Interviews with author. New York. November 13, 2002; November 30, 2012.

Rosenthal, Cindy. "Ellen Stewart: La Mama of Us All." *TDR* 50, no. 2 (T190) (2006): 12–51.

Rosten, Bevya. Review of *Firmament. Theatre Journal* 48, no. 2 (1996): 219–21.

Ryan, Thomas. "A Show of Dionysian Imagery at La Mama." *The Villager*, June 26, 1980, 13.

Schechner, Richard. Conversation with author. New York. 2002.

Schechner, Richard. Interview with author. New York. December 7, 2010.

Schillinger, Liesl. "A Lively Don Quixote Fantasy of Shadow Puppets and Stilts." *New York Times*. November 1, 2004.

Sell, Mike. "Introduction: A Literary Gangster from Those Primitive Times of the Twentieth Century." In *Ed Bullins: Twelve Plays and Selected Writings*, edited by Mike Sell. Ann Arbor: University of Michigan Press, 2006, 1–18.

Serban, Andrei. Interview with author. New York. October 27, 2003.

Serban, Andrei. Email correspondence with author. March 2, 2011.

Shepard, Sam. Remarks at La Mama Forty-Fifth Anniversary Gala. October 18, 2006.

Shirley, Don. "Cable Movie Review: 'Tidy Endings' Sunday on HBO deals with grief after AIDS death." *Los Angeles Times*. August 13, 1988.

Simmer, Bill. "The Theatrical Style of Tom O'Horgan." *TDR* 21, no. 2 (T74) (1977): 59–67.

Sirotta, Michael. Interview with author. New York. May 30, 2005.

Skal, David J., editor, and Robert E. Callahan, designer. *Graphic Communications for the Performing Arts*. New York: Theatre Communications Group, 1981.

Skipitares, Theodora. Interviews with author. New York. June 30, 2003; November 30, 2012.

Skoto Gallery. "Exhibition: The Luminous Landscapes and Metropolitan Facades, January 13–February 12, 2005. Press release. New York. N.d. Web. January 1, 2014.

Smithsonian Institution. *Art as Activist: Revolutionary Posters from Central and Eastern Europe*. New York: Universe Books; Washington, DC: Smithsonian Institution Traveling Exhibition Service, 1992.

Solomon, Alisa. "Dionysus in '88." *Village Voice*. February 15, 1988.

Solomon, Alisa. Review of *Belle Reprieve*. *Village Voice*. February 19, 1992, 110.

Solomon, Alisa. "Courage, Mother." *Village Voice*. November 8, 1994.

Staniewski, Włodzimierz. Phone interview with author. January 18, 2005.

Stein, Bonnie Sue. "Ghosts of Butoh Past and Present." *Village Voice*. November 17, 1989.

Stewart, Ellen. "La Mama Experimental Theatre Club." In *Eight Plays from Off-Off Broadway*, edited by Michael Smith and Nick Orzel. New York: Bobbs-Merrill, 1966, 163–64.

Stewart, Ellen. "Ellen Stewart and La Mama." *TDR* 24, no. 2 (T86) (1980):11–22.

Stewart, Ellen. Presentation at opening ceremonies for symposium on Off-Broadway at City University of New York. September 30, 2004.

Stewart, Ellen. Interviews with author. New York. November 1, 2002; June 30, 2003; June 4, 2004; May 23, 27, October 26, November 2, 2005; January 5, 2006; November 3, 2008. Bassano, Italy. July 24, 2003. Butrint, Albania. July 2007. Venice, Italy. July 2007.

Stimac, Elias. Review of *Hoplite Diary*. *Backstage* 45, no. 44 (October 29, 2004): 42.

Supon Design Group. *Absolutely Entertaining: The World of Entertainment Graphics*. Washington, DC: Supon Design Editions, 1997.

Suskin, Steven. *A Must See! Brilliant Broadway Artwork*. San Francisco: Chronicle Books, 2004.

Swados, Elizabeth. "Stretching Boundaries: The Merlin of La Mama." *New York Times*. October 26, 1986, C1, C16.

Swados, Elizabeth. Interviews with author. New York. July 2, 2003; May 10, 2005.

Tallmer, Jerry. "Julie of the Spirits." *New York Post*. April 5, 1969, 28.

Termine, Richard. Phone interview with author. January 10, 2013.

Thomas, Gerald. "Bio." *Gerald Thomas Blog*. N.d. Web. January 1, 2014. http://gerald thomasblog.wordpress.com/

Tkacz, Virlana. Email correspondence with author. November 8, 2013.

Tsuji, Yukio. Interview with author. New York. May 6, 2005.

Uno, Aquirax. *Aquirax Uno Posters 1959–1975*. Tokyo: Japan: Blues Interactions, 2003.

van Itallie, Jean-Claude. Interview with author. Bassano, Italy. July 24, 2003.

Weill, Alain. *Encyclopédie de L'Affiche*. Paris: Éditions Hazan, 2011.

Wetzsteon, Ross. "Chaikin and O'Horgan Survive the '60s." *Village Voice*. November 3, 1975, 81, 82, 84, 86, 136.

"Xerox History Timeline of Business Innovation and Design." *Xerox History Timeline of Business Innovation and Design*. N.d. Web. January 1, 2014. http://www.xerox .com/about-xerox/history-timeline/enus.html.

Yoo, Mia. Interview with author. Bassano, Italy. July 25, 2003.

Zimet, Paul. Remarks at opening ceremony of symposium on Off Broadway, held at City University of New York, September 30, 2004.

Zimet, Paul. Interview with author. New York. November 29, 2012.

Zinoman, Jason. "Music and Marshmallows, in Sync." *New York Times*. July 28, 2005.

ILLUSTRATION CREDITS

If no photographer is named, the works were photographed by Carol Rosegg with post-production by Amy Klein. All names listed in quotation marks refer to the signature found on the poster. Poster dimensions are in inches, height before width.

Frontispiece: Original artwork by Leonard Melfi, presented as a birthday gift to Stewart in 1972. Collage, stencil, type, Magic Marker, photography. Courtesy of La MaMa Archive.

Fig. 1. Photo of Ellen Stewart and La MaMa Archive director Ozzie Rodriguez, 1985. George Ferencz, photographer, courtesy of La MaMa Archive.

Fig. 2. Map of early Off-Off-Broadway theater spaces.

Fig. 3. Photo of Ellen Stewart at Café La MaMa, 82 Second Avenue, 1966. Photo by Dan McCoy, courtesy of the photographer.

Fig. 4. *One Arm*, 1962. Unattributed. 26" × 38".

Fig. 5. *Balls*, 1964. Unattributed. 14" × 17".

Fig. 6. *Balm in Gilead*, 1965. Unattributed. 69" × 29".

Fig. 7. *The Recluse*, 1965. "Lewis." 30" × 13.75".

Fig. 8. *The Recluse*, 1965. Yayoi R. Tsuchitani. 30" × 24".

Fig. 9. *Madonna in the Orchard*, 1965. Unattributed. Photograph on poster by James Gossage. 14" × 17".

Fig. 10. Costume designed by Ellen Stewart for *Madonna in the Orchard*, 1965.

Fig. 11. *Love Song for Mrs. Boas*, 1965. Joe Brainard. 11.25" × 8.5".

Fig. 12. *Love Song for Mrs. Boas*, 1965. Kenneth Burgess. 40" × 30".

Fig. 13. *El Rey se Muere*, 1968. Jon Oberlaender. Lithography by Escama. 19.5" × 14".

Fig. 14. *El Metro*, 1968. "Dugie." Lithography by Escama. 12.25" × 8.75".

Fig. 15. First European tour, 1965. Unattributed. 14" × 17".

Fig. 16: *White Whore and the Bit Player*, 1965. Unattributed. 17" × 12".

Fig. 17. Third European tour — La MaMa in Denmark, 1967. Unattributed. 23.25" × 16.25".

Fig. 18. Third European tour — La MaMa at the Mercury Theatre, 1967. Unattributed. 25" × 10".

Fig. 19. *America Hurrah* and *Pavane*, 1965. Unattributed. Calligraphy by Gwen Fabricant. 14" × 9".

Fig. 20. *Open Theatre Ensemble Improvisations*, 1965. Kenneth Burgess. Photograph on poster by Phill Niblock. 30" × 19.5".

Fig. 21. *Miss Nefertiti Regrets*, 1965. Kenneth Burgess. 40" × 30".

Fig. 22. Photo of Bette Midler and Martin Peisner in *Miss Nefertiti Regrets*, by James Gossage, courtesy of the photographer, 1965.

Fig. 23. *Comings and Goings* and *The Clown Play*, 1966. Unattributed. 30" × 21".

Fig. 24. *Viet Rock*, 1966. Esther Gilman. 20" × 30".

Fig. 25. Life-size photo "cut-out" of Ellen Stewart, Tom O'Horgan, and Sam Shepard, 1966. 53" × 51". NET-TV.

Fig. 26. *East Bleeker*, 1967. Bill Barrell. 11.75" × 9.5".

Fig. 27. *Futz*, 1967. Photographs on poster by Conrad Ward. 26.5" × 18.25".

Fig. 28. *Tom Paine*, 1967. Poster for the 1971 touring production. Unattributed. 30" × 20".

Fig. 29. *Spring Play*, 1967. "Kent." 28" × 22".

Fig. 30. Third European tour — *Experimenta 2*, 1967. Unattributed. 23" × 32".

Fig. 31. *The Moon Dreamers*, 1968. Poster for the 1969 Off-Broadway production. David Byrd. 22" × 14".

Fig. 32. Photo of Ellen Stewart at 74A East Fourth Street, 1969.

Fig. 33. *Vietnamese Wedding* and *The Red Burning Light*, 1969. Photograph on poster by Conrad Ward. 26.5" × 18.25".

Fig. 34. *A Rat's Mass*, 1969. Collage including photo and program created by Ozzie Rodriguez, photo of Mary Alice by Amnon Ben Nomis. 16" × 20".

Fig. 35. *Unseen Hand* and *Forensic and the Navigators*, 1969. Robert U. Taylor. 22" × 14".

Fig. 36. Photo of Ellen Stewart at the opening of *Golden Bat*, 1970. Photo by Tokyo Kid Brothers, courtesy of La MaMa Archive.

Fig. 37. Photo of Ellen Stewart and Andrei Serban, *Medea* rehearsal, 1987. Photo by Jerry Vezzuso, courtesy of La MaMa Archive.

Fig. 38. *IFSK*, 1966. Unattributed. 26.75" × 19".

Fig. 39. *Arden of Faversham*, 1970. Unattributed. Photograph on poster by Maria Austria. 16.75" × 12".

Fig. 40. *Medea*, 1972. Unattributed. Photograph on poster by René Pari. 21.5" × 15.5".

Fig. 41. *XVII Festival International de Baalbeck*, 1972. Unattributed. 17" × 11.5".

Fig. 42. *Good Woman of Setzuan*, 1976. Unattributed. Photograph on poster by Amnon Ben Nomis. 28" × 22".

Fig. 43. *The Trojan Women*, 1974. Poster for the 1996 production, Ozzie Rodriguez. Text layout by Mary Beth Ward, mask designed by Feu Follet, photograph on poster by Rosa Lopez. 36" × 24".

Fig. 44. Mask from production of *Medea*, 1974. Mask designed by Feu Follet. 15" × 10".

Fig. 45. *The Red Horse Animation*, 1971. Unattributed. Photograph on poster by Peter Moore. 17" × 11".

Fig. 46. *Dance Wi' Me*, 1971. Unattributed. Photograph on poster by Zodiac Photographers, Joseph Abeles and Sy Friedman. 20" × 15.75".

Fig. 47. *White Whore and the Bit Player*, 1973. Jose Erasto Ramirez. 14" × 8.5".

Fig. 48. *Horse Opera*, 1974. Unattributed. 14.25" × 11.5".

Fig. 49. Photo of train set from *Horse Opera*, 1974.

Fig. 50. *Quarry*, 1976. Meredith Monk and Monica Moseley. Photograph on poster by David Geary. 22" × 16.5".

Fig. 51. *Quarry*, 1976. Meredith Monk. Typography by Monica Moseley. 28" × 18".

Fig. 52. *The Architect and the Emperor of Assyria*, 1976. Poster for the 1986 production designed by M. Ilic and N. Lindeman. 24" × 18".

Fig. 53. *Caligula*, 1977. Randy Barcelo. 22.5" × 17.5".

Fig. 54. *Shango*, 1970. Nancy Colin. 34.5" × 23.5".

Fig. 55. *La Marie Vison*, 1970. Akira Uno. 26" × 29".

Fig. 56. *Golden Bat*, 1970. Poster for the Tokyo production by Pater Sato "design to M." 28.5" × 20.25".

Fig. 57. *Golden Bat*, 1970. Sato Kenkichi. 11" × 8".

Fig. 58. Photo of Ellen Stewart at *Golden Bat* opening, 1970. Photographer unknown, courtesy of La MaMa Archive.

Fig. 59. *The City*, 1971. Unattributed. 13.5" × 10.5".

Fig. 60. *Street Sounds*, 1970. Collage created by Ozzie Rodriguez, with program; photographs in the collage by Bradley Phillips. 25" × 16".

Fig. 61. *Cops and Robbers*, 1971. Photograph on the poster by Conrad Ward. 26" × 18".

Fig. 62. Jarboro and La MaMa Italy tour, 1972. Unattributed. 17" × 11".

Fig. 63. La MaMa and New Lafayette Theatre in Milan, 1972. Unattributed. 33" × 23".

Fig. 64. *Bluebeard*, 1970. Unattributed. Black and white line drawings based on photographs by Anita Shevett and Steve Shevett. 10.5" × 8.5".

Fig. 65. *XXXXX*, 1972. Photographs by Conrad Ward collaged on the poster. 26.5" × 18".

Fig. 66. *The Sixty Minute Queer Show*, 1977. Mark Ravitz. 20" × 16".

Fig. 67. *Vain Victory: The Vicissitudes of the Damned*, 1971. Ron Lieberman. 17" × 11".

Fig. 68. *Ekathrina Sobechanskaya Dances with her Original Trockadero Gloxinia Ballet Company*, 1974. Program designed by Mel Byars, photograph on program by Roy Blakey. 12.5" × 9.5".

Fig. 69. *Ekathrina Sobechanskaya Dances with her Original Trockadero Gloxinia Ballet Company*, 1974. Poster for the 1987 production designed by Robert W. Richards. One-color line rendering based on a photograph of Larry Ree by photographer Roy Blakey. 20" × 14".

Fig. 70. *Body Indian* and *NA HAAZ ZAN*, 1972. Unattributed. Program illustrations by Robert Shorty. 9.75" × 14".

Fig. 71. *Pompeii*, 1972. Bob Olson. 17.5" × 23.75".

Fig. 72. *The Dowager*, 1978. "J. Wu." 17" × 11".

Fig. 73. *Cotton Club Gala*, 1975. Annette Harper. 28" × 20".

Fig. 74. New Play Series / Third World Rituals and Folk Dramas (TWITAS), 1976. Unattributed. 23.5" × 17.5".

Fig. 75. *International Stud*, 1978. Churchill Rifenberg. Graphic on poster from a photo of Fierstein by KISCH. 20" × 15".

Fig. 76. *Faust Part 1*, 1978. Rudy Kocevar and Wes Cronk. 16.75" × 13".

Fig. 77. *The Dead Class*, 1979. Unattributed. Photo courtesy of Cricot 2. 14" × 8.5".

Fig. 78. Photo of Ellen Stewart, 1981. Higashi Yutaka, photographer, courtesy of La MaMa Archive.

Fig. 79. Photo of Ellen Stewart and Peter Brook at *The Conference of the Birds*, 1980. Henry Grossman, photographer, courtesy of La MaMa Archive.

Fig. 80. *Tutti Non Ci Sono (All Are Not Here)*, 1980. Unattributed. 23.5" × 17".

Fig. 81. *Directions to Servants*, 1980. Unattributed. Photographs on poster, Shuji Teryama. 20.5" × 14.5".

Fig. 82. *Rockaby*, 1981. Unattributed. Photograph of Beckett on poster by Guy Suignard. 17" × 20.5".

Fig. 83. *My Mother* and *Admiring La Argentina*, 1981. Photograph on poster by Ikegami. 16" × 11".

Fig. 84. *A.M./A.M.*, 1982. Ping Chong. 6.75" × 20.75".

Fig. 85. *Money: A Jazz Opera*, 1982. Unattributed. 11" × 8.5".

Fig. 86. *Red House*, 1984. John Jesurun. 21.5" × 13.5".

Fig. 87. *Alpha*, 1984. Visual Thinking. 30.75" × 21.75".

Fig. 88. *Theatre 1, Theatre II, That Time*, 1985. Gerald Thomas. 28" × 22".

Fig. 89. *Big Mouth*, 1985. Mary Frank. 14" × 17". Mary Frank is represented by DC Moore, New York, NY and Elena Zang, Woodstock, NY.

Fig. 90. Drawing by Mary Frank of Paul Zimet and actors in rehearsal for *Big Mouth*, 1985. 11" × 17".

Fig. 91. Lion mask designed by Mary Frank for *Big Mouth*, 1985.

Fig. 92. *Mythos Oedipus*, 1985. Jannis Voreadis, poster designer. 38" × 26".

Fig. 93. *Mythos Oedipus*, 1988. Photograph on poster by Jerry Vezzuso. 24" × 16".

Fig. 94. *Safe Sex*, 1987. G2. Poster graphic by Harvey Fierstein, 22" × 14".

Fig. 95. *Road*, 1988. James McMullan. 22" × 14".

Fig. 96: *Triplets in Uniform*, 1989. Unattributed. Photography on poster by Roy Blakey. 19.5" × 12".

Fig. 97. *Dionysus Filius Dei*, 1989. Poster for 2002 production. Photography on poster by David Adams, featuring Tom Lee. 19" × 13".

Fig. 98. *Sleep and Reincarnation from Empty Land*, 1989. Evelyn Sherwood Designs, printed by Charles Stecle at Watanabe Studio, NYC. Calligraphy by Hiroko Harada. Photograph on the poster by Nourit Masson-Skine. 24" × 18".

Fig. 99. Photo of Ellen Stewart in front of the La MaMa box office, circa 1990s. Photographer unknown, courtesy of La MaMa Archive.

Fig. 100. *Belle Reprieve*, 1991. Spark Ceresa. Photograph on poster by Amy Meadow. 23.25" × 16.5".

Fig. 101. *Haunted Host*, 1991. Unattributed. 22" × 14".

Fig. 102. Blue Man Group. *Tubes*, 1991. Jonathan Epstein. Photograph on poster by Mark Seliger. 31" × 27.5".

Fig. 103. *Hibiscus*, 1992. Christine Makela. Photograph on poster by Bernie Boston. 25.25" × 18".

Fig. 104. *Big Butt Girls, Hard-Headed Women*, 1992. Unattributed. Photograph on poster by Lorraine Capparell. 17" × 11".

Fig. 105. *Underground*, 1992. George Harris. Photograph on poster by Valerie Osterwalder. 12.5" × 20".

Fig. 106. *Under the Knife*, 1994. George Harris. 18.5" × 11.5".

Fig. 107. *500 Years. A Fax from Denise Stoklos to Christopher Columbus*, 1993. Unattributed. Photograph on poster by Flander de Souza. 20.75" × 11.5".

Fig. 108. *Faust/Gastronome*, 1993. Chris Muller. 11" × 8.5".

Fig. 109. *YokastaS*, 2003. Olivier Massot. 13.5" × 11.5".

Fig. 110. *Mother*, 1994. Poster painting by Kathleen Connolly. Photograph on poster by Becket Logan. Graphic art on poster by John Dib. 24" × 16".

Fig. 111. *Pass the Blutwurst, Bitte*, 1994. John Kelly. Photograph on poster by Paula Court. 24" × 9".

Fig. 112. *Firmament*, 1995. Susan Barras. Poster illustration, Mary Frank. 17" × 11".

Fig. 113. *Virtual Souls*, 1997. Carmen Pujols. 17" × 11".

Fig. 114. Photo of Ellen Stewart at La MaMa Umbria, 2006. Kaori Fujiyabu, photographer, courtesy of La MaMa Archive.

Fig. 115. Photo of Mia Yoo as Electra, 2007. Richard Greene, photographer, courtesy of La MaMa Archive.

Fig. 116. *Painted Snake in a Painted Chair*, 2003. Nic Ularu. 17" × 11".

Fig. 117. *Bokan, The Bad Hearted*, 2004. Denise Greber. Photograph on poster by Hendrik Smildiger. 12.5" × 18".

Fig. 118. *Decay of the Angel*, 2004. Unattributed. Photograph on poster by Lois Greenfield. 18.5" × 12.5".

Fig. 119. *Seven Against Thebes*, 2004. Richard Greene, photographer, courtesy of La MaMa Archive.

Fig. 120. *Hoplite Diary*, 2004. Brian Snapp. 17" × 11".

Fig. 121. *UnPOSSESSED*, 2004. Justin Handley. 11" × 8.5".

Fig. 122. *Elektra*, 2005. Krzysztof M. Bednarski. 17" × 11".

Fig. 123. *Iphegenia*, 2007. Julia bui-Ngoc. 24" × 16.5".

Fig. 124. *Women of Troy*, 2009. Theodora Skipitares. Photo on poster by Richard Termine. 15.75" × 20".

Fig. 125. *Being Harold Pinter, Zone of Silence*, and *Discover Love* by the Belarus Free Theatre, 2011. Unattributed, courtesy of the Belarus Free Theatre and La MaMa Archive. 12" × 18.5".

Fig. 126. *The Walk Across America for Mother Earth*, 2011. Kanan Shah. 24" × 18".

Fig. 127. *Heaven on Earth*, 2011. Kaz Philips Safer. 19" × 11.25".

Fig. 128. *Mandorla*, 2011. Joseph Ribas. 17" × 11".

Fig. 129. *Dream Bridge*, 2011. Kyrgyz-language production poster designed by Bakai Tashiev of Toi Art Design in Bishkek. 16.5" × 11".

Fig. 130. Photo of La MaMa 50 Block Party, 2011. Marc Bovino. 36" × 33".

Fig. 131. *Angels of Swedenborg*, 2011. Discovering Oz. Photograph on poster by Damia Cavallari. 18" × 11".

Fig. 132. *La MaMa Cantata* on tour, 2011. Photographed by Raffael Toledo, courtesy of La MaMa Archive.

Fig. 133. Photo of Ellen Stewart and Harvey Fierstein, celebrating the opening of *Hairspray* on Broadway, 2002. Unattributed photo, courtesy of La MaMa Archive.

INDEX

XVII Festival International de Baalbeck, 59, 182

Aaso Skole Theater, 33
Abeles, Joseph, 64, 182
Abraham, F. Murray, 2
Abuba, Ernest H.: *The Dowager,* 89
Ackamoor, Idris: *Big Butt Girls, Hard-Headed Women,* 132
Acropolis, 137
Adams, David: *Dionysus Filius Dei,* 123, 184
Admiring La Argentina, 101, 102, 183
Aiden, Betsy: *Road,* 121
Akalaitis, JoAnne, 63, 147. *See also* Mabou Mines Company
Alabu, Magaly: *The White Whore and the Bit Player,* 64
Albee, Edward, 26, 49; *The Goat or Who is Sylvia?,* 46
Alice, Mary: *The Delaney Sisters,* 49; *A Rat's Mass,* 49, 51, 182
Allcroft, Charles, 154
The Allegation Impromptu, 26
Allen, Peter, 85
Allen, Seth *Caligula,* 74; *A Rat's Mass,* 49
Alpha, 111, 112, 184
A.M./A.M., 101, 103, 183
America Hurrah, 36, 37, 41, 181
American Ballet Theatre, 142
American Indian Theatre Ensemble: *Body Indian,* 85, 86, 87
American National Theatre and Academy, 46
American Place Theatre, 133
Angels of Light, 130
Angels of Swedenborg, 101, 168–69, 170, 185
Annex (aka Ellen Stewart Theatre), 6, 71; *Antigone,* 154–55; *Being Harold Pinter,*
163; *Caligula,* 74; *Cotton Club Gala,* 88; creation of, 6, 20, 56; *Decay of the Angel,* 152; *Deep Sleep,* 110; dimensions, 56; *Discover Love,* 163; *Fragments of a Trilogy,* 56; *Mother,* 140, 184; *Optic Fever,* 133; *Perseus,* 158, 160; *Quarry,* 67; renaming to Ellen Stewart Theatre, 3, 20, 148, 171; *Road,* 121; *SEVEN,* 148; *Three Sisters,* 139; *Under the Knife,* 133; *The UnPOSSESSED,* 155; *Yocastas Redux,* 139; *Zone of Silence,* 163
ANTA Theater, 46
Antigone, 8, 148, 154–55
Apocalypsis, 137
The Architect and the Emperor of Assyria, 72, 74, 182
Arden of Faversham, 8, 55, 57, 182
Arrabal, Fernando: *The Architect and the Emperor of Assyria,* 72
Artaud, Antonin, 97, 99
Ashbery, John, 97
As Is, 85, 118, 129
Astor Place, 129; *Unseen Hand,* 52, 182
Austria, Maria: *Arden of Faversham,* 57, 182

Babb, Roger, 142
Bacon, Kevin: *Road,* 121
Bad Buka, 167
Ballet des Trocaderos, 98
Balls, 26, 27, 181
Balm in Gilead, 28, 29, 48, 181
BAM, 71, 132
Banes, Sally, 14
Baraka, Amiri, 20, 105–6; *Le Metro* (*Dutchman*), 33, 105; *Money: A Jazz Opera,* 105, 106; *The Slave,* 105; *The Toilet,* 105. *See also* Jones, Le Roi
Barcelo, Randy, *Caligula,* 74, 182; *The Moon Dreamers,* 46

Barnes, Clive, 48, 49, 74
Barrell, Bill: *East Bleeker*, 41, 182
Bartenieff, George, 20; *That Time*, 112, 114; *Theatre I*, 112, 114; *Theatre II*, 112, 114
Bataille, George, 97
BbAaNnGg!, 37
Beatles: *Sgt. Pepper's Lonely Hearts Club Band*, 78
Becham, Larl: *The Cotton Club Gala*, 88, 90
Beck, Julian, 20, 112; *That Time*, 112; *Theatre I*, 112; *Theatre II*, 112. *See also* Living Theatre
Beckett, Samuel, 26, 49; *Rockaby*, 100, 101; *That Time*, 112, 114; *Theatre I*, 112, 114; *Theatre II*, 112, 114
Bednarski, Krzysztof M.: *Elektra*, 159, 185
Being Harold Pinter, 162, 163, 185
Belarus Free Theatre: *Being Harold Pinter*, 162, 163, 185; *Discover Love*, 162, 163, 185; *Zone of Silence*, 162, 163, 185
Bell, Aaron: *Cotton Club Gala*, 90, 91
Belle Reprieve, 127, 128, 184
Benjamin, Vida M.: *Hibiscus*, 131
Bennetwitz, Fritz: *Caucasian Chalk Circle*, 94; *Faust Part I*, 94, 183
Bernard, Kenneth: *The Sixty-Minute Queer Show*, 83, 85
Being Harold Pinter, 162, 163. *See also* Pinter, Harold
Bentley, Eric: *Good Woman of Setzuan*, 60
Bessie Award, 132
Big Butt Girls, Hard-Headed Women, 130, 132, 184
Big Mouth, 113, 114, 184
Black Eyed Susan: *Red House*, 108, 109
Black Panthers, 79
Blakey, Roy: *Ekathrina Sobechanskaya Dances with her Original Trockadero Gloxina Ballet Company*, 86, 183; *Triplets in Uniform*, 122, 184
Blau, Herbert, 63
Bleckner, Jeff: *Unseen Hand* and *Forensic and the Navigators*, 52
Bloolips: *Belle Reprieve*, 127, 128
Bloom, Harold, 97
Bloomberg, Michael, 149, 168
Bluebeard, 79, 82

Blue Man Group, 167; *Tubes*, 129, 130, 184
Body Indian, 85, 86, 87, 183
Bokan, The Bad Hearted, 152, 185
Boston, Bernie: *Hibiscus*, 131, 184
Bovasso, Julie, *Gloria and Esperanza*, 46, 48; *The Moon Dreamers*, 46, 47, 84; *Moonstruck*, 46
Bovino, Marc, 168, 185
Braden, John, 67; *The Sixty-Minute Queer Show*, 83
Brainard, Joe, 32, 181
Braswell, John, 7
Brecht, Bertolt, 28; *Caucasian Chalk Circle*, 94; *The Clown Play*, 40; *Good Woman of Setzuan*, 60
Breuer, Lee, 63, 86
Brook, Peter, 4, 16, 17, 20, 57; *The Conference of the Birds*, 97, 98, 183; *The Ik*, 97; *Marat/Sade*, 28; *L'Os/Ubu*, 97; *Orghast*, 58
Bruckner, D. J. R., 118, 140
Bryant-Jackson, Paul, 49
bui-Ngoc, Julia: Iphenia, 159, 185
Bullins, Ed, 77; *Clara's Old Man*, 79, 81; *Short Bullins*, 79; *Street Sounds*, 79, 80
Burgess, Kenneth: *Love Song for Mrs. Boas*, 32, 181; *Miss Nefertiti Regrets*, 38, 181; *The Open Theatre Ensemble Improvisations*, 36, 181
Buried Child, 53
Buscemi, Steve, 107, 143; *Chang in a Void Moon*, 107; *Deep Sleep*, 110; *Pass the Blutwurst, Bitte*, 143; *Red House*, 108, 109
Bush, Catherine, 107
Bush, Josef: *Shango*, 75
butoh, 4, 20, 98, 101, 115, 116, 125, 152–53
Byrd, David: *The Moon Dreamers*, 46–47, 182; *Vain Victory: The Vicissitudes of the Damned*, 84, 85
Byrne, David: *Pass the Blutwurst, Bitte*, 143

Café La MaMa, 4, 9, 22, 29, 30, 181; East Village campus, 2, 5, 20, 23, 25, 56
Caffe Cino, 6, 14, 24, 25, 27, 34, 36, 37, 67, 82, 129
Cage, Nicholas: *Moonstruck*, 46
Caligula, 74, 182
Calm Down Mother, 41
Camus: *Caligula*, 74

Capparell, Lorraine: *Big Butt Girls, Hard-Headed Women*, 132, 184
Carlson, Chester, 14
Carousel, 120
Carril, Pepe: *Shango de Ima*, 75
Carson, Johnny, 13
Cartwright, Jim: *Road*, 17, 120
Casa, 135
Cavallari, Damia: *Angels of Swedenborg*, 170, 185
Centre International de Recherche Théâtrale, 97
Ceresa, Spark: *Belle Reprieve*, 128, 184
CETA (Comprehensive Employment and Training Act): *The Dowager*, 87
Chaikin, Joseph: 39–41; *Firmament*, 142, 144; *Viet Rock*, 40
Chang, Tisa, 87
Chang in a Void Moon, 107
Channing, Stockard: *Tidy Endings*, 119
Charba, Marie-Claire, 29
Charles, Valerie: *Red House*, 108, 109
Chen, H. T., 87
Cher: *Moonstruck*, 46
Chong, Ping, 20; *A.M./A.M.*, 101, 103, 147, 183; *Angels of Swedenborg*, 101, 168–69, 170; 2011 street party, 167; Company, 104; diversity, 105; *Humboldt's Current*, 101; *Quarry*, 67, 101
Cino, Joe, 14–15, 24, 41
Circus Amok, 167
The City, 77, 79, 183
Clark, Billy, 170–72; *Antigone*, 154
The Clown Play, 40, 182
The Club, 48, 128, 130
Club 82, 104
Clurman, Harold, 72
Coca-Cola Company: *Dream Bridge*, 166
Cockettes, 130
Colin, Nancy: *Shango*, 11, 75, 182
Colton, Jacques Lynn: *Hibiscus*, 130, 131; *The White Whore and the Bit Player*, 29
Comings and Goings, 40, 41, 182
commedia dell'arte, 97, 155, 162
Comprehensive Employment and Training Act: *The Dowager*, 87
Concklin, Eric: *The Haunted Host*, 129; *International Stud*, 93; *Safe Sex*, 119; *Torch Song Trilogy*, 93
The Conference of the Birds, 97, 98
Connolly, Kathleen: *Mother*, 140, 184

Cops and Robbers, 81, 183
Connolly, Kathleen: *Mother*, 140
Constant Prince, 137
Corry, John, 98
Cott, Thomas, 121
The Cotton Club Gala, 6, 20, 88, 90, 91, 183
Court, Paula: *Pass the Blutwurst, Bitte*, 143, 184
Cricot 2, 20; *The Dead Class*, 94, 95, 183
Crystal, Billy, 1; *Arden of Faversham*, 57; *Ubu*, 57
Cultural Odyssey, 132
CultureHub, 170, 171, 172
Cunningham, Merce, 97
Curtis, Jackie: *Vain Victory: The Vicissitudes of the Damned*, 84, 85
Curtis, Simon: *Road*, 120, 121
Cusack, Joan: *Road*, 121

Dabney, Sheilia: *Mythos Oedipus*, 115
Dafoe, Willem: *Pass the Blutwurst, Bitte*, 143
Dalai Lama, 130
Dalí, Salvador, 28
D'Ambrosi, Dario, 20, 97, 98, 169; *Tutti Non Ci Sono (All Are Not Here)*, 99
Dance Theatre Workshop, 142
Dance Wi' Me, 63, 64, 182
Darling, Candy: *The White Whore and the Bit Player*, 64, 65
Davis, R. G., 63
DC Moore, 113, 184
The Dead Class, 94–95, 139, 183
Dear Friends, 27
Decay of the Angel, 152, 153, 185
Deep Sleep, 110
DeNiro, Robert, 2
de Shields, Andre, 1, 91
de Vries, Jon: *Good Woman of Setzuan*, 60
Diamond, David, 97
Dib, John: *Mother*, 140, 184
Dionysus Filius Dei, 8, 123, 184
Directions to Servants, 183
Discover Love, 162, 163, 185
Discovering Oz: *Angels of Swedenborg*, 170, 185
Dog, 53
Dog's Eye View, 107
Doris Duke Foundation, 6, 48

Double Edge Theatre: *The UnPOS-
 SESSED*, 155, 157
Douglas Dunn and Dancers, 167
The Dowager, 87, 89, 183
Drama Desk Award, 42, 93
Dream Bridge, 166, 167, 185
Dukakis, Olympia, 2; *Moonstruck*, 46
Dunn, Douglas, 142, 167
Dunning, Jennifer, 125
Duo Theater: *The White Whore and the
 Bit Player*, 64, 65
Dutchman, 33, 105, 181

East Bleeker, 41, 42, 182
East Coast Artists: *Faust/Gastronome*,
 138; *Three Sisters*, 137
Eastman, George, 13
Eichelberger, Ethyl: *Chang in a Void
 Moon*, 107
*Ekathrina Sobechanskaya Dances with
 her Original Trockadero Gloxina Ballet
 Company*, 85, 86, 142, 183
Electra, 55, 56, 148
Elektra, 58, 158, 159, 185
Ellen Stewart Theatre, 3, 20, 148, 163, 171
Ellison, Ralph: *Invisible Man*, 133
El Metro (Dutchman), 33, 105, 181
El Rey se Muere (Exit the King), 32, 181
Epstein, Jonathan: Blue Man Group:
 Tubes, 130, 184
Equity Showcase Code, 139
Escama: *El Rey se Muere (Exit the King)*,
 32, 181; *Le Metro (Dutchman)*, 33, 181
Essman, Jeffrey: *Triplets in Uniform*, 122,
 125
Euripides: *Elektra*, 159; *Iphegenia*, 159;
 The Trojan Women, 160
Eustis, Oskar, 147
Evelyn Sherwood Designs: *Sleep and
 Reincarnation from Empty Land*, 125,
 184
Experimenta 2, 45, 182
Eyen, Tom, 63–64; *Caution: A Love
 Story*, 48; *Dreamgirls*, 38; *Miss Nefertiti
 Regrets*, 38, 39; "Theatre of the Eye" 38;
 The White Whore and the Bit Player,
 29, 34, 64, 65

Fabricant, Gwen: *America Hurrah* and
 Pavane, 36, 181
Faust/Gastronome, 137, 138, 184

Faust Part I, 94, 183
Feldman, Peter: *Comings and Goings*,
 40; *Interview*, 36; *The Open Theatre
 Ensemble Improvisations*, 36; *Pavane*,
 36; *Viet Rock*, 40
Ferlinghetti, Lawrence: *The Allegation
 Impromptu*, 26
Festival International de Baalbeck, XVII,
 59, 182
Fierstein, Harvey, 92, 127; *Fugue in a
 Nursery*, 93; *Hairspray*, 172, 185; *The
 Haunted Host*, 129; *International Stud*,
 92–93, 183; *Safe Sex*, 118–19, 121, 184;
 Tidy Endings, 119; *Torch Song Trilogy*,
 93, 119; *Widows and Children First*, 93
Fiji Company, 101
Firmament, 142, 144, 184
first European tour, 7–8, 33, 181
*500 Years: A Fax from Denise Stoklos to
 Christopher Columbus*, 135–37, 184
Flanagan, Neil: *Love Song for Mrs. Boas*, 32
Fleming, Maureen, 148; *Decay of the
 Angel*, 152, 153; *Water on the Moon*, 154;
 Sphere, 154
Follet, Feu: *Trojan Women*, 62, 182
Ford Foundation, 6, 48, 56, 79, 85
Forensic and the Navigators, 52, 182
Fornes, Maria Irene, 20, 46; *A Vietnamese
 Wedding*, 49; *The Red Burning Light*,
 49; *The Successful Life of Three*, 49
Foster, Paul, 5, 20, 23, 24, 41; *Balls*, 26, 27;
 BbAaNnGg!, 37; *The Hessian Corporal*,
 45; *Hurrah for the Bridge*, 6, 26, 28;
 Madonna in the Orchard, 31; *The Re-
 cluse*, 14, 30, 42; *Tom Paine*, 43, 44
Fourteen Hundred Thousand, 42
Fourth Street, 1, 6, 7, 20, 48, 56, 104, 139,
 149, 167, 182
Fragments of a Trilogy, 17, 56, 118, 148
Frank, Mary, 16–17, 163; *Firmament*, 142,
 143, 144, 184; *Big Mouth*, 113, 114, 184
Friedman, Gary William: *East Bleeker*,
 41–42; *The Me Nobody Knows*, 43
Friedman, Sy, 64, 182
Fugue in a Nursery, 93
Fujiyabu, Kaori, 146, 184
Fulham, Mary, 8
Futz, 43–44, 45, 46, 182

Gallo, Max, 9
Gary, Steve: *Dear Friends*, 27

The Gate, 67

Geary, David: *Quarry*, 69, 70, 182

Geiogamah, Hanay: *Body Indian*, 86

Genet, Jean, 98; *The Maids*, 42, 46

Gibson, Charles Dana, 47

Gilman, Esther, 182

Ginsberg, Allen, 130

Glaser, Milton, 72

Glass, Philip, 1; *The Red Horse Animation*, 63, 64. *See also* Mabou Mines Company

Gloria and Esperanza, 46, 48

Golden Bat, 54, 77, 78, 182, 183

Goldfarb, Sidney: *Big Mouth*, 113

Goldman, Matt, 129. *See also* Blue Man Group

Good Woman of Setzuan, 60, 182

Gorky, Maxim: *Mother*, 140

Gossage, James, 39; *Madonna in the Orchard*, 31, 181; *Miss Nefertiti Regrets*, 39, 181

Graham, Martha, 17

Great Jones Repertory Company, 8, 21, 58, 123, 148, 151, 154, 159–60, 169, 170; creation, 55. *See also* Angels of Swedenborg; *Antigone*; *Good Woman of Setzuan*; *Electra*; *Dionysus Filius Dei*; *Fragments of a Trilogy*; *Medea*; *Dionysus Filius Dei*; *Mythos Oedipus*; *Perseus*; *SEVEN*; *Seven Against Thebes*; Swados, Elizabeth; *The Trojan Women*

Great Jones Street, 2, 104, 139, 148

Greber, Denise, 10–11; *Bokan, The Bad Hearted*, 152, 185

Greene, Richard, 149; *Seven Against Thebes*, 155, 185

Greenfield, Lois: *Decay of the Angel*, 153, 185

Grossman, Henry: *The Conference of the Birds*, 98, 183

Grotowski, Jerzy, 63, 139, 155, 158; *Acropolis*, 137; *Apocalypsis*, 137; *Constant Prince*, 137

Guare, John, 47

Guggenheim Fellowship, 107, 113

Guggenheim Museum *The Red Horse Animation*, 63, 64

Gussow, Mel, 101

Hair, 4, 40, 43, 72

Hairspray, 172, 185

Handley, Justin: *The UnPOSSESSED*, 157, 185

Harada, Hiroko: *Sleep and Reincarnation from Empty Land*, 125, 184

Haring, Keith: *Pass the Blutwurst, Bitte*, 143

Harper, Annette: *The Cotton Club Gala*, 90, 183

Harris, George III, 130, 131; *Underground*, 135, 184; *Under the Knife: A History of Medicine*, 135, 184

Harris, W. Michael: *Hibiscus*, 131

Harris, William, 107

The Haunted Host, 129, 183

Heaven on Earth, 165, 185

Henderson, Mary, 12

The Hessian Corporal, 45

Hibiscus, 130, 131, 184

Hibiscus and the Screaming Violets, 130

Hickman, Lee: *Spring Play*, 45

Higashi, Yutaka, 96, 183; *The City*, 79; *Golden Bat*, 77, 96

Hijikata, Tatsumi, 101, 125

Hoffman, William: *As Is*, 85, 118, 129; *Spring Play*, 45; *XXXXX*, 83, 85

Hoplite Diary, 156, 185

Horn, Alex: *East Bleeker*, 42

Horse Opera, 64, 66, 67, 182

H. T. Chen and Dancers, 87

Humboldt's Current, 101

Hurrah for the Bridge, 6, 26, 28

IFSK, 57, 182

Ilic, Mirko: *The Architect and the Emperor of Assyria*, 72, 182

The Ik, 97

Ikegami, Naoya: *Admiring La Argentina*, 102, 183; *My Mother*, 102, 183

Industrial Revolution, 9, 12

International Festival in Zagreb, 55, 57

International Meeting / Symposium of Ancient Greek Drama, 115, 116. *See also* Mythos Oedipus

International Stud, 92–93, 183

Interview, 36, 37, 42

Ionesco, Eugene, 46, 49; *El Rey se Muere* (*Exit the King*), 32; *Rhinoceros*, 72

Iphegenia, 159, 185

I Shall Never Return, 95

Isherwood, Christopher, 162

Jacobson, Bernie, 140

Jagger, Mick, 130

Japan Arts Association, 148

Jarboro, Katarina, 77

Jarboro Company, 20, 77, 183

Jarmusch, Jim: *Pass the Blutwurst, Bitte,* 143

Jarry, Alfred: *Ubu Roi,* 57

Jaworowski, Ken, 160

Jay Z., 130

Jerusalem, 116

Jesurun, John, 15–16, 18–19, 20, 107–12, 147, 169, 170, 184; *Chang in a Void Moon,* 107; *Dog's Eye View,* 107; *Red House,* 16, 107, 108, 109

Jesus Christ Superstar, 4, 72, 74

Jim Henson Foundation, 152 *Hoplite Diary,* 156

Jones, Bill T., 132

Jones, Le Roi (Amiri Baraka): *Le Metro (Dutchman),* 33, 105; *Money: A Jazz Opera,* 105, 106; *The Slave,* 105; *The Toilet,* 105

Jones, Patricia Spears: *Mother,* 140

Jones, Rhodessa, 147; *Big Butt Girls, Hard-Headed Women,* 130, 132

Judson Poets Theatre, 6, 49, 67

Kahn, Michael: *America Hurrah,* 36

Kang, Manhong: *Mythos Oedipus,* 115

Kantor, Tadeuz, 4, 20; *The Dead Class,* 94–95, 139; *I Shall Never Return,* 95; *Let the Artists Die,* 95; *Today Is My Birthday,* 95; *Wielopole, Wielopole,* 95. *See also* Cricot 2

Kaprow, Allan, 64

Kaufman, Moises: *One Arm,* 25

Kaufman, Walter, 94

Keitel, Harvey, 1; *Madonna in the Orchard,* 31; *Spring Play,* 45

Kelly, John, 20, 140, 142, 148; *Akin,* 142; *Pass the Blutwurst, Bitte,* 142, 143, 184; *Chang in a Void Moon,* 107; *Dionysus Filius Dei,* 123; *Ode to a Cube,* 142

Kenkichi, Sato: Flyer for *Golden Bat,* 78, 183

Kennedy, Andrienne: *A Rat's Mass,* 49, 51; *Funnyhouse of a Negro,* 49

Kennedy's Children, 129

Kent: *Spring Play,* 45, 182

Kerr, Walter, 37

Killacky, John, 67

Kinney, Kathy: *Triplets in Uniform,* 122

KISCH: *International Stud,* 93, 183

Klein, Stacy, 157: *The UnPOSSESSED,* 155

Kline, Elmer: *Dear Friends,* 27

Koch, Ed, 25

Koutoukas, H. M., 38; *One Man's Religion / The Pinotti Papers,* 92

Kramer, Hilton, 4

Kramer, Larry: *A Normal Heart,* 118

La Chiusa, Michael John: *Marie Christine,* 125; *See What I Wanna See,* 125; *Triplets in Uniform,* 122, 125; *The Wild Party,* 125

La MaMa Bogotá, 6, 32, 33

La MaMa Cantata, 169, 171, 185

La MaMa E.T.C., 7, 26, 28

La MaMa Experimental Theatre (La MaMa Troupe/La MaMa Repertory Company), 8, 46; first fifty years overview, 19–21; 1960s, 23–54; 1970s, 55–96; 1980s, 97–126; 1990s, 127–46; 2000s, 147–72; "satellites," 6

La MaMa Moves Dance Festival, 165

La MaMa Plexus, 7, 63, 64

La MaMa Troupe, 6, 34, 42, 43, 53, 55, 130

La MaMa Umbria (International), 2, 8, 104, 146, 147, 184

La Marie Vison, 76, 77, 183

Lane, Diane, 58

Leach, Wilford, 6–7, 20, 72; *Horse Opera,* 64, 66, 67; *The Mystery of Edwin Drood,* 67; *The Pirates of Penzance,* 67

le Doux, Pierre, 34

Lee, Leslie, 77; *Cops and Robbers,* 81 Lee, Tom, 148, 154–5; *Antigone,* 154–55; *Dionysus Filius Dei,* 123; *Hopelite Diary,* 156

Lenny, 72

Leo Castelli Gallery: *Vain Victory: The Vicissitudes of the Damned,* 84

Let the Artists Die, 95

Levy, Jacques, 39

Lichtenstein, Roy, 52

Lieberman, Ron: *Vain Victory: The Vicissitudes of the Damned,* 84, 183

A Light from the East, 144

Lights, Fred, 5, 23

Lincoln Center for the Performing Arts, 17–18, 120, 121
Lindeman, N.: *The Architect and the Emperor of Assyria*, 72, 182
lithography, 12, 32, 33, 84
Living Theatre, 39, 114
LOCO7, 151; *Bokan, The Bad Hearted*, 152
Logan, Becket: *Mother*, 140, 184
Lopez, Rosa: *Trojan Women*, 61, 62
L'Os/Ubu, 97
Love Song for Mrs. Boas, 32, 181
Lowry, W. McNeil, 6, 48, 56, 79
Ludlam, Charles: *Bluebeard*, 79, 82
Lysheha, Oleh, 167

Mabou Mines, 20, 86; *Mother*, 140; *The Red Horse Animation*, 63, 64
Mac, Taylor: *The Walk Across America for Mother Earth*, 162, 164
MacArthur Fellowship, 8, 97, 107, 147
MacArthur Foundation, 97
Machado, Agosto, 85
Maddow, Ellen, 17, 18, 115, 116; *Painted Snake in a Painted Chair*, 150, 151; *The Walk Across America for Mother Earth*, 162, 163–64. *See also* Talking Band
Mad Men, 130
The Madness of Lady Bright, 34
Madonna: *Pass the Blutwurst, Bitte*, 143
Madonna in the Orchard, 31, 181
Magic Marker, 13, 16, 32, 36, 45, 109
Makela, Christine: *Hibiscus*, 131, 184
Maleczech, Ruth: *Mother*, 140. *See also* Mabou Mines Company
Mandorla, 165, 167, 185
Mann, Thomas, 28
Marat/Sade, 28
Margolin, Deb, 127
Marie Christine, 125
Martin Beck Theatre, 28
Mary Stuart, 135
Mason, Marshall: *Balm in Gilead*, 28, 29
Masson-Skine, Nourit: *Sleep and Reincarnation from Empty Land*, 125, 184
Massot, Olivier: *YokastaS*, 138, 184
Ma Yi Theatre Company, 87
McCartney, Paul, 130
McCauley, Robbie, 142
McCoy, Dan, 22, 181
McGrath, John Edward: *Mother*, 140

McMullan, James, 18, 121; *Anything Goes*, 120; *Carousel*, 120; *Road*, 17, 120, 184; *South Pacific*, 120
McNulty, Charles, 137
Meadow, Amy: *Belle Reprieve*, 128, 184
Medea, 55, 56, 58, 59, 61, 62, 132, 148, 182
Mee, Chuck: *Heaven on Earth*, 165
Melfi, Leonard, 4; *Horse Opera*, 66, 67; *Times Square*, 45
Mellon Foundation, 6, 56
The Me Nobody Knows, 43
Micheline, Jack: *East Bleeker*, 41, 42
Midler, Bette, 1; *Miss Nefertiti Regrets*, 39, 181
A Midsummer Night's Dream, 167
Milligan, Andy, 10, 24; *One Arm*, 9, 25
mimeograph, 13, 14, 15.
Miss Nefertiti Regrets, 39, 181
Modern Photography, 64
Money: A Jazz Opera, 105, 106, 184
Monk, Meredith, 17, 18–19, 20, 169; *Quarry*, 67, 69, 70, 101, 182
Monroe, Marilyn, 13, 64, 65
Montez, Mario, 85
The Moon Dreamers, 46, 47, 84, 182
Moonstruck, 46
Moore, Jim, 41
Moore, Peter: *The Red Horse Animation*, 64, 182
Moreau, Peter, 47
Moseley, Monica, 70; *Quarry*, 69, 182
Mostel, Zero, 72
Motel, 37
Mother, 140, 184
Mother Courage, 1
Mrożek, Sławomir: *Alpha*, 111, 112
Muller, Chris: *Faust/Gastronome*, 138, 184
Muteki-sha Dance Company, 125
My Big Fat Greek Wedding, 63
My Mother, 101, 102, 183
Mythos Oedipus, 8, 115, 116, 117, 118, 148, 184

Nagrin, Lee, 67, 101
NA HAAZ ZAN, 86, 87, 183
Nakajima, Natsu: *Sleep and Reincarnation from Empty Land*, 125
Nation, 72
Native American Theatre Ensemble, 20, 85, 91

Negret, Edgar: *Que Viva El Puente*, 28–29
Nelly Vivas Company, 72
Neumann, Fred: *That Time*, 112; *Theatre I*, 112; *Theatre II*, 112
New Lafayette Theatre, 51, 183
New Play Series / Third World Rituals and Folk Dramas, 91, 183
New York Public Theater, 7, 148, 163; Under the Radar Festival, 162
New York Times, 4, 10, 17, 37, 48, 49, 57, 98, 101, 114, 118, 125, 129, 133, 137, 140, 142, 147, 152, 155, 157, 160, 162, 165
Niblock, Phill: *The Open Theatre Ensemble Improvisations*, 36, 181
Ninth Street basement, 1, 5, 23, 25, 26, 26
Nomis, Amnon Ben: *A Rat's Mass*, 51, 182; *Good Woman of Setzuan*, 60, 182
Noonan, Tom Ford, 47

Obama, Barack, 130
Oberlaender, Jon: *El Rey se Muere* (*Exit the King*), 32, 181
Obie Award, 8, 43, 49, 71, 105; *The Dead Class*, 94; *Futz*, 46; *Gloria and Esperanza*, 46; *Humboldt's Current*, 101; *The Maids*, 46; *Painted Snake in a Painted Chair*, 152; *Pass the Blutwurst, Bitte*, 142; *Wielopole, Wielopole*, 95
Off-Off Broadway, 8, 14, 15, 21, 24, 28, 31, 37, 39, 41, 43, 46, 72; map of early theater spaces, 7, 181
Ohno, Kazuo, 4, 20, 152; *Admiring La Argentina*, 101, 102; *My Mother*, 101, 102
O'Horgan, Tom, 5, 6, 20, 34, 41, 43, 53, 55, 61, 117, 130, 182; *The Architect and the Emperor of Assyria*, 72, 74; *Caligula*, 74; *Dear Friends*, 27; *Hair*, 4, 43, 72; *Interview*, 36; *Jesus Christ Superstar*, 4, 72, 74; *Lenny*, 72; *The Maids*, 42; *Tom Paine*, 44
Okking, Jens, 29
Old Reliable Theatre Tavern: *XXXXX*, 83
Olson, Bob: *Pompeii*, 88, 183
Ondine, 85
One Arm, 9–10, 24–25, 181
One Ring Zero: *Mandorla*, 165
Ono, Yoko, 85

Open Theatre, 17, 20, 36, 39, 40, 41, 49, 114, 115, 116, 139, 142; *The Open Theatre Ensemble Improvisations*, 36, 181
Optic Fever, 133
Order of the Sacred Treasure, 8
Orghast, 58
Orpheum Theater, 43
Osterwalder, Valerie: *Underground*, 135, 184
Our Town, 165
Ouya, Prisca, 160
Overbeck, Lois, 49
Owens, Rochelle, 46, 92; *Futz*, 43, 44, 45

Paar, Jack, 13
Paik, Nam June, 64
Painted Snake in a Painted Chair, 149, 150, 151, 185
Pan Asian Repertory Theatre, 20, 91; *The Dowager*, 87, 89
Papp, Joseph, 4, 7
Paraiso, Nicky, 67, 167
Pari, René: *Medea*, 59, 182
Pass the Blutwurst, Bitte, 142, 143, 184
Patrick, Robert, 15, 24, 38; *BbAaNnGg!*, 37; *The Haunted Host*, 129; *Kennedy's Children*, 129
Paulson, Robert, 5
Paulus, Diane: *Hair*, 4
Pavane, 36, 37, 42, 181
Pearsall, Amy Lee, 167
Peisner, Martin: *Miss Nefertiti Regrets*, 39, 181
Perez, Lazaro: *Caligula*, 74
The Performance Group, 137, 139
Performing Garage, 132, 139
Perlman, Ron: *The Architect and the Emperor of Assyria*, 74
Perseus, 158, 160
Petty, Beverly, 8
Phillips, Bradley: *Street Sounds*, 80, 183
photostats, 13, 14, 30, 79, 83, 88
Pinter, Harold, 1, 26, 162; *The Room*, 25
Playhouse of the Ridiculous, 20, 82; *XXXXX*, 83
Plexus Group, 63, 117
Pocket Theatre, 41; *America Hurrah*, 37; *Motel*, 37; *TV*, 37
Pollitt, Barbara: *Big Mouth*, 113
Pompeii, 88, 183

posters: hand-drawn to digital, 14–19; La Mama's history, 9–11; U.S. theater, 11–14
Praemium Imperiale, 8, 148
Price, Gilbert: *A Rat's Mass*, 49
Price, Leontyne, 161
Pua Ali'I 'Ilima, 167
Public Theater: *Being Harold Pinter*, 162, 163; Under the Radar Festival, 162
Pujols, Carmen: *Virtual Souls*, 145, 184
Purvis, Alston W., 9
Pyramid Club, 107

Quarry, 67, 101, 182

Ragged Edge Press, 164; *Big Mouth*, 113
Ragni, Gerome: *The Clown Play*, 40; *Comings and Goings*, 40; *Hair*, 40
Rainer, Yvonne, 64
Ramirez, Jose Erasto, 65, 182
A Rat's Mass, 49, 51, 182
Ravitz, Mark (M.R.): *The Sixty-Minute Queer Show*, 83, 183
The Recluse, 14, 30, 42, 181
The Red Burning Light, 49, 50, 182
The Red Horse Animation, 63, 64, 182
Red House, 16, 107, 108, 109, 184
Ree, Larry, *Ekathrina Sobechanskaya Dances with her Original Trockadero Gloxina Ballet Company*, 85, 86, 142, 183
Reed, Lou: *Pass the Blutwurst, Bitte*, 143
Remick, Lee, 28
Remington, R. Roger, 9
Restrepo, Federico, 148, 151–52, 159–60, 171; *Bokan, The Bad Hearted*, 152; *Perseus*, 158. *See also* LOCO7
Rhinoceros, 72
Ribas, Joseph: *Mandorla*, 165, 185
Richards, Robert W.: *Ekathrina Sobechanskaya Dances with her Original Trockadero Gloxina Ballet Company*, 86, 183
Richard's Lear, 139
Rifenberg, Churchill: *International Stud*, 93, 183
Road, 17, 120, 121, 184
Roberts, Marilyn, 49
Rocha, Jenny: *Mandorla*, 167
Rocha Dance Theatre: *Mandorla*, 165, 167

Rockaby, 100, 101, 183
Rockefeller Foundation, 6, 48, 85
Rocking Chair, 53
Rodriguez, Ozzie, 3, 8, 10–11, 15, 16, 167, 169, 181; *A Rat's Mass*, 51, 182; with Stewart, x; *Street Sounds*, 80, 183; *Trojan Women*, 61, 62, 182
Rolling Stone, 130
Romanian Ministry of Culture, 56
Rosenberg, Stanley, 34, 63
Rosenthal, Sidney, 13
Rosten, Bevya, 142
Ryan, Thomas, 98

Sacharow, Lawrence: *Madonna in the Orchard*, 31
Sadan, Mark, 6
Safer, Dan: *Dancing VS. The Rat Experiment*, 165
Safer, Kaz Philips, 165, 185
Safe Sex, 118–19, 121, 184
Sanford Manufacturing Company, 13
Sato, Pater: *Golden Bat*, 78, 183
Scavullo, Francesco, 85
Schechner, Richard, 20, 137–40, 147, 158; *Acropolis*, 137; *Apocalypsis*, 137; *Constant Prince*, 137; *Faust/Gastronome*, 137, 138; *Richard's Lear*, 139; *Three Sisters*, 137, 139; *YokastaS*, 138, 139; *YokastaS Redux*, 139. *See also* The Performance Group
Second Avenue theater, 6, 22, 26, 27, 28, 34, 53, 181
See What I Wanna See, 125
Seliger, Mark: *Tubes*, 130, 184
Sell, Mike, 79
Seoul Institute of the Arts, 170
Serban, Andrei, 4, 20, 56–59, 75, 117, 139, 169; *Arden of Faversham*, 8, 55, 57; *Fragments of a Trilogy*, 17, 56, 60, 118; *Good Woman of Setzuan*, 60; *Medea*, 56, 59, 61, 148, 182; *Good Woman of Setzuan*, 60; *Ubu*, 8, 55, 57
SEVEN, 8, 21, 148, 154, 155
Seven Against Thebes, 8, 148, 155, 169, 185
Shah, Kanan: *Discovering Oz*, 162, 163, 164; *The Walk Across America for Mother Earth*, 162–63, 164, 185
Shakespeare, William: *A Midsummer Night's Dream*, 167
Shakespeare and Company, 29

Shango, 11, 75, 182

Shaw, Paul: *Belle Reprieve*, 127, 128. *See also* Bloolips

Shaw, Peggy, 20; *Belle Reprieve*, 127, 128. *See also* WOW Café

Shawn, Wallace, 2

Shepard, Sam, 2, 20, 24, 37, 41, 47, 49, 182; *Dog*, 53; *Fourteen Hundred Thousand*, 42; *The Right Stuff*, 53; *Rocking Chair*, 53; *Unseen Hand*, 52; *The White Whore and the Bit Player*, 34

Shepard, Tina, 115, 116, 142; *Big Mouth*, 113. *See also* Talking Band

Shevett, Anita: *Bluebeard*, 82, 183

Shevett, Steve: *Bluebeard*, 82, 183

Shiele, Egon, 142

Shorty, Robert: *NA HAAZ ZAN*, 86, 183

Shuji, Terayama: *Directions to Servants*, 100, 183; *La Marie Vison*, 77

Signature Theatre, 49

silkscreen, 12–13, 78, 110

Silver Cloud Native American Drummers and Singers, 167

Sirotta, Michael, 117; *Jerusalem*, 116; *Mythos Oedipus*, 116; *Perseus*, 158

The Sixty-Minute Queer Show, 83, 85, 183

Skipitares, Theodora, 18, 19, 20, 132–34, 161–62, 169; *Underground*, 135; *Under the Knife: A History of Medicine*, 135; *Women of Troy*, 160, 161, 185

The Slave, 105

Sleep and Reincarnation from Empty Land, 125, 184

Smildiger, Hendrik: *Bokan, The Bad Hearted*, 152, 185

Smith, Jack, 130

Smith, Patti, 4, 143; *Pass the Blutwurst, Bitte*, 143

Smith, Priscilla: *Good Woman of Setzuan*, 60; *Medea*, 58, 59

Snapp, Brian: *Hoplite Diary*, 156, 185

Solomon, Alisa, 118, 127, 140

South Pacific, 120

Souza, Flander de, 137; *500 Years: A Fax from Denise Stoklos to Christopher Columbus*, 136, 184

Spiderwoman Theater, 127

Split Britches, 169; *Belle Reprieve*, 127, 128

Spring Play, 45, 182

Stanescu, Saviana: *YokastaS*, 138

Staniewski, Włodzimierz, 137, 147, 157–58; *Elektra*, 158, 159; *Metamorphoses*, 158. *See also* Gardzienice Theatre

Stanislavsky, Konstantin, 137

Stanton, Phil, 129. *See also* Blue Man Group

Stecle, Charles: *Sleep and Reincarnation from Empty Land*, 125, 184

Stein, Gertrude, 49

Stewart, Ellen: background, 4–8; "babies," 23–24; death, 8, 21, 56, 162, 169–70; first directorial credit, 6, 88; first theater, 23–24; Fourth Street, 1, 6, 7, 20, 48, 56, 104, 139, 149, 167, 182; funeral, 148; Great Jones Repertory Company, 123, 148; MacArthur Fellowship, 8, 97, 147; mother figure, 5, 14, 21, 24, 134; Ninth Street, 1, 5, 23, 25, 26, 26; Obie Awards, 8; photo with Rodriguez, x; Praemium Imperiale, 8, 148; real-estate savvy, 1, 5, 6; Second Avenue, 6, 22, 26, 27, 28, 34, 53; Special Obie Citation, 97; Tony Honor for Excellence in Theatre, 8, 148. *See also Antigone; The Cotton Club Gala; Dionysus Filius Dei; Electra; Medea; Mythos Oedipus; Perseus; The Red Horse Animation; SEVEN; Seven Against Thebes; Shango; Trojan Women*

Stoklos, Denise, 134–35; *Casa*, 135; *500 Years: A Fax from Denise Stoklos to Christopher Columbus*, 135–37; *Mary Stuart*, 135

Stone, Laurie, 137

Stone, Rebecca: *Hibiscus*, 131

Stopped Bridge of Dreams, 110

St. Patrick's Cathedral, 1, 148, 149

Streetcar Named Desire, 127, 128

Street Sounds, 79, 80, 183

Suga, Shigeko, 11

Suignard, Guy: *Rockaby*, 100, 183

Swados, Elizabeth, 20, 117, 147, 151; *Good Woman of Setzuan*, 60; *Electra*, 148; *Fragments of a Trilogy*, 17, 56, 148; *Jerusalem*, 116; *La MaMa Cantata*, 169, 171; *Medea*, 55, 58, 59, 60–61, 148; *SEVEN*, 8; *The Trojan Women*, 148. *See also* Great Jones Repertory Company

Sykes, Kim: *Triplets in Uniform*, 122

Talking Band, 17, 114, 115–16, 169; *Big Mouth*, 113; *Painted Snake in a Painted Chair*, 150; *The Walk Across America for Mother Earth*, 162, 164

Tallmer, Jerry, 46

Tanaka, Min, 116, 148, 152; International Meeting / Symposium of Ancient Greek Drama, 115

Tashiev, Bakai: *Dream Bridge*, 166, 185

Taylor, Cecil: *A Rat's Mass*, 49

Taylor, Elizabeth: *Cleopatra*, 39

Taylor, Robert U.: *The Unseen Hand* and *Forensic and the Navigators*, 52, 182

TCG Mentor/Mentee Fellowship Award, 169

TDR: The Drama Review, 2

Teatret, Odin, 157

Tenjo Sajiki (Peanut Gallery), 77

Tenorio, Danilo: *Le Metro* (*Dutchman*), 33

Terayama, Shuji ; *Directions to Servants*, 98, 99, 100; *La Marie Vison*, 77

Termine, Richard: *Women of Troy*, 161, 185

Terry, Megan, 20, 39, 46; *America Hurrah*, 41; *Calm Down Mother*, 41; *Comings and Goings*, 40, 41; *Viet Rock*, 40, 41

That Time, 112, 114, 184

Theater Hall of Fame, 8

Theatre I, 112, 114, 184

Theatre II, 112, 114, 184

Theatre Genesis, 6, 53

third European tour, 45, 181, 182

Third World Institute of Theatre Arts Studies (TWITAS), 91, 92, 94, 132, 183

Thomas, Gerald: *That Time*, 112, 114, 184; *Theatre I*, 112, 114, 184; *Theatre II*, 112, 114, 184

Three Sisters, 137, 139

Three Stooges, 122

Tibetan Book of the Dead, 117

Tidy Endings, 119

Tkacs, Virlana, 169; *Dream Bridge*, 166, 167; *A Light from the East*, 144; *Virtual Souls*, 145

Today Is My Birthday, 95

Toi Art Design: *Dream Bridge*, 166, 185

The Toilet, 105

Tokyo Kid Brothers, 20, 77; *The City*, 77, 79, 183; *Golden Bat*, 54, 77, 78, 182, 183

Toledo, Raffael: *La MaMa Cantata*, 171, 185

Tom Paine, 43, 44, 46, 182

Tony Honor for Excellence in Theatre, 8, 148

Torch Song Trilogy, 93, 119

Travolta, John: *Saturday Night Fever*, 46

Triplets in Uniform, 122, 125, 184

The Trojan Women, 56, 58, 61, 62, 63, 148, 157, 160, 182

Tsuchitani, Yayoi R.: *The Recluse*, 14, 30, 181

Tsuji, Yukio: *Tibetan Book of the Dead*, 117

Tutti Non Ci Sono (*All Are Not Here*), 99, 183

TV, 37

TWITAS. *See* Third World Institute of Theatre Arts Studies

Ularu, Nic: *Painted Snake in a Painted Chair*, 149, 150, 185

Under the Knife, 133

The UnPOSSESSED, 155, 185

Ubu, 8, 55, 57

Underground, 133, 135, 184

Under the Knife: A History of Medicine, 133, 135, 184

Under the Knife II, 133

Under the Knife III, 133

Uno, Akira (Aquirax): *La Marie Vison*, 76, 77, 183

Unseen Hand, 52, 182

U.S. Embassy: *Dream Bridge*, 166

Vaccaro, John, 20, 82; *Body Indian*, 85, 86, 87; *The Sixty-Minute Queer Show*, 83, 85; *XXXXX*, 83, 85. *See also* Playhouse of the Ridiculous

Vain Victory: The Vicissitudes of the Damned, 84, 85, 183

van Itallie, Jean-Claude, 20, 24, 34–37, 39; *America Hurrah*, 36; *Interview*, 36, 37, 42, 42; *Pavane*, 36, 37, 42; *Tibetan Book of the Dead*, 117

Vezzuso, Jerry: 56, 182; *Mythos Oedipus*, 115, 184

Vietnamese Wedding, 49, 50, 182

Viet Rock, 40, 41, 67, 182

Village Voice, 10, 27, 107, 118, 127, 137, 140, 142, 151

Villechaize, Hervé: *The Moon Dreamers*, 46

Virtual Souls, 144–45, 184

Visual Thinking: Alpha, 111, 184

Voreadis, Jannis: International Meeting / Symposium of Ancient Greek Drama, 115, 184

Wałesa, Lech, 111, 112

The Walk Across America for Mother Earth, 162, 163, 164, 185

Walter, Sidney Schubert: *Balls*, 27

Ward, Conrad, *Cops and Robbers*, 81; *Futz*, 43, 44, 182; *Vietnamese Wedding* and *The Red Burning Light*, 50, 182; *XXXXX*, 83, 183

Ward, Mary Beth: *Trojan Women*, 62, 63, 182

Warhol, Andy, 13, 78, 84, 85

Warren, David: *Triplets in Uniform*, 122

Warrilow, David, 63. *See also* Mabou Mines Company

Watanabe Studio: *Sleep and Reincarnation from Empty Land*, 125, 184

Water on the Moon, 154

Weaver, Lois, 20, 127, 128

Wellman, Mac, 147

West, Mae, 65

Westley, Richard, 77; *Black Terror*, 81

The White Whore and the Bit Player, 29, 34, 64, 65, 181, 182

Whitney Museum of Art, 138

Widows and Children First, 93

Wielopole, Wielopole, 95

Wigfall, James: *Dear Friends*, 27

Wild, Chris: *Antigone*, 154; *Perseus*, 160

Wilder, Thornton: *Our Town*, 165

The Wild Party, 125

Williams, Tennessee: *One Arm*, 9–10, 24–25; *Streetcar Named Desire*, 127, 128

Wilson, Lanford, 20, 24, 37–38; *Balm in Gilead*, 28, 29; *The Madness of Lady Bright*, 34

Wilson, Robert, 37

Wink, Chris, 129. *See also* Blue Man Group

Winter Project, 17, 41, 114, 116, 142, 144

Women of Troy, 160, 161, 185

Women's Interart Center, 71

Woodard, Shawnecka, 154

Woodlawn, Holly, 85

Workman, Jason: *The Haunted Host*, 129

Works Progress Administration, 13

World War I, 47

World War II, 67, 70, 101

WOW Café, 127

Xerox, 14, 15–16, 30

XXXXX, 83, 85, 183

Yara Arts Group, 169; *Dream Bridge*, 166, 167; *A Light from the East*, 144; *Virtual Souls*, 144–45

Yeh, Ching, 87; *Pompeii*, 88

YokastaS, 138, 139, 184

YokastaS Redux, 139

Yoo, Duk-Hyung, 148

Yoo, Mia, 8, 97, 148, 149, 169–70, 184; *Angels of Swedenborg*, 169; *Seven Against Thebes*, 169

Yorck, Ruth Landshoff, 28, 38; *Love Song for Mrs. Boas*, 32

Zang, Elena, 113, 184

Zimet, Paul, 17, 18, 20, 113, 114, 115–16, 147, 184; *Firmament*, 142; *Painted Snake in a Painted Chair*, 149, 150, 151; *The Walk Across America for Mother Earth*, 162–63, 164. *See also* Talking Band

Zodiac Photographers, 64, 182

Zone of Silence, 162, 163, 185

Zwick, Joe, 7, 20, 72; *Dance Wi' Me*, 63, 64; *Happy Days*, 63; *Laverne and Shirley*, 63; *My Big Fat Greek Wedding*, 63. *See also* La MaMa Plexus